Alexander McQueen

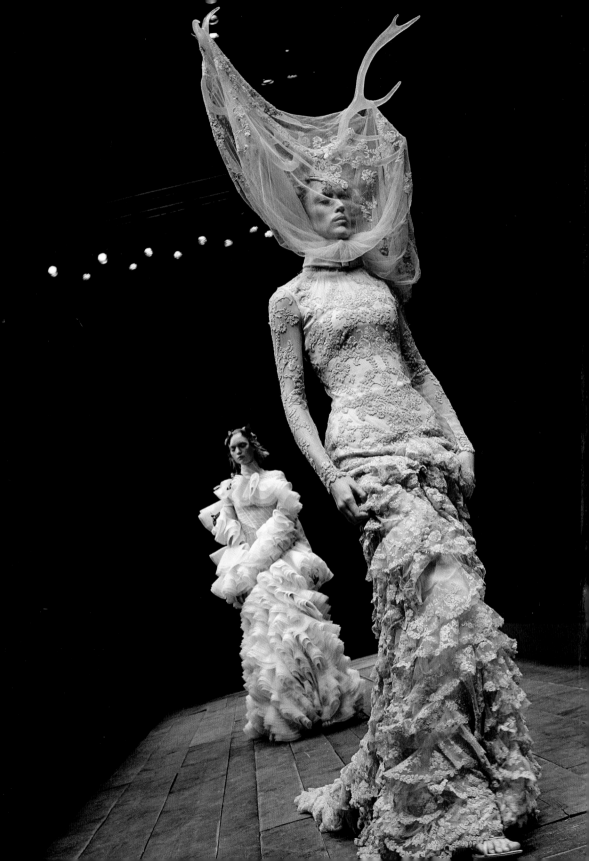

Alexander McQueen

The Life and the Legacy

Judith Watt

Foreword by Daphne Guinness

HARPER DESIGN

An Imprint of HarperCollinsPublishers

For Bobby Hillson, with love

Alexander McQueen
The Life and the Legacy

Copyright © 2012 by Judith Watt.

First published in 2012 by
Harper Design
An Imprint of HarperCollins*Publishers*
10 East 53rd Street
New York, NY 10022
Tel: (212) 207-7000
Fax: (212) 207-7654

Library of Congress Control Number: 2012947281
ISBN 978-0-06-213199-7

Book Design by Iris Shih
Printed in the United States of America
First printing, 2012

CONTENTS

FOREWORD

When I think of Alexander McQueen, I tend to picture him laughing. During those times together, he was not the visionary designer or the inspired fantasist, but just Lee—my confidante and support, my loyal friend. And yet I was always aware of a pulse that beat within him, a reminder that beneath this quiet, reflective person, an artist lingered. Lee's imagination never holidayed, never flagged. He drew inspiration from everything around him; he was as passionate on the subject of his Anglo-Scottish heritage as he was on other cultures, on art and music, and always at the center of it all, people. He saw people as they were, grasped their cracks and complexities, embraced them. He loved women, really adored them—and not just for our statuesque

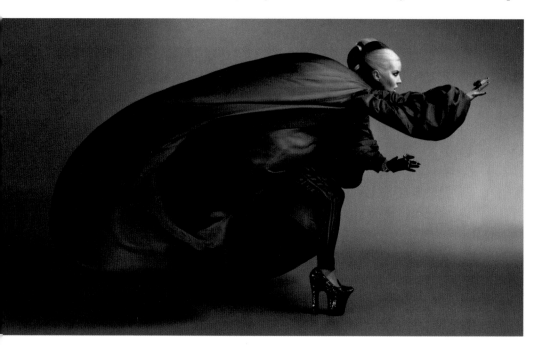

beauty but for our fragility as well as our strength, our ghosts and demons alongside our accomplishments. I always felt that when Lee looked at you, he saw the vulnerabilities in an instant and nodded to them, drinking in a sense of who you were. On our various collaborative projects, it was only then, when he'd paused and made his internal sketch of you on that particular day, that he started to conceive whatever it was he was about to design.

Alexander McQueen was a designer of our time, but really, he was outside and beyond all of that. He has been referred to as the fashion world's darling, its rebel and pioneer. He was both

Above: Alexander McQueen in his studio, photograph by Derrick Santini for *Flaunt* magazine, 2008. **Opposite:** Daphne Guinness wearing McQueen photographed by Sølve Sundsbø, May 2011 for "The Real McQueen," *Harper's Bazaar UK*.

all of these things and none of them at all, because actually, what he was, was an artist. He was both architect and artisan, with an insatiable appetite for creativity. Had he chosen paint or wood for his canvas instead of material, I genuinely believe he would have been determined to master and challenge their disciplines in that same defiant, obsessive way he worked with clothes. It is quite plausible that McQueen would have gone on to yield as profound an impact on another creative stage as he did on that of the fashion world. Painting's loss was fashion's gain, however, and how very glad I am of it.

—Daphne Guinness

PREFACE

In the early 1990s, McQueen did what is a rare thing in fashion—he introduced some things that were totally new. When diaphanous femininity had outstayed its welcome, he launched the low-rise "bumster" trousers, which filtered down into the high street; he reintroduced tailoring for women when it was at its nadir; he introduced frock coats; he referenced menswear without doing drag; and above all, he experimented with the silhouette, confidently playing with proportion, shifting emphasis from the waist, padding the hips, spiral-cutting around the body.

At Givenchy, McQueen brought his own transgressive, challenging and often hostile vision with him, born of the East End streets and forged by a love of history, an imagination completely unlimited and an identity formed in the gay subculture of London, with its fierce women and high priest, Leigh Bowery. He wanted to be known as the designer who took fashion into the twenty-first century, and realized this with support from the Gucci Group. What followed was a relentless drive to bring his vision of not only how women could look (empowered, frightening, sexual) but also how fashion could be—multilayered, visually extraordinary, a fantasy that expressed sometimes the darkness and sometimes the light of being human. It was his complexity, his hunger for experience, his ability to look beyond fashion and interpret his ideas with a rare cutting and technical skill that made him unique.

All of this, of course, came at a cost. By the time he left Givenchy, accusations of cocaine abuse were in the press and, fol-

lowing his death, became common knowledge. He also suffered from depression, a condition accentuated by the high of producing his shows and the lows that followed, accompanied by sheer exhaustion. Could he have stepped away, pursued a career as a photojournalist or lived quietly, surrounded by nature? His last three collections were confrontational, pleas against the excess of fashion, the plundering of the earth's resources and the destruction of oceanic flora and fauna by man. Yet each collection escaped being a mere polemic through his considered vision— a vision by this time expressing despair while ironically feeding the legend that he had become: fashion's greatest magician, the maestro who created the new, the man with his own, uncompromised voice.

During his short life, McQueen crossed from a background of perceived limitations to one of perceived glamour, and by 2004, it made him feel like he was living in a "glass box." In his early struggle, working with his fantastic team of like-minded rebels, producing collections that shocked the press, he was a happier man than the one who achieved fashion's golden prize of financial backing and shows in Paris. Finally, his mother's death, in February 2010, destroyed his most important emotional bulwark, and he killed himself before her funeral. He was just forty years old.

There have been three designers whose work changed the way women looked and whose influence has continued: Coco Chanel, Yves Saint Laurent, and Lee Alexander McQueen. Never limited by fashion, his clothes unleashed the possibilities of what a woman could be.

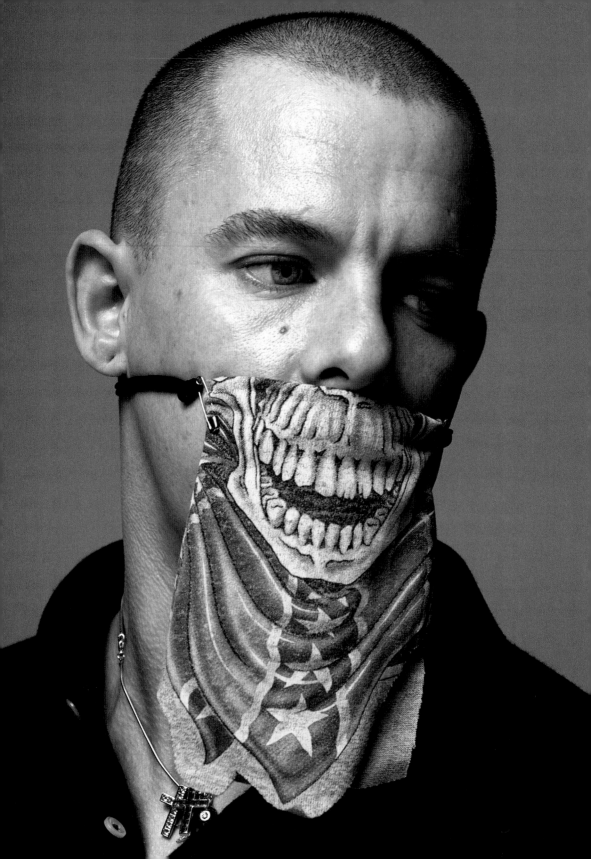

INTRODUCTION

On March 17, 1969, Lee Alexander McQueen, the greatest British fashion designer of his generation, was born in Lewisham, South London. Both his parents came from Stepney and they were Cockneys, being born within the sound of the Bow Bells. His father, Ronald, is of Scottish descent, hailing from the Isle of Skye. He worked, like other members of his family, as a London cabbie—one of the elite black taxi cab drivers whose job requires an encyclopedic knowledge of the capital's historic cityscape. His mother, Joyce, (1935–2010) was a teacher, florist and amateur genealogist, whose family came from the Forest of Dean on the English and Welsh borders. Unraveling the family tree, Joyce discovered Viking, Norman and Huguenot ancestry; her fascination with history and identity had a lasting effect on Lee and opened up a world of possibilities that fed his imagination.

He was the baby of the family, who moved to a block of flats on Biggerstaff Road, Stratford, East London, along with his five older siblings (three sisters and two brothers) while he was still in nappies. McQueen remembered drawing on the wall of his

Portrait of Alexander McQueen by Inez van Lamsweerde for V magazine, 2004.

bedroom from the age of three, particularly a Cinderella-style gown with a crinoline, much to his father's irritation. Apart from drawing and early attempts at dressmaking, his other great loves were birds and swimming. He joined the Young Ornithologists Club and went "twitching" on the roof of the flats, fascinated by the beauty and freedom of the kestrels wheeling high above, hunting for food, and by the miracle of avian engineering. The silhouette of birds taking flight

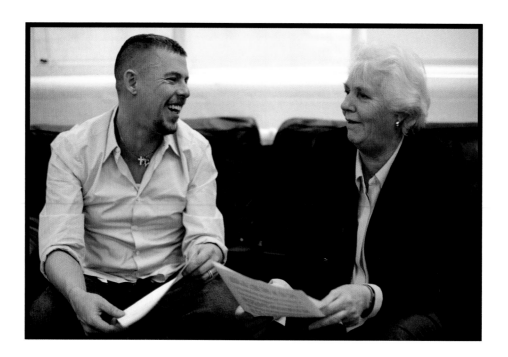

informed his later design method, which would always start by look-
ing at a body in profile, as if the rear had bobbing tail feathers. Like
all good designers, he had an advanced spatial awareness. Indeed, the
late Ossie Clark, one of the finest cutters in twentieth-century British
fashion, came from a similar background and had initially trained as
a builder.

Born under the astrological sign of Pisces, McQueen had a real
passion for water and soon became an excellent swimmer, joining a
local synchronized swimming class. The only boy in a class of forty
girls, he thoroughly enjoyed wearing a grass skirt at a gala and later
described himself as "the pink sheep of the family." The little boy
lived in a fantasy world of birds and dresses—a fledgling Poseidon in
his underwater kingdom—"I always, always wanted to be a designer.
I read books on fashion from the age of twelve. I followed designers'
careers. I knew Giorgio Armani was a window dresser, Ungaro was
a tailor."[1]

Meanwhile, his attendance at the local Rokeby Comprehensive School for boys was sporadic, and school reports noted he had difficulty in concentrating. In those days, attention deficit disorder (ADD) was put down to naughtiness or, worse, stupidity, in a similar way to dyslexia. Lee McQueen was anything but stupid: a voracious reader, he also studied images keenly, if they were of interest to him. Although not an academic, he was visually literate, the most important attribute for a designer to possess.

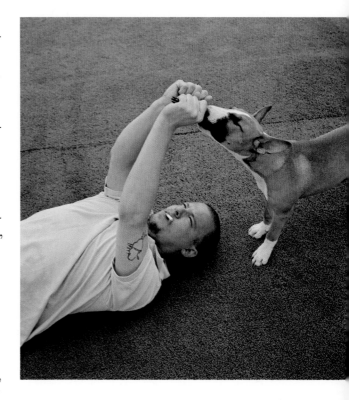

When McQueen was given the somewhat supercilious moniker "Yob of Fashion" by the *Daily Mail* in 1997, his mother bridled. As far as her children were concerned, Joyce always had a firm no-swearing policy. "He's never sworn in this house. I've never allowed it, and I never will," she insisted.[2] Always supportive and encouraging, Lee McQueen was fortunate to have a mother who refused to allow him to be limited by his background. "In a working-class family in London, you have to bring the money in, and artistic routes were never the means to that end. But I put my foot down. I thought, 'I'm not gonna do that. I'm not gonna get married, live in a two-up, two-down and be a bloody black-cab driver,'" he told *Women's Wear Daily* in 1999.[3]

Opposite: Lee with his mother, Joyce, photographed for the *Guardian* by Dan Chung, guest-edited by Sam Taylor Wood, April 16, 2004. **Above:** Lee McQueen playing with Juice, his English bull terrier puppy, photograph by Derrick Santini for *i-D* magazine, 1998.

FROM SAVILE ROW
TO CENTRAL
SAINT MARTINS

A lexander "Lee" McQueen left school at
sixteen years of age and went to the local technical college, clearing
beer mugs at a pub to earn money. In 1985, when Lee's mother,
Joyce, saw a television program about Savile Row that featured
the need for apprentices, she suggested he try to secure a position.
Shortly afterward, he became an apprentice tailor at Anderson &
Sheppard. It was the firm's policy to take young people who had not
been to college for the simple reason that they were easier to train.
The august establishment at No. 30 was arguably the most famous
on the Row, then holding a Royal Warrant as outfitters to Prince
Charles, HRH the Prince of Wales. It had nothing to do with
London fashion, then led by
designers from the city's art
college system, who drew and
draped, questioned the rules
of gender, challenged tradi-
tional silhouettes and put on
shows that were truly theatrical
performances.

This bondage-inspired leather jacket and
trousers was made in the spring of 1991, at John
McKitterick's Notting Hill Gate studio. From
McKitterick's "Manism 2—Glamour Out of Chaos"
A/W 1991 collection, it shows an early influence
of the fetish aesthetic that would become part of
McQueen's work.

It was "a phenomenon peculiar to London," wrote fashion editor
Sally Brampton that "the English have always been astonishingly good
at ruling a world that exists only in their minds and memories."[1] The
"young designers" of London were the enfants terribles, iconoclasts

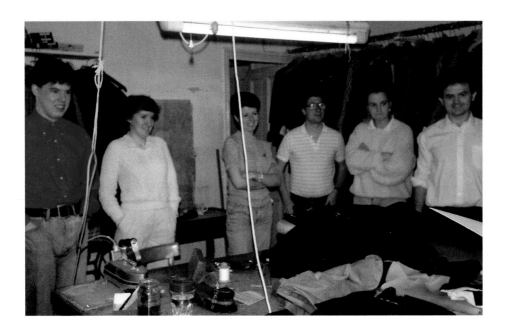

McQueen during his apprenticeship in the workroom at Anderson & Sheppard. "In those days," says Mr. Tomlinson, who apprenticed with him, "we were seen and not heard. He was like us all, straight from school. He was a blank canvas." Three of the people in the picture are still at the firm, as well as Mr. Tomlinson.

who regarded Paris haute couture as outmoded, whose roots in the gay and club subcultures brought forth a vision of what fashion could be. McQueen was their natural descendant, but part of his roots lay in the traditions of bespoke tailoring—skills that allowed him to realize his vision and placed him beyond his peers in the early 1990s.

From 1985 to mid-1987, he learned cutting and tailoring, completing the make of a "forward" (a type of coat) in two and a half years instead of the usual three. On his first day at Anderson & Sheppard, he was given a thimble and a pair of shears (never "scissors")—ancient tools of sewing and cutting, subconscious symbols of a form of menswear that is uniquely British. "London will always be to the man what Paris is to the woman," observed *Vanity Fair* in 1926.[2]

In 1992, when he joined recruitment agents Smith & Pye, he told Alice Smith that his work was defined by three things: cut, pro-

portion and color, and that he learned their importance on Savile Row.[3] With the relaunch of McQueen menswear in 2004, he told *GQ Magazine*, "I come from Savile Row. What I learned at sixteen is that to change menswear, you have to be like an architect; you work on the cut and proportion. You're not going to put men in all-in-ones and things like that. I've tried it before and it failed, and that was a good learning process. You've got to know the rules to break them. That's what I'm here for, to demolish the rules but to keep the tradition. You have to move forward because we're not stuck in '30s England, making tweed suits for people to go shooting on the weekend. Let's keep it real."[4]

Anderson & Sheppard was established in 1906 by Peter "Per" Gustaf Anderson, who was joined by Sidney Horatio Sheppard in 1909. They were "civil tailors" unlike many of their peers, who also catered to the military. The skills perfected by tailors on the Row are steeped in the history beloved of Lee McQueen and evolved in the early nineteenth century.[5] The ideals of democracy and liberty behind the French Revolution of 1789 had led to what Freudian psychologist and dress theorist J. C. Flugel (1884–1955) described as the "Great Masculine Renunciation," which saw the transformation of men's dress from a means of conspicuous display to one of quiet rectitude based on English riding dress. Superfluous decorative detail was stripped away, and the focus was a silhouette perfected by tailoring to the body, with woolen cloth replacing silk. It was a great equalizer, the beauty lying in cut and fit. Nonostentation and excellence in tailoring were the key elements informing what became the British suit.

The company specialized in the "London Cut"—a development of the "drape" coat perfected by Frederick Scholte, tailor from 1919 to HRH the Prince of Wales, later Edward VIII and Duke of Windsor. When Scholte refused to dress show-business stars such as Fred Astaire, they crossed Savile Row to Anderson & Sheppard,

who welcomed an exotic clientele. Their London Cut was a softer line, which gave a flattering, modern emphasis to shoulder width and waist, reflecting the influence of the more relaxed American style. The Anderson & Sheppard "drape" to the coat (jacket) was achieved when the fabric was not tightly fitted but fell from the collarbone in soft, vertical ripples. Today, as then, the shoulders are not padded but follow the natural frame of the wearer, with upper sleeves generous, allowing for movement; armholes are cut high and small, which prevents the coat from riding up when the arms are raised.

Lee McQueen was apprenticed to one of the firm's best coat-makers, master tailor Cornelius "Con" O'Callaghan, an exacting and strict teacher who he nevertheless recalled with "gratitude and fondness."[6] For this training he was paid around £100 a week (a small wage but considerably better than the unpaid internships operating in the British fashion industry today).

At that time, the work environment was extremely formal, with a strict sense of hierarchy. "In those days," recalls Derrick Tomlinson, who apprenticed with McQueen, "we were seen and not heard. He was like us all, straight from school—he was a blank canvas." Already into house music, McQueen's two fellow apprentices (both female) thought he was joking. "How could music be called 'house'?" they mused. The teenage girls would tease Lee over his sexual preferences. "Have you got a girlfriend?" they would say, with gales of laughter. It was ever thus but tough on someone who didn't come out to his own family until he was eighteen, two years later. "I was only a spring chicken. Only a spring *poulet*," he told *Vogue* magazine in 1996.

Determined and self-disciplined, he worked quietly, arriving at 8 a.m., listening to Radio 2 in the background, leaving at 5 p.m. (or later), clocking off at 4 p.m. on a Friday. The Anderson & Sheppard method of training is to provide a mentor for each apprentice, providing one-on-one training from a master tailor. "It was," says Leon

Powell now an undercutter, "imposing and scary" at first. For the first two months he, like McQueen, mastered how to pad undercollars, learning to control the needle and work at speed with the thimble on the middle finger, its protective metal providing extra strength to push the needle through canvas, horsehair and cloth. "I sat for two months padding collars, and two years learning how to cut a jacket," recalled McQueen, adding he would inscribe, "McQueen was here," on the interlining of the Prince of Wales's coats. "I used to sign the canvas 'McQueen was here' so I'd know I was always close to his heart."[7] (This account, and more florid obscenities in other coats, he later denied.) Anderson & Sheppard recalled all the suits made for the Prince of Wales and said they found no such graffiti, but this urban legend persists, sustaining McQueen's reputation as fashion's rebel.

The goal of the apprentice is to produce a perfect forward, which is approved by his mentor. This is a coat in which the sleeves have only been basted into place, the lining is set in the front and sleeves only, the top collar has not been put on and the buttonholes and finishing hand stitches are incomplete. As soon as one technique has been mastered, the apprentice moves on to learn the next, all the time working on "live" garments destined for a bespoke customer. Leon Powell said, "Everything is methodical—you become a perfectionist; you learn the work ethic."

From sewing collars, the apprentice moves on to canvas padding, learns how to fit a collar, set a sleeve, to cut precisely the jigsaw of cloth that makes the coat, place a lining and put in breast, side and fob watch pockets (immaculately set so as not to spoil the silhouette of the body). Working with velvet, tweed, different weights of suiting cloth, horsehair and canvas, McQueen learned how different fabrics handle and move, and how to cut dress coats, morning coats and jackets. Canvas had to be shrunk in a bucket of water and pegged out to dry before use, thread waxed, cloth pressed (never "ironed"). He also learned how to attach a button perfectly and make immaculate

buttonholes. Importantly for Lee, whose love of history always fed his imagination and informed his work, these skills linked him with the great craftsmen who had dressed Beau Brummell, Fred Astaire and Marlene Dietrich—knowledge handed down over generations.

And finally: his eye was trained and his sense of spatial awareness became acute. A great cutter can look at a shape, understand it three-dimensionally and cut the fabric to fit without first making the pattern. In creating a bespoke garment, if there is a whisker of doubt, then the offending element is ripped out and redone, repeatedly as necessary. "That's the thing about when Lee McQueen went on to do his own collections," noted Leon Powell, who studied fashion before his apprenticeship at Anderson & Sheppard. "He will have looked properly at something, seen a mistake and rectified it by ripping it apart and starting again. It's easier in fashion to wing it. But that's the thing that you learn as a tailor: you see if something's wrong and you fix it."

After McQueen had completed his forward, his mother became ill and he took time off to be with her. However, the firm felt that "he was not committed or reliable" and decided that he was "not suitable as a long-term Anderson & Sheppard coatmaker." McQueen told *Vogue* that his departure in 1987 was due to the attentions of a wigmaker who had ogled him from across Clifford Street; in another interview, he said he was bored.

In order to complete his tailoring skills, he joined Gieves & Hawkes at 1 Savile Row, where he trained as a trouser cutter. Founded in 1785 and 1771, respectively, Gieves and Hawkes were traditionally outfitters to the military and had dressed both Admiral Lord Nelson and the Duke of Wellington. By 1988, when McQueen was cutting in the workrooms, managing director Robert Gieve was of the firm belief that the bespoke suit was again an object of desire: "Style and commitment to detail are coming back, and there is a strong hankering for the elegance of prewar years."[8] At Gieves & Hawkes, trousers

were cut higher in the waist so a gap showing the shirt did not appear, and the waistband at the rear had a "fishtail," further concealing the shirt, if and when the wearer bent over. Little did Mr. Gieve know, down in the cutting rooms a plot was being hatched by his young cutter. (McQueen left on March 17, 1989, his twentieth birthday, because of an alleged "homophobic" atmosphere.) Whatever he may have felt about the establishment, the designer's skill in cutting trousers developed there and was demonstrated in October 1993, when he launched his "bumster" trousers that skimmed the pubic bone.

McQueen then worked as a freelance machinist and pattern cutter, and a fascination with historical garments was sparked with a stint at a Brighton-based designer who worked with costumiers Berman & Nathans.[9] (Established in 1790 as a gentleman's tailor, Nathan's has a nice McQueen-like touch in its history. In 1846, it began hiring out secondhand liveries to artisans so they could visit the Royal Parks, subverting the ordinance that forbade this recreation to craftsmen.) In 1989, he worked on costumes for the musical *Miss Saigon*, which designer Andrew Groves believes awakened McQueen to the richness of Orientalism. Another commission was to supply costumes for *Les Misérables*, the musical based on Victor Hugo's epic tale of the French Revolution of 1848. With a huge stock of costumes for him to examine, he developed "a passion for the sixteenth-century techniques evident in his collections."[10] In fact, he found a facsimile of the sixteenth-century Juan de Alcega's *Tailors' Pattern Book*, published in 1589, in a secondhand bookshop, a source he referred to in his application of slashed fabric and androgynous fitted jackets.[11]

23

On a Fashion Trajectory

"If you don't have passion for something, you shouldn't be doing it in the first place." —Alexander McQueen

From 1989 to early 1990, Lee McQueen worked for Koji Tatsuno (then backed by Yohji Yamamoto) as a pattern cutter. McQueen told *Sky* magazine that he admired Tatsuno and had been "hired on the spot." Japanese Tatsuno, who had launched his brand Culture Shock (1982–86) in London, was now based on Mayfair's Mount Street, where he developed innovative tailoring techniques, working fabric on the stand, tearing, cutting and building up organic forms around the body. "Really, it was ahead of its time," he told *Vogue* in 1992, after he had relaunched in Paris.[12]

The designer recalls that McQueen "came to me because I had a classic Savile Row tailor working for me and he wanted to learn how to cut a frock coat." Tatsuno took McQueen beyond his previous experience and introduced him to the possibilities of realizing fantasy on the runway. "I guess I did influence his work, particularly in making fabrics three-dimensional, but also in not accepting the limitations of conventional 'fashion,'" says Tatsuno.[13] Tatsuno's eclectic use of materials, his love of fabrication and sense of theater in his own shows influenced McQueen and was noted in the "Nihilism" S/S 1994 collection[14] and in the mille-feuille chiffon of the "Oyster" dress for "Irere," S/S 2003; McQueen's frock coats were a signature throughout his career.

"He was always interested in taking a catwalk show to the next realm and incorporating installations into his shows," Tat-

The S/S 1993 dress of nylon net ribbons by Koji Tatsuno is constructed in two huge circles to create a spectacular series of spirals. Tatsuno's influence on McQueen was, he believes, "in making fabrics three-dimensional, but also in not accepting the limitations of conventional 'fashion.'"

suno continues. "Alexander was very absorbing, and he had a very strong personality. When he came to me in 1989, he didn't have any experience in fashion on his CV, but he was such an interesting and somewhat twisted character that I was intrigued by him and let him

work with me. I tend to always choose interesting and original people to work with me, as they inspire the most. I think his work was very much about shocking people until he started working with Givenchy, where he perfected his couture skills and moved more into his era of Dark Beauty. I used to see him quite a bit when he came to Paris, and I remember him saying, 'Fuck French fashion!'"

All of this work had been quite peripatetic, though—he took jobs as and when they came up. A friend at Tatsuno introduced him to John McKitterick, designer for streetwear brand Red or Dead, and for a year he worked as a part-time machinist and pattern cutter. "He was very good at it," recalls McKitterick. "I wasn't looking for talent but for someone who could do these things. He was never late, he never gave me attitude and was always organized." After Red or Dead's A/W 1990 show at London Fashion Week, McQueen began to express ambition, although not specifically to become a fashion designer. "I told him that he should go to Milan," says McKitterick, "to try and find work there, because he really didn't have an idea how to proceed."

McKitterick took out his book of contacts and gave the relevant ones to the twenty-year-old novice. "It was everyone I knew—people I'd hired, friends, those working on magazines who would help British people trying to crack the Italian fashion industry. He really didn't know anything, so I explained that the best time to try for a job was when the shows had happened and the designers and brands were thinking about the next season; that's when they hired for the studios. I also thought

McQueen's "Oyster" dress from "Irere," S/S 2003, photograph by Rankin. Like Tatsuno, McQueen loved organic forms; the dress, with its mille-feuille layers of ivory silk, was constructed to look like graded frills on the shell of an oyster.

he was a bit mad—he hadn't been to college, he hadn't done an MA. I envisaged him coming back with his tail between his legs, but I also thought, 'Good for him.' And also he was incredibly shy, didn't come across as either smart or worldly, wasn't articulate, and dressed in

jeans and big, baggy shirts. He wasn't camp, so lots of people thought he was straight, but I knew he was gay after talking to him for ten minutes." (McKitterick found the fact that he adored Sinéad O'Connor interesting.)

"Part of the problem was that he was, in fashion terms, unprepossessing, and people found him difficult," McKitterick adds. Why? "Because of how he looked, because he knew a lot." In the hierarchical world of fashion design, where egos are often fragile and you are only as good as your last collection, it was unsettling for those who thought machinists and cutters should know their place. Of course, the ability to cut and make were McQueen's weapons, later applied so cleverly. "When he called me from Milan and told me he had a

position cutting patterns for Gigli, I thought it was amazing—I was really pleased for him," says McKitterick.

The one designer in Italy who was creating clothes that related to the body, whose trademark was proportion, color and cut, was Romeo Gigli. He brought back the shawl collar and banished the shoulder pad—the emblem of power dressing—to create a soft, draped line. His neoromantic clothes, widely referencing art, history and the exotic, were beautifully captured for British *Vogue* by Paolo Roversi. Of his A/W 1989 collection, he told *Vogue*, "When I am working on a collection, it's a spontaneous, chemical thing. [It is the] color and the opulence of the fabrics. The shapes are always

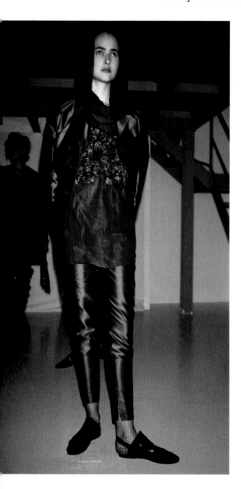

the same, two-dimensional. Ethnic culture is very important for me, the way it plays with the flat shapes wrapped around the body." With a love of art, books and travel, Gigli's references were encyclopedic; he was the only person in Milan who Lee McQueen wanted to work for.[15] McQueen bought a one-way ticket to Milan and, with no appointment, turned up at Gigli's headquarters on 10 Corso Como one day in March 1990.

Lise Strathdee met McQueen while working at Romeo Gigli. She recalls, "It wasn't a friendship as such—more like an unspoken connection between us. Further in the season, there was a problem with his accommodation. I was living in a four-bedroom apartment. There was a spare bedroom so I offered it to Lee. He took me up on my offer and moved in. He kept himself to himself, but sometimes we would all meet up in the big kitchen in the evenings, various meals being cooked and glasses of wine being drunk, sitting around the table. I remember being surprised once

when we were talking about Milan nightclubs. Previously I had thought Lee was homophobic because he'd made some very odd remarks about queers and such-like, but then when we were talking about these clubs, he named every single gay club in Milan—it was evident he was a frequent patron. I remember my housemates Frans, Karen and I all looked at each other—it was quite a revelation and a mystery, as well. So he had his own crowd of friends, with which he socialized. I also remember being quite shocked at the food he cooked (or attempted to cook) for himself. The combinations of things he would pull out to eat scared me, and I realized he didn't have the first clue about nutrition or looking after himself, so I insisted a few times that he eat the dinners I prepared.

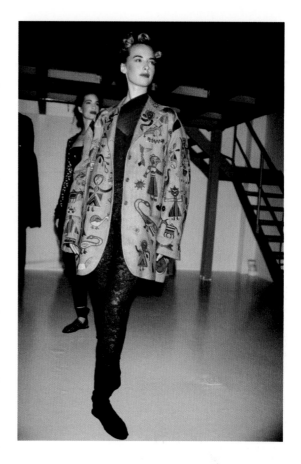

McQueen's work on the S/S 1991 Romeo Gigli collection included deconstructed jackets. McQueen wanted to work for Gigli not only because he admired his work but also to find out why he was the most important name in Italian fashion at the time. He discovered that Gigli maintained a certain distance from the press, and this influenced McQueen's approach early in his career. Yet the beauty of Gigli's work, his sumptuous femininity, influenced him, too.

"At Gigli, he was present at the weekly collection fittings, which Romeo attended in the enormous mirrored fitting rooms at Zamasport. Years later, when he became known as 'Alexander' rather than 'Lee,' a colleague remarked that his deconstructed linen jackets for Romeo's womenswear line were remarkable. He would have worked on the shoulder shapes and

LISE STRATHDEE
FASHION DESIGNER
On Working with McQueen

Between 1984 and 1991, Lise Strathdee's role at Romeo Gigli was in the design studio, working as "Romeo's right hand" when it came to show organization and as press attaché to Carla Sozzani, Gigli's partner and the sister of editor-in-chief of Italian Vogue, Franca Sozzani. The main design studio was at Corso Como while production was based at the Zamasport factory in Novara, an hour away. Responsible for McQueen's employment by Gigli, Lee called her his "Italian momma."

I was at my desk at the back of the studio at Corso Como that morning and got called to the front to see a chap who had walked in with his book. Lee and a friend were there. He was very young, unassuming and polite. He wasn't wearing anything outlandish, like he wanted to make a statement. I liked the way he was casual, quite different from most aspiring fashion designers.

As we sat down, I could sense a compelling mix of focus and nerves. I remember his eyes being quite penetrating as I turned the pages of his book and asked him questions. I don't recall his drawings or what was in his book—it wasn't like a WOW book—but what I did note was that he'd just come from pattern making at the London label Red or Dead, which he talked about. I don't recall his having worked at Koji Tatsuno, but that would have been another indication to me that he had an interesting and unusual fashion trajectory. My main impression is that he wanted to work.

The detail that most interested me was his training on Savile Row because Romeo loved all aspects of traditional menswear tailoring. It was unusual for someone so young to have come from a hands-on practical experience. Most people came to us straight out of design school or because they had a fantasy of working for Romeo, but there was a practical sense of purpose about him. He didn't come across as a dreamy designer but as someone who was committed to the art and skills of pattern making.

Romeo and Carla were engrossed in a meeting, so I took Lee's contact details in Milan, thanked him and let him go. I sensed his disappointment. As I returned to my desk, I saw that Romeo was in between doing things, so on impulse I told him that I'd just seen

this young man who had Savile Row experience and I thought it would be interesting for Romeo to meet him. Romeo agreed and told me he didn't have much time. So I took off, running onto the street. There was no sign of Lee. On a whim, I decided to run toward the Garibaldi Metro station. Just as I turned the corner, I saw Lee and his friend heading down the underground steps. I whistled loudly and yelled out his name, then made a beckoning motion with my hand. He came over, looking a bit puzzled, and I explained that I had managed to secure him an appointment with Romeo right then but that we had to be quick.

Lee's face broke into a huge grin, and we rushed back, talking and laughing. The serious intensity I had felt at our first meeting in the studio disappeared, and it was as if the sun had appeared from behind the clouds. He was very laddish, cracking jokes; I found him endearing. We got back to the studio, both breathless, and I took him over to Romeo's table and introduced them. A very happy Lee was hired on the spot to work on S/S '91 menswear and womenswear collections. The next day he went with Romeo to Zamasport.

It was decided that he would work both at the factory and in the design studio as pattern cutter. At Zamasport, he was with two of the senior male menswear pattern makers. It can't have been easy—he had a daily commute, was working in a completely new environment [that] adheres to industrial manufacturing modus operandi alongside two very talented pattern makers who had their ways of doing things, all in a foreign language that Lee neither spoke nor understood; he was in a situation where he had been given an opportunity to prove himself and was left to get on with it. There were a few occasions that season where I'd get a phone call from Lee, exasperated with communication problems or frustrated about how he was supposed to be doing things or how things were being done.

I'd also get calls from the production manager out at Zamasport, telling me to talk to him—Lee would be frustrated about something, and he'd have wound up the older pattern makers in the process. In most cases, it was about easing Lee into the way of doing things out at the factory. Lee probably would have preferred to work at the studio with the rest of the young, expat design assistants rather than be working alone in such a structured, formal environment. This would have been his first experience of working on such an industrial scale.

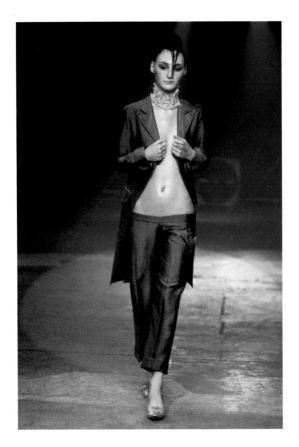

McQueen's second show "Nihilism," S/S 1994, was held at the Bluebird Garage on King's Road. Suit of "bumster" trousers and gray silk/wool frock coat, in which McQueen played with proportion, elongating the torso and shortening the legs. This creation of the revealed pelvis as an erogenous zone was totally new.

the torso silhouette of the jackets. I think his pieces did make it on the runway. The jacket my colleague was referring to was a womenswear one in a dark navy blue linen—no lining."

When designing for S/S '91 was over that summer, McQueen's contract ended. The company was in turmoil, as Gigli and his partner, Sozzani, were separating. Lee returned to London. He told fashion designer Carmen Artigas that he "didn't know what he was going to do" and gave her his mother's address. In fact, he returned to John McKitterick of Red or Dead, working at the designer's Ladbroke Grove studio on his second collection for A/W '91. With fetish overtones, it was, says McKitterick, "very sexual in nature—tight-fitting, in leather and plastics, bright prints, lots of zip and rivet details." Suddenly Lee started to open up, asking interesting questions. "He showed me the work he'd done and began to talk about my designs—asking me how I had done this, why hadn't I done that. He wanted to become a designer, and I told him he had to go to art college—and gave him Bobby Hillson's details [founder and head of the MA fashion course at Saint Martin's College of Art and Design and a friend of McKitterick's].[16]

CARMEN ARTIGAS
FASHION DESIGNER
On Unexpected Beauty

Carmen Artigas, originally from Mexico City, was a design assistant at Romeo Gigli, having found the job three days before graduating from the Istituto Marangoni, where she studied fashion design. She remembers the day Lee walked into the design studio and was asked to work in the center of the room on a pattern for a shirt. Part of the collection was inspired by Josef Koudelka's book Gypsies (1975), and the photo he had to work with was of a boy tugging at another boy's shirt, which created an interesting pleat that Gigli wanted Lee to develop but in the end rejected.

There was never an introduction to the team. I guess because of the season's rush, but he began work on the pattern, standing in the middle of the room, and once in a while I noticed he made a gesture of pain and held his cheek. ...I introduced myself and asked if everything was okay. Afterward, I found out he wanted an aspirin, and once I brought him one, he felt a sense of relief and our friendship started.

McQueen and design assistant Norio Surikabe at work in the Romeo Gigli showroom, 10 Corso Como, Milan 1990.

On one occasion he invited me to a party and we met under heavy rain on a street corner. I noticed from a distance he was under a huge umbrella; once I got closer, it turned out to be a vintage Japanese waxed paper and bamboo parasol that started to fall apart in the rain. The umbrella belonged to a Japanese friend of his where he was staying for a few days while she was traveling for work. I mentioned to him that it was getting ruined with the rain, and he just laughed it off! Now I realize it was a very McQueen thing to do, disturbing the senses and yet finding beauty in decay.

During the sales period, we were asked to create technical specs for handbags, and we would spend up to a couple of weeks just sketching. Once in a while he would hand me sketches signed 'Carmen with love, Lee'... It was very sweet but puzzling because some of the sketches had an aggressive tone—one was a drawing of a woman with an arrow shot through her belly, another of male torsos, also featuring arrows, a drawing of a woman in a caped hood and one of dogs and a mythical bird—especially since Romeo Gigli was all about soft Pre-Raphaelite beauty. I would then sketch something for him, and we kept exchanging sketches.

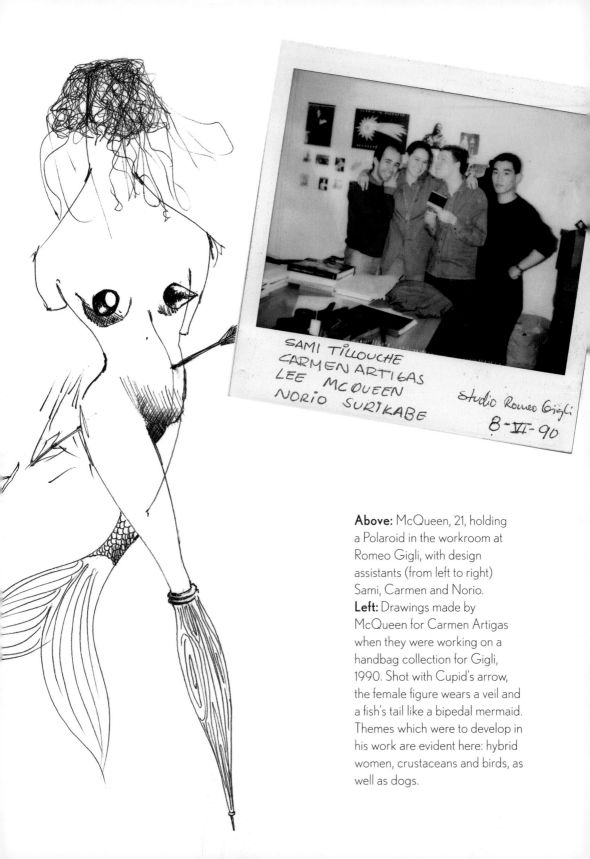

SAMI TILLOUCHE
CARMEN ARTIGAS
LEE MCQUEEN
NORIO SURIKABE

Studio Romeo Gigli
8-VI-90

Above: McQueen, 21, holding a Polaroid in the workroom at Romeo Gigli, with design assistants (from left to right) Sami, Carmen and Norio.
Left: Drawings made by McQueen for Carmen Artigas when they were working on a handbag collection for Gigli, 1990. Shot with Cupid's arrow, the female figure wears a veil and a fish's tail like a bipedal mermaid. Themes which were to develop in his work are evident here: hybrid women, crustaceans and birds, as well as dogs.

Central Saint Martins

"[Through cutting, I try] to draw attention to our unrelenting desire for perfection. The body parts that I focus on change depending on the inspirations and references for the collection and what silhouettes they demand." —Alexander McQueen

When Bobby Hillson found Lee McQueen waiting outside her office at Central Saint Martins, she invited him to speak with her, thinking that, with his experience, he was looking for a job teaching pattern cutting; instead he was interested in studying there. In 2004, when he was awarded a professorship at the college, he thanked Bobby Hillson and stated he owed his career as a fashion designer to her, so this was a life-changing meeting.

As an acclaimed fashion illustrator as well as an award-winning designer, Hillson knew full well that to be able to draw beautifully and then realize the designs with skill at cutting was exceptional: "When I saw them, I was impressed and said that I thought he should do the MA fashion course and offered him a place then and there, to his amazement." With more than twenty applicants for each place, the scholarships had already been allocated, and so Lee would have to find the money himself to complete the eighteen-month-long course. His auntie Renee gave him a loan of £4,000 to do so. Hillson adds, "There was evidently real talent and determination, and what struck one was that he was desperate to communicate ideas—they came tumbling out—but he was rather inarticulate. You sensed the

emotion and intelligence coming through, but he had not had a conventional education that would have helped this happen."

Bobby Hillson took a gamble. In the old days, art colleges would grant places based on talent, but by the 1990s, academic qualifications were replacing vocational qualities. She told Jane Rapley, then dean of fashion and textiles, that she had taken on someone who might have difficulties in dealing with an academic environment. "All that talent came via a very complicated personality," recalls Hillson. Now head of the college, Rapley told the *Guardian* in 2003, "From the beginning it was obvious he was different, but he struggled. He found many of the requirements difficult, like writing and the nature of educational bureaucracy. He had something special, otherwise he wouldn't have got onto the course in the first place."[17]

BOBBY HILLSON
PROFESSOR
On Meeting Alexander McQueen

I found him lurking outside the office and asked, "Who are you and who do you want to see?"

"You," he replied.

"But you don't have an appointment—it can only take about five minutes."

He stepped into my office carrying piles of clothes, which he threw onto the sofa, telling me that they were patterns he had cut working for Romeo Gigli, along with his own work. Gigli was different from other designers of the time, very creative, and I was amazed that a boy with a tailoring background was working in fashion, not stuck in tailoring. So I was very intrigued. I quickly assessed that he was very young [twenty-one], and he looked very unprepossessing. He was too young for teaching—the students simply wouldn't have taken any notice. So it was interesting but…then I asked him if he ever drew. When he said yes, I asked him to bring the drawings in.

In 2009, Lee McQueen told the BBC a little of what Saint Martins meant to him: "It was the place to go. What I really liked was the freedom of expression and being surrounded by like-minded people."[18] John McKitterick believes that life for Lee transformed at Saint Martins: "It was there that he developed, and really quickly. I began to see him out on the gay scene in Soho, and I remember looking through the looks for his degree collection and really liking it."

He wasn't "influenced" by anyone, but he was obsessed by John Galliano, says McKitterick—"as another British designer, he was very important to him. [Galliano was then in Paris trying to reestablish himself following bankruptcy.] For Lee, he was the one to beat, he was the benchmark." Meanwhile, some of the staff and students at Saint Martins found the new student hard to handle—he would interrupt lecturers and give them the benefit of his opinion, arguing his point. While Bobby Hillson ran the course, unbeknownst to her there was a clash between McQueen and another member of the staff. At one point, he was allegedly moved from the MA studios into the BA area, potentially a humiliation but "he didn't care," laughs McKitterick. Indeed, McQueen made no bones about the fact that he had trained on Savile Row and cut for Romeo Gigli. But McKitterick understood the motivation for apparent truculence: "Instinctively, he knew a lot and would stare at people and think, 'But I can do better than you.' He rubbed some people up the wrong way."

"Once he'd relaxed and found friends among the other students—particularly textile designer Simon Ungless, with whom he later collaborated—the MA course worked for him," Bobby Hillson insists. It was a challenging time, and he wanted to cram as much as possible into the course load. He and Simon Ungless would go off to the latter's home in the country to gather pheasant and other feathers to use in his show. He'd buy cheap fabric from Berwick Street in Soho, which Bobby Hillson would confiscate and replace with expensive fabric from her store cupboard instead. There was production sup-

port from college machinists, with an outside machinist also allocated to the students. They were all given the same amount of hours with them but cut their own work, which was approved by Hillson. "It was all about fabrication for him," says Hillson. "I didn't believe that they should have stylists, so they had to style their work themselves."

Part of the MA fashion course requires each student to produce a written "market report"—often more of a chore than a pleasure. Eschewing high-street trends and with his fascination for history, McQueen chose to focus on Jack the Ripper. The infamous killer, who ritually murdered five prostitutes in Whitechapel, London, in 1888, is the East End's ultimate bogeyman. Lee was descended from the French Protestant Huguenots of the 1690s, refugees who worked as silk weavers in Spitalfields and Whitechapel. "I like to challenge history because of the traditions my life is based on, and sometimes [my work is] autobiographical," he later revealed in an interview with the BBC.[19]

"Jack the Ripper Stalks His Victims," Lee McQueen's degree collection, was shown in July 1992 at London's Kensington Olympia exhibition center. He demonstrated an ability to take elements from the past and reinvent them for a modern audience. In this, he was singularly like John Galliano, who looked to the post–French Revolution *Directoire* for ideas (equally linked with violence) for his degree collection of 1984. Alice Smith remembers McQueen showing her little books of Victorian pornography, fetish in nature, obtained from the Central Saint Martins Library; he told Alice that his favorite film was Pasolini's *Salò, or the 120 Days of Sodom* (1975).

Sadomasochism aside (a theme of John McKitterick's label, too), his six-piece MA collection showed an ease with tailoring and fabric. Fashion images from 1888 show women's bodies sculpted by cuirass corsetry, tight lacing and bustles. Heavy chignons were enhanced by the addition of a "tail" of human hair, which arrived at the waterfront docks in bales to cater to the British market. However, London prostitutes also supplemented their meager income by sell-

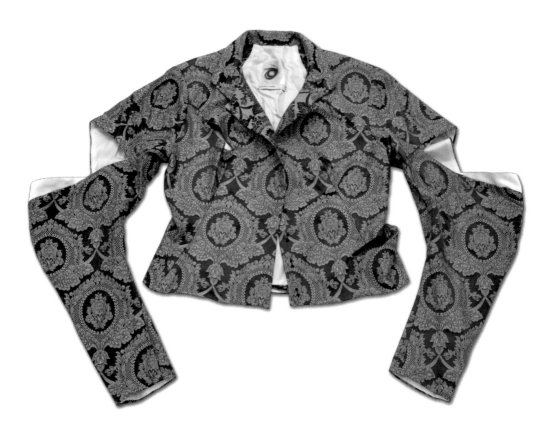

ing their hair, too. McQueen alluded to this by cutting his own hair
and transposing it into his collection. "The inspiration behind the
hair came from Victorian times," he later explained, "when prosti-
tutes would sell theirs for kits of hair locks, which were bought by
people to give to their lovers. I used it as my signature label with locks
of hair in Perspex. In the early collections, it was my own hair." [20]

It was punk's furious outrage reborn but instead of referencing
contemporary subcultures, his source came from deep inside. A black
tight-waisted jacket with a rear-enhancing peplum was in black silk, the
lining decorated with human hair. Another coat in cherry pink silk (with
barbed thorn print by Simon Ungless) was cut tight to the body, Ander-
son & Sheppard–style, with tight sleeves; the interior with a layer of
hair. The prostitutes killed by the Ripper would all have been wearing
frayed and torn secondhand clothes, so McQueen distressed the calico
skirt with burn marks and papier-mâchéd magazine articles onto it. The

Ripper, in mad vanity, ensured he became a celebrity serial killer via the press; red paint was spattered liberally to denote blood. This was not the charming historicism of post-punk Westwood but something more complex and multilayered. "His facility was that he could interpret whatever inspired him," Bobby Hillson remembers, "it was undiluted and absolutely his own." Certainly, there was no compromise regarding the ideas—"I had the freedom to block off commercialism and do it from the heart," McQueen later said.

"It was," says Hillson, "a strong year." In the event, McQueen was given penultimate placing, not the glory slot of the finale. Hillson felt there was more to come and wishes the course had been two years long for him to really hit his stride. "His collection was interesting, and he did some very nice clothes but it wasn't heart-stopping," says Jane Rapley, Head of Central Saint Martins. John McKitterick disagrees: "I saw it on the rail before he showed, and I thought it was good." "His real advantage was that Isabella Blow spotted him," recalls Rapley. "That helped him network."[21]

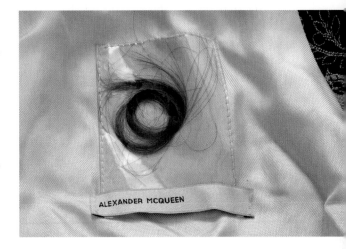

Above: The Alexander McQueen label was unique—containing a lock of hair, not always his own—encased in plastic. Fashion designer Andrew Groves recalls McQueen insisting that an assistant have his head shorn for further supplies.
Opposite: Renaissance, brocade-style print jacket from the "Dante" collection, courtesy of Alice Smith. The cut and slashing of the sleeves was based on a jerkin inspired by Juan de Alcega's *Tailor's Pattern Book* of 1589.

Isabella Blow loved talent and adored clothes. Most often described as an eccentric, she was in fact a throwback to the "dames de vogue" of the interwar period such as the Honorable Daisy Fellowes, client of the finest couturiers of the period. Like Fellowes, who was one of Elsa Schiaparelli's greatest promoters, Blow was utterly fearless about how she looked, and her joy came from the creativity of those she befriended. She became known as the friend and patron of milliner Philip Treacy and had assisted fashion visionary Michael

Roberts (who turned *Tatler* into a style bible in the 1980s), but as a freelance stylist, she was relatively new on the scene (her work at British *Vogue* began in 1989 and her editorship at *Sunday Times Style* magazine would follow from 1997 to 2001).

"Issie needed dramatic, extraordinary clothes to make an impact when she styled a shoot," says her friend, designer Antony Price.[22] Indeed, she was on the lookout for something new and exciting, and this subconsciously tapped into her love of history. "The one thing about Issie is that she didn't care about what other fashion editors thought, and that is unusual in the fashion industry," continues Price. "She trusted her own eye." So while the rest of the fashion pack missed what was good about McQueen's graduate collection, Blow didn't—"The tailoring was excellent. No one spotted it. They kept thinking it was just blood and paint. They weren't looking at the cut![23] It was obvious from the first outfit that here was someone of enormous potential and great gifts."[24]

Black wool single-breasted coat from "Jack the Ripper Stalks His Victims," McQueen's Central Saint Martins MA collection, March 1992. A traditional man's frock coat is given a twist by cutting the sleeves in two sections, the lower put in reverse so that the lavender lining was revealed; lavender and mauve were Victorian mourning colors.

The legend that Isabella Blow "discovered" Lee McQueen persists, but the truth is, he had already discovered himself at Saint Martins. Nevertheless, her support would prove invaluable, and key to this was the fact that she showcased his work because she wore it. Blow had a perfect catwalk shape: UK size 10 shoulders and bust, size 8 waist/hips, with fantastic legs and ankles.

Left top: The inverted pleat at the shoulder, giving a rounded sleeve head gives a subversive feminine softening to the silhouette. McQueen took the rules of Savile Row and played with them with subtlety.
Left bottom: The unconventional number of five buttons face in toward the body. **Below:** The long back vent has an insert cut and again is set in reverse so the contrasting nap gives texture (echoed in the contrasting lining).

SIMON COSTIN
JEWELRY AND SET DESIGNER
On Collaborating with Lee

Simon Costin first collaborated with Lee on his Central Saint Martin debut show and then worked on shows from "The Birds" to "Untitled."

Lee wrote to me a very sweet letter from Saint Martins and said that he loved my jewelry—and wondered if there was anything left that he could borrow for his degree show. He was lovely—very grateful and borrowed everything that I had left. He used seven pieces, including two headdresses—one a tiara—and two massive necklaces made from bird claws, teeth, bones and hair. For me, it was just another student collection, it didn't resonate particularly, but then I don't have a fashion background.

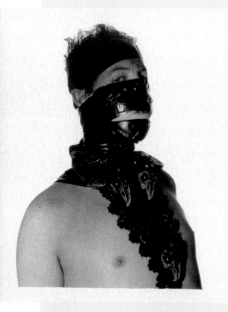

In a Polaroid image of himself given to Simon Costin, circa early 1993, McQueen's face is wrapped in gaffer tape. The necklace of crow skulls on black lace, embroidered with jet, is by Simon Costin—it was used by McQueen in his Central Saint Martins MA Fashion degree show in March 1992.

Why did he have an apparent obsession with death? Lee wouldn't have been aware of memento mori. He would have seen imagery from death as transgressive, associated with a negativity that he would turn on its head and make into an "anti" statement.

Lee was essentially contrary, so these images—like crows or skulls—were part of his lexicon of symbols associated with death, and there were, of course, images of bodily restriction, [like] bondage [corsetry, hoods] that were about passion, and that was very potent.

These ideas were very important and were reflected in his love of Joel Peter Witkin. In 1993, I had taken part in a group show in Milan with Joel Peter Witkin and brought the catalog back for Lee. I thought, this catalog shows work that is so twisted

and incredibly transgressive with its use of human cadavers and thought, "I know who will like this." So I inscribed it, "Dear Lee, I think this is right up your street, Love Simon."

I like to pin things on a story. If a collection was very directional, it would help me to develop the idea for the set by making a story to go with it. A good presentation should give an audience aspects of a collection that wouldn't otherwise be apparent if the set wasn't used. The set is an interactive environment, the icing on the cake.

The point of the shows was the way he did them. It was about upping the ante—a means of tightening the thumbscrews on the audience, not only was it seeing but hearing. They operated on multilayers, delivering a much harder punch.

The way we worked, I would see what he wanted to do with a collection and then think about how it could be staged. We would all sit around the table and discuss it . . . which meant that it was never just one person's idea.

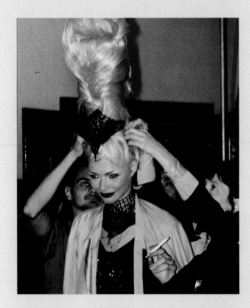 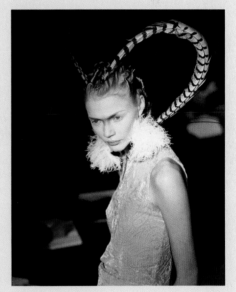

Left: Backstage at "Eclect Dissect," McQueen for Givenchy couture, A/W 1997–98, photography courtesy Simon Costin. Hairstylist Guido Palau is fitting the towering blond wig, a pastiche of the hairstyle worn by Audrey Hepburn in the ball scene in *My Fair Lady* (1964). McQueen designed a black version of the high-waisted dress Hepburn wore in the scene, covering it in jet beading. **Right:** Model Kirsten Owen wears a headpiece of six-foot-long tail feathers from a cross between a Reeves and Silver pheasant, supplied by Simon Ungless's father, in "Dante" A/W 1996–97. The collar of the velvet sleeveless top, printed with a paisley pattern, is ostrich.

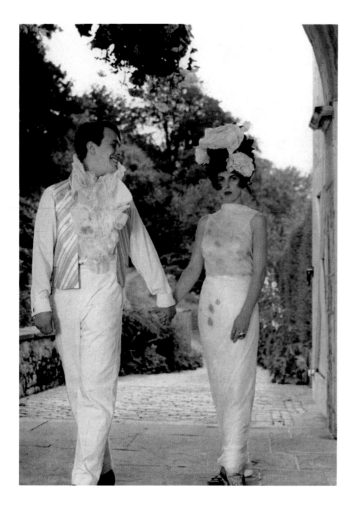

Detmar and Isabella Blow, photograph by Oberto Gili for *Vogue*, November 1992. Isabella Blow wears a look from McQueen's degree collection, "Jack the Ripper Stalks His Victims," a streamlined column-style dress in organza with imitation rose petals applied between layers of fabric; a technique used by Koji Tatsuno and repeated in the "Nihilism" collection the following year. Hat by Philip Treacy, shoes by Manolo Blahnik.

"She could wear catwalk clothes, which are the designer's vision undiluted. Issie was a dream client because she had the balls to do it," adds Price. Blow was determined to buy the collection, obtained McQueen's mother's telephone number from the college and left messages for him to call her. "She wouldn't stop badgering me," he recalled in 1996. "I wondered who this nutty lady was, who kept ringing my mum. So she came and saw me and asked how much this jacket was, and I just thought I'd try it on, didn't I? So I said 450 quid and she bought it!"

He charged her £5,000 for the whole collection, which she paid off in monthly installments over the year. Meanwhile, Blow took the

young designer under her wing, introducing him to Philip Treacy and a whole new world of artists, aristocrats and actors. "I add something because I'm Establishment. I can ring up Elton John and say, 'Come down in ten minutes,' and he'll be there," she once boasted to the *New Yorker*.[25]

SIMON UNGLESS
DIRECTOR OF THE GRADUATE SCHOOL OF FASHION, ACADEMY OF ART UNIVERSITY, SAN FRANCISCO
On Meeting McQueen at Central Saint Martins

Lee and I met on the first day at Central Saint Martins. We gelled instantaneously. All of us had done a summer entry project, which had a critique, and one of the other students was asked who their customer was, and they said "Kylie," and we both started to laugh, because we had never heard of anyone who would want Kylie Minogue to be their customer. We had another class when someone was asked who their favorite designer was and a student said "Versace"—pronouncing the name as "Versayce." We thought that was hilarious.

For us, it was all about Margiela and Helmut Lang. None of the others had ever heard of them; it was all people from Hyper Hyper like Pam Hogg. We were both into things happening in Paris, and got our information via magazines like *i-D*, or by going to Paris to see for ourselves. It was about being into that real fashion mix and having that understanding, not like *Vogue*, which was a year and a half out of date. And London Fashion Week was all about Wendy Dagworthy and Betty Jackson, as Galliano and Westwood were showing in Paris.

The designers we liked? We both were in love with Azzedine Alaïa, but he was not of the moment. We were into Margiela and Jean Colonna, who was overlocking fabrics in his suits. I rapidly had a vinyl and a rubber "Jean Colonna" suit made for me by Lee, who also made me a "Margiela" overcoat—the most incredible coat I have ever had. Louise Wilson [director at CSM] said to me, "But Margiela doesn't do coats!" I said, "He does now!"

What drew Lee to my work was that he had the same passion for nature and he respected it. He loved birds, skins, crystals, fossils, eggs, feathers, bones. I had grown up in the country; my father was a gamekeeper, surrounded by birds and animals, and I had been collecting since I was a child. He loved the collecting aspect. For our first college project, I designed a "cabinet of curiosities" print, with a background taken from historic

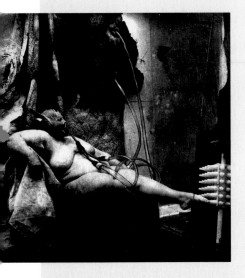

prints of Scottish Highlanders in plaids, superimposing the woven fabrics with images of butterflies and eggs, which he really liked. I ended up selling it to some pajama manufacturer.

We liked similar things, in particular the artist Joel-Peter Witkin and reading books—I remember reading the Marquis de Sade's *The 120 Days of Sodom, or the School of Libertinism* (1785) together, laying on the floor of the sitting room, sharing the book. It was very dark and deep, and was an influence in terms of the 'darkness' on his work. We'd go swimming at Tooting [Bec] Lido on poppers, loved dancing, anything good, whether house or Diana Ross—he loved Michael Jackson's *Off the Wall*—anything he could dance to, definitely not Björk or Portishead, because we thought they were so boring.

We came from similar backgrounds. We were blue-collar people and at Central Saint Martins it was rather unusual then; the other students looked down their noses at you. We were both gay, but not typical gays of the time, when it was all dancing with your shirts off to show your [worked-out] body. So there was a level of unacceptance, too, among the community of clubbers and gays—we both looked so different that we were bullied. It was amazing when he got famous; suddenly all those people wanted to be friends with him, but he stayed true to the underdogs!

We shared a house in South London, 169 Lessingham Avenue in Tooting, in the middle of a huge council estate. I would come back from home with a brace of pheasant or French partridge, pluck them, cook and eat the birds and keep the feathers. Then he'd ask me to go home and get more. We used the partridge feathers for a bustier top, fusing together the layers. My dad also had ornamental pheasants and had crossed a Reeves

with a Silver pheasant, producing incredible hybrid plumage, which Lee was fascinated by. We used their six-feet-long tail feathers in the "Dante" show, worn by Kirsten Owen in a headpiece.

Incorporating hair was an early thing of Lee's, either encased in fabric or in plastic labels. It was anti what everybody else would consider and was done to provoke people who had a fear of it. So the hair happened at the beginning, as he started to build up a brand identity, which went against what Galliano and Westwood were doing: presenting what we felt was costume. This approach didn't have anything to do with us or what we wanted to do in fashion.

His terror of the press at the beginning was because he was collecting unemployment benefits and was terrified that the authorities would find out. He needed that rent check coming in every two weeks. Then he started learning about the power of keeping something back, making the press want it even more. For us, it was all about making lovely things and having fun. We had a brilliant time creating all those things, struggling with no money and coming up with good ideas. Young designers today need to know that they can do it, too.

Simon Costin introduced McQueen to the work of the American photographer and artist Joel-Peter Witkin, after taking part in a group exhibition with him in 1993.
Above: Michelle Olley in "Voss," S/S 2001, McQueen's homage to Witkin's work.
Opposite: Witkin's *Sanitarium*.

THE EARLY
SHOWS

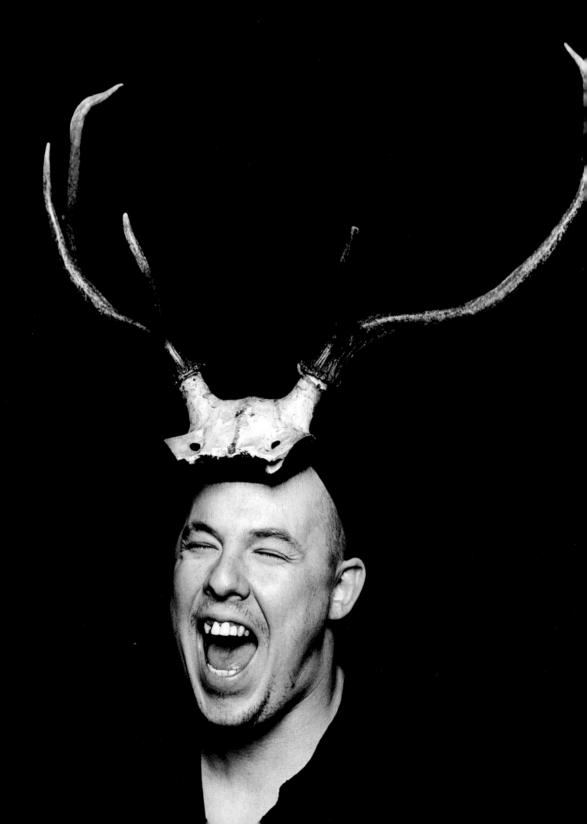

M cQueen continued to draw
social security benefits for his first few seasons, but before the launch
of his own label, the most pressing issue was employment, preferably
a design job for a French or Italian label. He approached fashion
recruitment agency Denza and was interviewed by Alice Smith and
Cressida Pye. "We had seen the show," recalls Smith, "and when
he came to see us, we said to each other, 'We have a star!' He was
completely absorbed in getting it right. His drawings were beauti-
ful, very architectural, with precise, full-length slim figures. His first
appointment was with Alberta Ferretti, and he turned up wearing
a three-piece suit he had made himself—very smart, looking like a
little hamster. He was such a sweet person and looked totally different
from the other interviewees. He didn't get the job."

Soon afterward, the two young women left Denza to set up their
own fashion recruitment agency, Smith & Pye (on the corner of St.
Martin's Lane and Long Acre, Covent Garden). At the same time,
McQueen was working as Isabella Blow's assistant. John McKit-
terick remembers him visiting
the studio in 1992 and taking
some pieces for a shoot: leather
trousers and a waistcoat, both

McQueen wearing antlers provided by Isabella
Blow for "Dante." Photograph by Marc Hom,
Sunday Times Magazine, 1997.

decorated with rivets from his final collection. "It was a Monday
or a Tuesday, and the following Saturday night, Ike Rust [now pro-

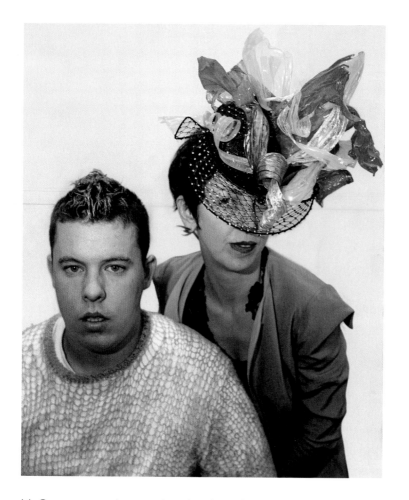

McQueen in a punk-inspired, mohair-knitted sweater, with a slicked Mohawk. Isabella Blow, wearing a hat by Philip Treacy, 1996. Photograph by Peter Thorn. Blow worked tirelessly to help promote McQueen and urged him to take the position of designer-in-chief at Givenchy, which he did later that year.

fessor of menswear, Royal College of Art] and I went to a gay club in South London. Who should we bump into but Lee, dressed in my clothes, with a tie he had made from laces round his neck, hair slicked back. I laughed my head off—we both did!"

According to McKitterick, this newfound confidence came from Saint Martins: "He moved forward really quickly. I was invited

to 'Directions'—an exhibition of students' work at the Lethaby Galleries in 1993, curated by Bobby Hillson.[1] A dress by McQueen was suspended from the ceiling, and Hussein Chalayan, who had graduated from the MA Fashion course that year, also took part; the event was opened by Issey Miyake, and there was a party downstairs. I sat with [Lee] and Andrew Groves [his former boyfriend, now a designer himself and an invaluable helper in the studio from 1994–95], and then a girl came in, a journalist, and [Lee] went straight up to her and started talking. Suddenly, I didn't recognize him—I realized he knew all the names of the stylists, the photographers, the journalists. . . . He was evidently extremely ambitious and that was new."

Much of this confidence also came from the backing of Isabella Blow, who defined her generosity of spirit as being like a chemist. "I like putting new people together and have this instinctive feel for who will work well with who," Blow said.[2] It was Blow who undoubtedly pushed him toward setting up on his own, like her other protégé, Irish milliner Philip Treacy. "Isabella was very supportive, the key to his 'discovery,'" agrees Alice Smith. "He was always popping into *Vogue* to see her, making sure everyone knew who he was."

ALICE SMITH
FASHION CONSULTANT
On McQueen's Love for Fashion

He used to run up the flight of stairs to our office carrying plastic bags full of fabric from Berwick Street, plunk himself down on a chair, open a copy of *Drapers Record*, examine it voraciously, chanting, "Fashion, fashion, fashion!" He loved it—I remember him admiring Helmut Lang's priest's coat, but he would never have dreamt of copying anybody. He had a totally different way of talking about his work, unlike anyone else—he would go into a kind of trance.

However, the story that Blow persuaded him to drop the Lee and go under his second name—Alexander—was untrue, he claimed.[3] Apparently he did this to stop the Department of Health and Social Security (DHSS) from tracing him, as he was still drawing social security. "When I introduced him once to a friend as Alexander McQueen, he went ballistic," recalls John McKitterick. "'Don't you use that name, I fucking hate it!' he exploded."

"All Lee's collections were autobiographical," says Andrew Groves. "His first collection, 'Taxi Driver,' probably referred to his

father."[4] McQueen told British *Vogue* much the same thing in 2002, but he was an extremely private person and chose to keep many details from the press until an interview with *Women's Wear Daily* in 1999, when the reasons for his portrayal of "strong" women (as an example) became apparent. Typically, he cited the 1976 film by Martin Scorsese as inspiration for "Taxi Driver," which featured prints of the face of Robert De Niro's tormented protagonist, Travis Bickle. The show was held at the Bluebird Garage on King's Road, Chelsea, in March. McQueen negotiated cheap fabric deals from Berwick Street wholesalers and arranged that Smith & Pye would afterward show the collection to press and buyers in a small room at the Ritz (they then kept it in their offices, where they would find the dead locusts he had applied in unlikely places).

"When I saw the show, I realized just how powerful his talent was," says Bobby Hillson, continuing, "it was very romantic as opposed to the aggression one later could see in his work. This was very ethereal and strange. Everything was in white, and models walked the runway in bare feet. To fully appreciate the breadth of his abilities, it was necessary to see the clothes in the context of his shows. His imagination was such that he took you into his world." Alice Smith agrees: "That show was groundbreaking—it wasn't like anything else that was happening at the time." In fact, the audience had to stand because there were no seats. "It was all incredibly cool,"

remembers Katy England, then fashion director of *Dazed & Confused* magazine. "The girls came out covered in terra-cotta makeup. There were so many beautiful things in that show—it was relentless."[5] The

tailoring was precise but his repertoire included locusts, shellac and human hair; rust had been applied to fabric, and beading appeared between layers of organza—a reference to Koji Tatsuno, perhaps?

At the end, he simply popped his head round the back really quickly, terrified he might be recognized by the DHSS. "The show," says Smith & Pye, "and those that followed, were orchestrated to give him publicity. He did it at first so people would become aware of him." Attendance at the small showroom at the Ritz (with the collection on just one rail) was slow at first, remembers Smith—"but Isabella made sure people came to see it; got Hamish Bowles and *Vogue* in [which published its first article

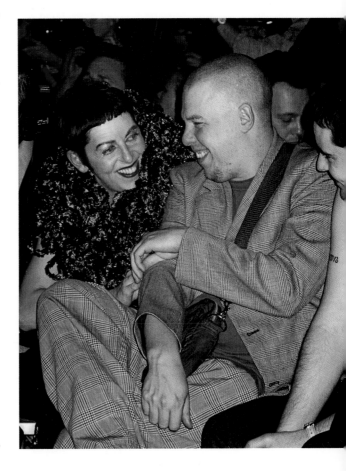

Isabella Blow and McQueen at a fashion show, 1996. Photograph by Iain R. Webb. Isabella's husband, Detmar Blow, in the background.

on McQueen in June 1994]. We'd handle the incoming calls. There were quite a few from mad ladies in Paris, voices quavering, 'I'd like to buy that dress.' Lee ignored them, of course."

With no money to go into production let alone couture, the "Taxi Driver" collection was a showcase. Each style had the McQueen

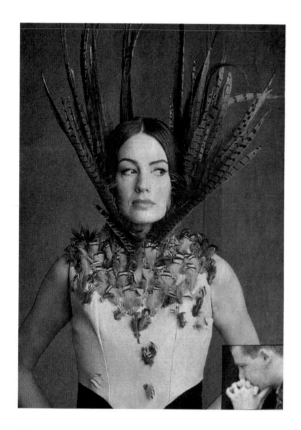

Pheasant tail form a ruff, and delicate partridge feathers decorate the leather bustier in this photograph of Alice Smith, from a feature on designers' muses in the *Daily Telegraph*, 1993. Alice Smith, along with Cressida Pye, became McQueen's agents and friends after he left Central Saint Martins in 1992.

trademark label of human hair in plastic, a symbolic piece of "him" with a touch of fetish. Naturally, he soon had to stop using his own hair and would visit hairdressers to collect tresses from shop floors, but the notion of memento mori was there, a gothic sensibility he was to develop. And the press began to pick up. Alice Smith arranged for journalist Katie Webb to run a profile on McQueen in *Sky* magazine.[6] The material, like the story of his Cinderella drawing on the wall when he was three (see page 10), has been referenced again and again. However, the designer's portrait by Richard Burbridge, showing his face bound up with gaffer tape, infuriated the editor. In fact, this was more to do with hiding his face from the DHSS than about making a personal statement, though wrapping themselves in gaffer tape for a lark before going out clubbing was a favorite pastime for McQueen, Groves and their friend "Trixie" (Nicholas Townsend—whose drag looks were based on Rachael in *Blade Runner*). Then the *Daily Telegraph* decided to run a feature on designers' muses.[7] "Lee rang up and said, 'Will you be my muse?'" says Alice Smith. "So I was photographed with lots of makeup, my head surrounded by pheasant feathers provided by Simon Ungless from his father, a gamekeeper."

SIMON UNGLESS
DIRECTOR OF THE GRADUATE SCHOOL OF FASHION,
ACADEMY OF ART UNIVERSITY, SAN FRANCISCO
On "Taxi Driver"

I did a huge photoprint of De Niro as Travis Bickle on a taffeta tailored jacket. Nothing exists from that collection because, after the show, Lee and I put everything into black garbage-bags, got into a taxi and on the way home decided to pop into the [sublimely named] Man Stink, a club in the basement of a pub in King's Cross. We decided to leave the bags tucked behind garbage containers rather than pay the coat-check fee. We had a dance and some sherries, and when we came out, the bags were gone, collected by the garbage truck!

Nihilism

Spring/Summer 1994

"I want to empower women. I want women to be afraid of the women I dress." —Alexander McQueen

What most perturbed the press, and was extremely apparent in the reaction to McQueen's next collection, "Nihilism," was his portrayal of women. His friends Alice Smith and Cressida Pye were (and still are) nonplussed by the accusations of misogyny. "He definitely loved women—'strong' women—more than he did men," says Smith. "I remember him saying to me, 'I really want the woman to feel strong and powerful. I don't want to project myself onto the clothes—I want a woman to put on a jacket of mine and be themselves.'"

Andrew Groves stresses McQueen's references went beyond fashion, into art, film and theater. "He didn't understand why fashion

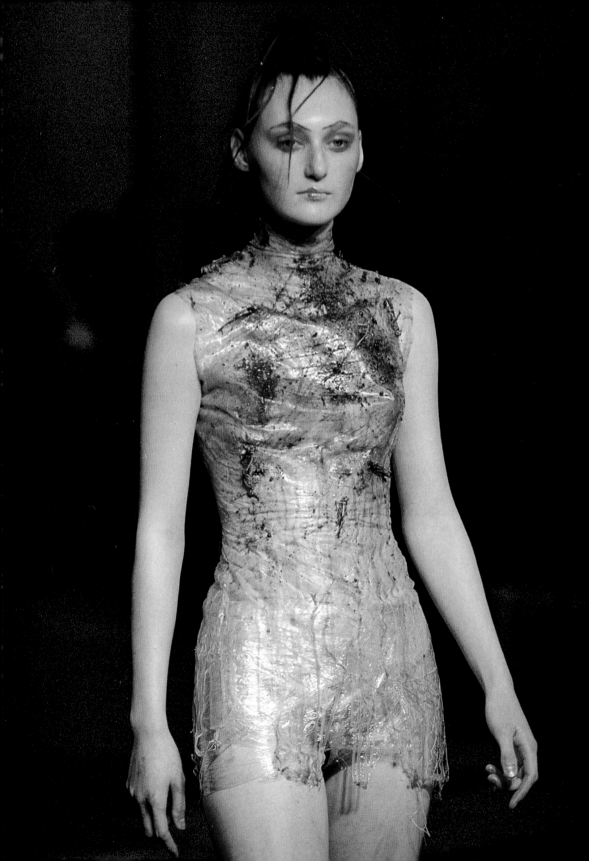

could only have one view of women. His women friends, gay or straight, went to gay clubs, so they were powerful characters anyway. And he liked them," says Groves. "Lee's women—it wasn't that they weren't vulnerable, it was that they had confidence. They were usually people who had been 'outsiders' at school, who had something different about them; androgynous women who held themselves confidently, it didn't matter if they were tall or short. That 'strongness' was in their sense of self, invariably gained from hanging around in clubs with others who were 'outsiders,' too," agrees Trixie. "My look was very punk," he adds.

"He wasn't an intellectual," explains Bobby Hillson. "He was intuitive, and, at that stage, not particularly articulate." McQueen's theme—felt more than reasoned at this time—was that women should be invulnerable, and he was able to express this through his technical skills.

The fashion press was looking for the "new punk" in October 1993, wrote Marion Hume in her review of his second show, the hottest in London Fashion Week.[8] But they didn't find it in the clubs of Soho and King's Cross, but on McQueen's runway. His "Nihilism," S/S 1994 presented them with a range of references beyond expectation. Some were shocked by the hard house music broken by complete silence, the models in transparent cling-film (plastic wrap) panties, blood-like detailing on breasts suggestive of amputation à la St. Agatha and the new "bumster" trousers. The *Independent* devoted a whole

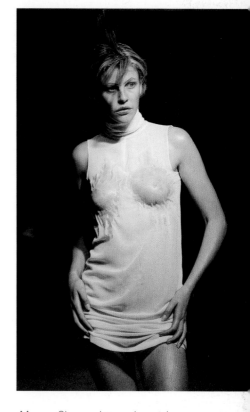

Above: Sheer white polo-neck dress, wetted with water over the bust in the style of the French *élégantes* of the Directoire in the late 1790s. The last time London had seen this was in John Galliano's "Forgotten Innocents" collection of 1986, which also played with the idea of violation. Nevertheless, McQueen's women in "Nihilism" were more knowing and less victims—although many members of the press branded him as a misogynist. **Opposite:** A sheer plastic minidress with red mud applied to the upper body suggests blood; the model's nakedness revealed through transparent material.

page to Hume's piece—"McQueen's Theatre of Cruelty: After the glitz of Paris, something shattering. Marion Hume was shaken but not stirred."

The collection swam against the prevailing mode, which was anti–hard chic and antitailoring. In December 1989, British *Vogue* predicted fashion historians would see the tailoring boom of the 1980s "as a mere interlude in the underlying trend toward casual dressing." Its August 1993 issue proclaimed the "new silhouette," a triumph of the softly feminine, with its minimized shoulders and swirling long skirts. "A floaty imposing whirl" at the thighs *Vogue* said—"Either way, it is as far from the geometric certainties of the power suit as you can get."[9]

Designers Donna Karan, Rifat Ozbek, Calvin Klein and Ann Demeulemeester all embraced the "maximum fluidity," as described by *Vogue*—"Women who like their fashion strong and assertive may need a strong, assertive drink." McQueen served the drink with gusto, presenting beautifully tailored jackets influenced by Anderson & Sheppard's London Cut, emphasizing the shoulder, broadening it slightly, with lapels as sharp as shark fins; the jackets and frock coats cut away at the front, dipping low at the back.

Teamed with the bumsters (introduced for the first time), some of the looks displayed exposed torsos and bottoms in a way more the norm on the beach, not in daywear. The bumster's "waistband" sat 2 inches below the height of hipsters on the torso (the inside was rubberized so the low-rise trousers wouldn't slip). McQueen wanted to move "proportions away from the traditional, transcending what we think is the norm for a woman to look like," he later explained to the BBC. "I'm always challenging that aspect. It was done purely to elongate the torso and change the way we look at proportion, because [usually] you want a longer leg, but I wanted a longer top part." The aesthetic was borrowed from the homoerotic ideal of long torso, short legs. "To me, that part of the body—not so much the buttocks,

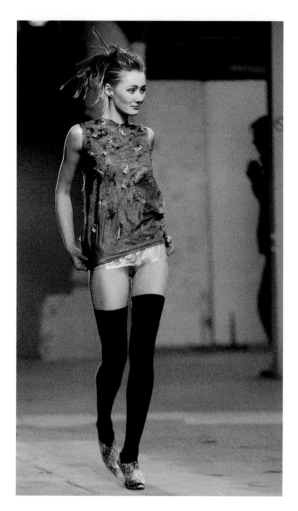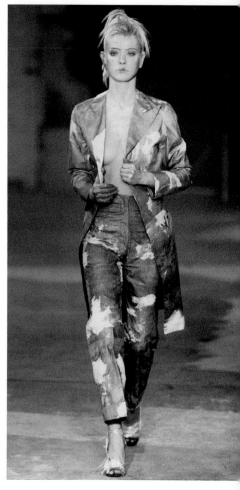

Left: A slashed top in Elizabethan style over a sheer shift reveals the model's genitalia, styled with schoolgirl-style hold-up tights. Marion Hume wrote that McQueen's London Fashion Week debut "was a horror show . . . of battered women, of violent lives, of grinding daily existences offset by wild, drug-enhanced nocturnal dives into clubs where the dress code is seminaked." **Right:** A frock coat distressed with white paint and high-rise trousers with McQueen's anti–Savile Row twist, a revealing of the ankles.

but the bottom of the spine—that's the most erotic part of anyone's body, man or woman."[10]

The dropped waist was probably sourced from his copy of Juan de Alcega's 1589 *Tailor's Pattern Book*, when the waistband of men's breeches would sit loosely on or below the hipline. By blending this

Model, wearing bumster trousers with MC in double stitching on the back pockets, walks the runway at McQueen's first New York fashion show at a former synagogue on Norfolk Street (now the Angel Orensanz Foundation Center for the Arts) in March 1996.

line with modern tailoring techniques to create a fresh area of erotic interest, he achieved something new.

The collection was made at Simon and Lee's house in Tooting, with Simon making the pickled-locusts dress in the garden. Fleet Bigwood designed and produced all the prints. "The whole collection was about tailoring," said Simon Ungless. "I did tons of stuff for that. There was one incredible peacoat jacket made from burnt-out lamé. . . . At this stage, Natalie Gibson told me she needed a print technician at Saint Martins, and I took the job so that we had somewhere to print the collection."

The *Independent* piece went on to describe it as "a catalogue of horrors . . . tasteless innovation . . . the high price of originality." In its view, the collection degraded women. Of course, it cited his "East End" background, too. The word *misogyny* did not appear, but it was inherent, with parallels drawn to others with a seemingly "perverse" view of women—Thierry Mugler, Claude Montana and Gianni Versace.

It was amazing, too, how the class stereotype set in—astonishing that the press didn't immediately label him the Bill Sykes of

Fashion.[11] Yet writer Marion Hume was astute: "Here was someone with something new to say in a business where designers gorge on each other's ideas. The shock of the new has to be just that: shocking."[12] "It suited him to let the press think all that stuff about his being an East End yob," observes Andrew Groves. "He just let them get on with it. It meant they had a story and left him alone." Meanwhile, the *Daily Telegraph* reported he had sold two hundred pieces from the collection by the following February.[13]

The Soho Scene

"My collections have always been autobiographical, a lot to do with my own sexuality and coming to terms with the person I am—it was like exorcising my ghosts in the collection. They were about to do with my childhood, the way I think about life and the way I was brought up to think about life." —Alexander McQueen

And the designer was also coming out of his shell. His birthday party in March 1993 was held downstairs at Maison Bertaux, the Soho patisserie, and there were just five guests, including Smith and Pye. "He'd hired a Hungarian accordion player, and we sat around drinking wine. Then the owners started doing Hungarian dances. One day I told him about seeing a gay couple holding hands, and how good I thought it was. He was really touched by that because he was at first very nervous about his gayness, and it was very difficult with some of his family, particularly his dad, who had difficulty with it. And of course, he would have loved to have kids." (He had dogs instead—

"They always love you," McQueen once said. First, a Samoyed, then an English bull terrier named Juice and a Staffordshire—Minter—from Battersea Dogs & Cats Home.)

John McKitterick bumped into him in Soho after his first show. He recalls, "There was a confidence about him that was new. He was with his [then] boyfriend, Andrew Groves, and they were going to the opening of a Jake and Dinos Chapman exhibition, 'Tragic Anatomies,' at the ICA."

McQueen was also present at the "Lash Bash"—a birthday party at a club in Apple Tree Yard, Soho, held for the drag persona Stella Stein (historian Dr. Stephen Brogan). Free admission was given to anyone wearing false eyelashes, and Bodymap's David Holah, dressed as Marilyn Monroe, leaped out of a 7-foot high "cake" made by Leigh Benjamin to serenade Stella with "Happy Birthday." "We then went on to perform 'Two Little Girls from Little Rock' [originally sung by Monroe and Jane Russell in *Gentlemen Prefer Blondes* (1953)] but our version was 'We're two little girls who love big cock,'" recalls Dr. Stephen Brogan. "Lee was invited by a mutual friend, the fashion designer Sue Stemp—I remember Lee being there, sitting on a sofa, laughing with the boys from Vivienne Westwood."

On November 24, 1994, he attended a performance by Minty—artist Leigh Bowery's group—at the Freedom Café on Wardour Street, London, where Bowery simulated "giving birth" to Nicola Bateman. "He [McQueen] worshipped Leigh," says Brogan (a member of Bowery's previous troupe, Raw Sewage), "I remember him at Kinky Gerlinky when Leigh was there."[14]

Leigh Bowery with his wife Nicola Bowery attached in a harness underneath the dress. He is about to "give birth" to her onstage at Freedom. Bowery was thrilled when the *Sun* dubbed Minty the "sickest band in the world." A. M. Hanson, who took the photographs here, comments that "these pictures represent the kind of out-there, edgy performance Lee McQueen loved."

Having worked with John McKitterick and Koji Tatsuno, Lee McQueen had his fashion roots firmly in London of the 1980s, linked with club culture and its desire to shake up fashion's status quo. Quite simply, says Andrew Groves, he came out of the Kinky Gerlinky era. The club had opened in April 1989 and was run by former Comme des Garçons model Michael Costiff and his wife, Gerlinde Costiff, who also owned World, a boutique in Covent Garden. "It started at Legends, New Burlington Street," recalls Dr. Stephen Brogan, "and lasted until the summer of 1994. Within a year of opening, it was London's most cutting-edge club, having brought about an explosion of drag, funky house music and disco, all served up in

Audience, including some of London's most transgressive gay royalty, watching Leigh Bowery and Minty performing at the Freedom Café on Wardour Street, Soho, November 24, 1994. Minty comprised Leigh Bowery, Richard Torry, Nicola Bateman and Matthew Glamorre. Simon Ungless and McQueen sit at the right in the front row, along with Sue Tilley. Other attendees included Lucian Freud, Antony Price, Marc Almond and members of Blur, Suede and Oasis. It was Bowery's last performance. He died on December 31, 1994.

a carnivalesque, party atmosphere. The bulk of the crowd were men in drag, who had drunk liberally while getting ready and so were up for fun; but Kinky Gerlinky also attracted lots of dressed-up women—gay and straight, as well as muscle queens, fetish freaks, skater dudes, curious heterosexuals—you name it, they were all there. At the time, this vibrant mix of people was new, in itself invigorating."[15]

Andrew Groves remembers McQueen attending a Kinky Ger-linky night wearing a wig split into three points and extending out at the sides with a high peak in the middle—clownlike but also a satire on John Galliano's wigs on the runway from his S/S 1993 show in Paris and the contorted hairstyles of the mid-1830s. It was perhaps more than a personal moment: he used the same look for some of the models in "What a Merry-Go-Round," A/W 2001. John McKitterick says from his conversations with McQueen, it was evident that for him, Galliano was the benchmark of success for a British designer—"He was obsessed by him, he was the one to beat." By 1994, Lee McQueen started to know the more established art and fashion crowd that made up a powerful gay subculture with whom he went on to collaborate, most notably dancer Michael Clark in "Deliverance" and film director Baillie Walsh in "Widows of Culloden." The iconoclastic outrageousness—the shock value—of Leigh Bowery influenced his idea of what a fashion show could be. He made Trixie, a person of character, a pair of bumsters. Absolutely nothing was taboo.

Banshee

Autumn/Winter 1994–1995

"You've got to know the rules to break them. That's what I'm here for, to demolish the rules but to keep the tradition." —Alexander McQueen

McQueen's third collection, "Banshee," was presented at Cafe de Paris, London. He told the *Daily Telegraph* the theme was Luis Buñuel's film *Belle de Jour* (1967) in which Catherine Deneuve, dressed by Yves Saint Laurent, plays a housewife-turned-prostitute. Of course he was joking—nothing so predictable. Alice Smith points out, "Lee wasn't entirely naïve when it came to publicity. He'd say with a completely straight face, 'Karl Lagerfeld's coming to my show,' or 'Michael Jackson will be there.' The rumor would spread, then we'd get calls asking if it was true. We'd say, 'That's what we've heard.' He was a very good operator and fantastic at spin."

Instead, he looked to Celtic culture and the Scottish *bean sìth* or "banshee"—a fairy from the otherworld, who would be seen washing the blood from clothes of men about to die. It was sponsored by Stella Dry and *Dazed & Confused* magazine. Hence a model in a white shift drenched with a degradé print of bloodred from neck to midthigh and ethereal white dresses in floaty organza. McQueen was building his signature look, with its references to historic tailoring. The bumster appeared again, this time styled with fitted militarylike jackets trimmed with gold braid and roll-collars that skimmed about the waist to reveal tantalizing flesh. There were knee-length frock coats in gray silk, with high-rise trousers and hems settled above the ankle—a travesty of the trouser lore at Gieves & Hawkes. Also there were his "real women": a heavily pregnant woman, hair short in Sinéad O'Connor–style, posing like the bride in Jan van Eyck's

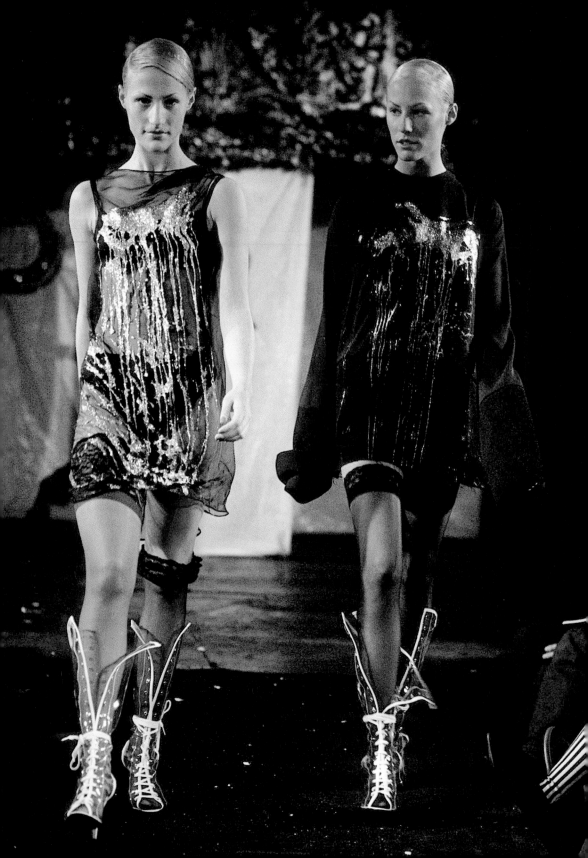

The Arnolfini Marriage of 1434—his "favorite painting."[16] "McQueen" was spray-painted in silver on the model's head, as it was on Isabella Blow's (who also strode the runway in a lace dress worn by Stella Tennant in British *Vogue's* "London Babes" story, styled by Blow and Joe McKenna for the December 1993 issue).[17]

He was hailed a "new force in British fashion" by astute retailer Joseph Ettedgui in *Vogue*; celebrated shoe designer Manolo Blahnik told the magazine it was "modern couture." And the only problem? Too many ideas. "I can't see myself going on for much longer like this with no backing, but I don't know how to approach a big backer," McQueen told the *Daily Telegraph*.[18] Nevertheless, his floaty dresses, fabricated from three layers of chiffon cut into rectangles beneath an empire-waistline, were now on sale or return at Pellicano in London's South Molton Street.

Above: Isabella Blow modeled in "Banshee," wearing McQueen's purple shirt with exaggerated collar based on an early nineteenth-century style. The McQueen logo, misspelled, has been sprayed on her head in silver, a demonstration of how far she was prepared to go to promote the McQueen brand. She ensured that both Michael Roberts and Manolo Blahnik were there to see his work, and got *Vogue's* Plum Sykes to model, too. **Opposite:** Black chiffon shift dresses with prints by Simon Ungless. The simple chiffon dresses were sold at Pellicano in London's fashionable South Molton Street.

McQueen met Andrew Groves early in 1994 at Comptons, a well-known gay pub on Old Compton Street in Soho. They were introduced by a mutual friend, designer David Kappo, part of the

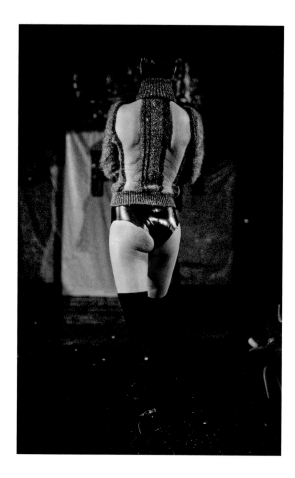

Backless knit sweater with spine detail and fetish-style PVC underpants. The rawness of these shows, the starkness of the aesthetic, broke finally with the luxe glamour or soft-focus blur of femininity of late 1980s and early 1990s fashion. McQueen's work relates to grunge-style images of Kate Moss, photographed by Corinne Day and published in *Vogue's* June 1993 issue.

Central Saint Martins' crowd. "There was a buzz about Lee," says Groves, "and we both had theater backgrounds"—Groves had made props for *Miss Saigon* while McQueen was making costumes. At the time, McQueen was living in Clapton Heath, Essex, in a ground-floor flat belonging to his sister, reached by train from Liverpool Street Station. "There was a thick shagpile carpet covered in pins, a sewing machine and cutting table in the sitting room and that was it, really," recalls Groves. "Lee showed me how to pin a hem, and together we produced the chiffon dresses for Pellicano." At the same time, McQueen was making trousers for Alice Smith—"I'd buy fabric and he'd come round, lay it out on the floor and cut straight into the fabric with such confidence. 'Are you sure you want high-rise?' he'd ask—he probably wanted me to wear bumsters, but he made me beautiful palazzo pants instead."

Clapton Heath was in the suburbs, half an hour away from Central London by train, so that summer, Isabella Blow suggested McQueen and Groves move into the basement of her house at

67 Elizabeth Street in Belgravia, then empty because the house next door had semicollapsed and was condemned. They brought the machine and cutting table with them, but life was tough: there was no hot water or electricity, and they had no money. By now, the fashion machine had kicked in and it was McQueen's all-important third collection, the one the industry always scrutinizes to see if the talent and ideas are really there, so he knew he had to deliver. However, there was no backer to do the September collection, and so he negotiated special deals with Bagleys fabric house and made a dress out of builders' plastic palette wrapping that he found in the street. Andrew Groves recalls, "He heard that Bagleys Warehouse in King's Cross was empty, so we went up to ask if we could use it for the show. It was just a large, vacant shell, and we saw one lonely Portakabin on the building site. I watched as he went up to it and knocked on the door. The foreman was there—he negotiated with him

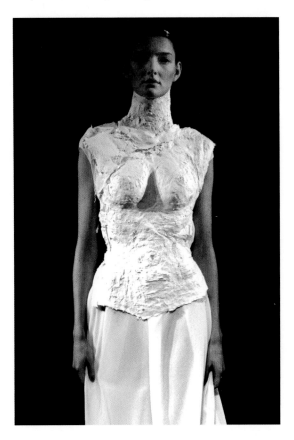

"Banshee" referred to the mystical spirit world of Celtic mythology and to the notion of breaking forth—as in John Wyndham's novel *The Kraken Wakes* (1953)—rising from the deep, hence the plaster of paris–molded corset, which symbolized constraint before it broke open on the runway. The collection was made at the house in Tooting that McQueen shared with Simon Ungless, who could be found battling with plaster in their back garden. Fleet Bigwood designed and produced all the prints.

to have permission to use the warehouse for a fashion show. They agreed on a price, and then he got sponsorship from Beck's Beer."

The Birds

Spring/Summer 1995

"I know I'm provocative. You don't have to like it, but you do have to acknowledge it." —Alexander McQueen

The collection, called "The Birds" after Alfred Hitchcock's eponymous film (1963), was made by McQueen, Groves and David Kappo, accessorized by jewelry designer and artist Simon Costin, with prints by Simon Ungless—McQueen's early creative "family." As with other shows, the theme was multilayered, tapping into his fascination for birds, the way they moved and the motion of taking flight. He studied artist M. C. Escher's bird illustrations (which morphed into geometric shapes) and chose one to develop. Ungless printed the fabric on a Saturday at a college in Stratford, and it was delivered in a taxi for which £30 had been borrowed to pay the fare.

The birds were swallows (long used by sailors in tattoos to symbolize the fact they had sailed for five thousand nautical miles), but they also represented masculine courage and endurance and were used by skinheads—a look that McQueen loved. "Lee was always happiest when he was just sitting and making the collection," says Groves. "He turned all the buttonholes of the prototypes himself, for example. It was part of the design process, part of the decision making—he loved all that." Groves also believes theater was a far more important influence on McQueen than Savile Row, and this collection employed drama and surprise. He asked the couture corsetiere Mr. Pearl to make a corset and to model it, so Mr. Pearl came for fittings at Elizabeth Street, his waist a neat 18 inches. When he made his entrance on the runway, he paused, his wasp-waisted silhouette casting a huge looming shadow. Then he walked on—a man with the

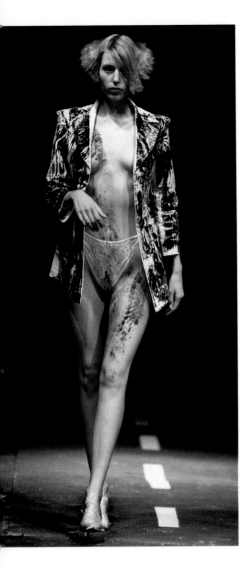
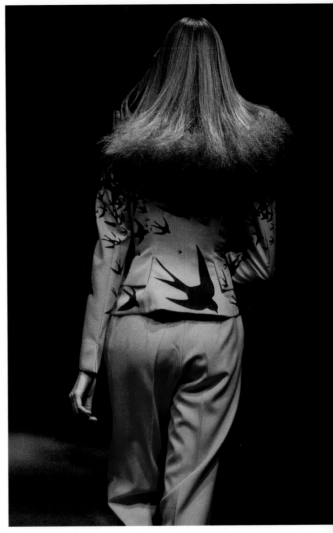

Left: Burned-out silver lamé frock coat over just a pair of underpants, the model's body printed backstage at the last minute with tire marks, for "The Birds" S/S 1995. Simon Costin says, "This was the first time I worked on set design. There was no budget, but Lee wanted the story to be about roadkill as well as Sir Alfred Hitchock's *The Birds*, so I painted the runway with white lines to look like a road." **Right:** Suit in burnt-orange fabric, printed in an M. C. Escher–inspired swallow design in black by Simon Ungless. Note the pocket details ending at the side seam.

Victorian feminine ideal of a tiny waist—in tailored jacket, pencil skirt, shirt and tie.

This was the first time that McQueen had used a man on the runway dressed as a woman—and it was nothing to do with drag. It was about an alternative notion of perfection. The fact that another theme was roadkill, with models and fabric beautifully printed with tire-marks, did not help when the accusations of misogyny started up. He rebuffed the claims, stating, "I design clothes because I don't want women to look all innocent and naïve, because I know what can happen to them. I want women to look stronger." The experimentation with plastic and out-of-context, shocking prints, the inspiration from nature and a new, empowering shoulder, however, was reminiscent of the experimental and, in her time, controversial designer Elsa Schiaparelli—a redoubtable, independent woman, who dressed equally independent women of the 1930s in suits blocked at Anderson & Sheppard. His father watched his son's show from the back, having crept in at the last minute.

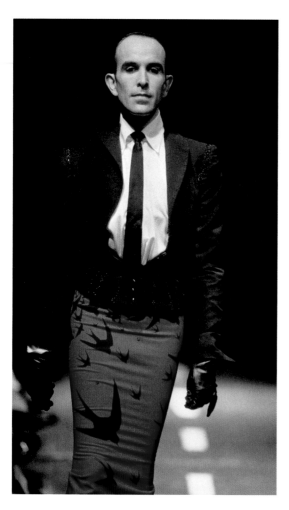

Mr. Pearl, the master corsetiere, with the black jacket buttoned low over his eighteen-inch waist and swallow-print skirt. For McQueen, rules about gender and what was blandly "normal" were there to be challenged.

SIMON UNGLESS
DIRECTOR OF THE GRADUATE SCHOOL OF FASHION,
ACADEMY OF ART UNIVERSITY, SAN FRANCISCO
On "The Birds"

It was with "The Birds" that we first felt that we were getting somewhere, there was defi-nitely a "voice," and it was more than just fun. The hair stood up at the back of my neck because I could see that there was something new. It was a fashion moment because it hit the moment when people were ready for tailoring and modernity, with the sportswear references in the fabrics that predated Prada's nylon range. The strength of the collection was phenomenal, the slickness of it. It felt like it could have been staged anywhere. We had no money for fabrics, so I took all the material from the fabric store at Saint Martins, which included lovely burnt oranges, and printed them at my old college. "What a great show, blah, blah, blah," said the people from Saint Martins. I thought, "Yeah, right! You don't even recognize your own fabrics."

Highland Rape

Autumn/Winter 1995–1996

"I hate it when people romanticize Scotland.... There's nothing romantic about its history." —Alexander McQueen

"The Birds" was a prequel to "Highland Rape," the collection cementing critical acclaim. Soon afterward, there was a call from Eo Bocci, the Turin fashion sales agency. McQueen and Groves bor-rowed more money for a taxi and sped off to Soho to meet him. Bocci offered McQueen £10,000 for a major stake in the company but

was firmly turned down. An arrangement that meant Eo Bocci would handle sales and production in Italy was a huge breakthrough, though. Now McQueen could concentrate on designing, while production ensured there were clothes that people could buy.[19]

Lee moved his studio to the Clerkenwell Workshops at 31 Clerkenwell Close, near St. Paul's and the City of London, while staying at home with his parents and with Groves at his flat in East London. He had already encountered stylist Katy England (then at *Dazed & Confused* magazine) at "Banshee," but was properly introduced by a mutual friend, Sue Stemp. With her cropped hair, quiet strength and fresh vision, England soon became a close friend and his in-house stylist. "He liked the way I looked and thought I'd bring something to it," she told *Women's Wear Daily*.[20] While Isabella Blow was a friend, the role of collaborator was given to England. The latter described McQueen's appeal as having the same rebellious attitude: "I just like the punky element and the hardness of Alexander's clothes."[21] It was the equivalent of John Galliano and Amanda Harlech's collaborations, a fusion of the same vision, a practicality brought on board that acted like a motor to his work.

"Highland Rape," McQueen's fifth collection, was their first together. Any Scot, any member of the Scottish diaspora such as McQueen, has an awareness—albeit in degrees—of Scotland's troubled past. For McQueen, this knowledge was part of his identity and he acutely sensed the depredations practiced on his Highlander ancestors. Politically, 1995 was an interesting time because the Scottish Constitutional Convention published a final report, "Scotland's Parliament, Scotland's Right," which called for devolution and a Scottish parliament at Holyrood. In April and May 1995, two Hollywood blockbusters were released: *Rob Roy* and Mel Gibson's *Braveheart*, respectively. Both Rob Roy and William Wallace, on whom Gibson (also a member

Gray lace dress cut to reveal the floral shapes—and the body.

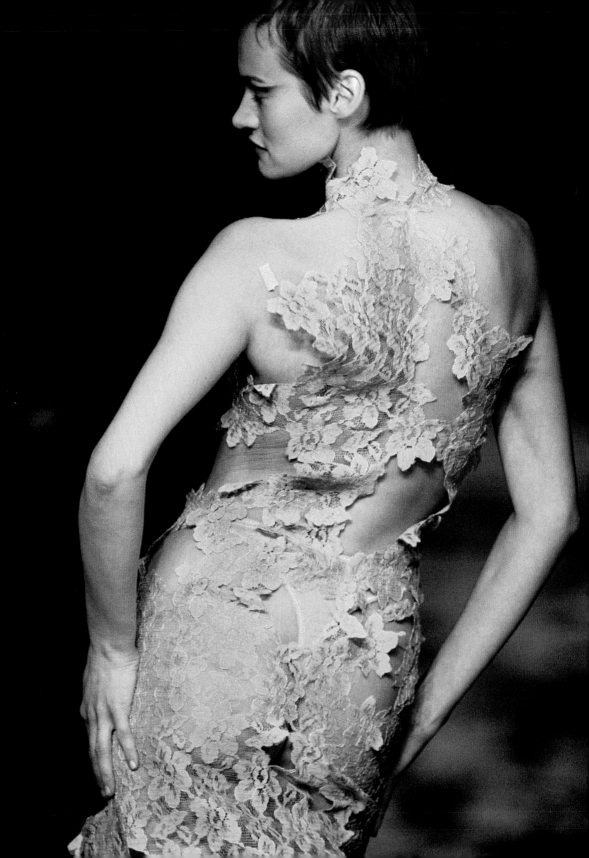

of the Scottish diaspora) based his film, were folk heroes, romantic figures and subjects for Sir Walter Scott's pen. Gibson's work, agitating for Scottish independence, was a phenomenal popular success and with intuitive prescience, McQueen superseded both with the collection.

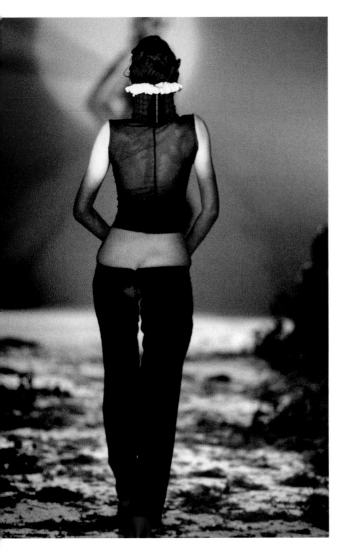

Naturally, the inclusion of the word *rape* was deeply contentious, but for McQueen, it was about genocide—the rape of a *culture*—and he wasn't about to apologize. Unfortunately for him, the London audience viewing the show had not yet been able to see and experience for themselves the pleasures of *Braveheart*. Had they already done so, the response would have been that he was using old news as inspiration. Instead what they "read" was that it was degrading to women and McQueen was simply retreading Vivienne Westwood's tartan territory. "They completely misunderstood 'Highland Rape,'" he told the *Sunday Times*. "It wasn't antiwoman. It was actually anti the fake history of Vivienne Westwood. She makes tartan lovely and romantic and tries to pretend that's how it was. Well, eighteenth-century Scotland was not about beautiful women drifting across the moors in swathes of unmanageable chiffon."[22]

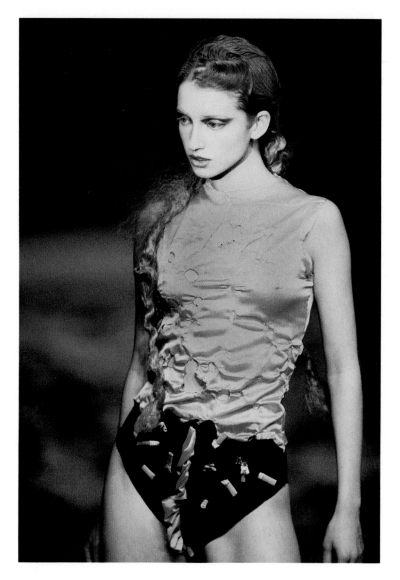

Above: A torn lavender satin top that suggests assault, with cutaway shorts appliquéd with cigarette butts, the satin frill at center front labial in inspiration. **Opposite:** "Highland Rape" was the most shocking McQueen show and the one that made his name. Masculine military stock in McQueen tartan, edged with a Marie Stuart frill, and transparent top and bumsters cut dangerously low, the fabric tantalizingly worn away at the buttocks. Central Saint Martins students had photocopied the invitation, and the London Fashion Week tent was filled to bursting as his friends were left outside, unable to fit in.

In turn, Westwood riposted furiously that he was a measure of "zero talent." But McQueen was right: clan tartans did not exist formally until the nineteenth century, and the wearing of plaid was made illegal by Westminster decree. Nevertheless, he used his own clan tartan in the show and tapped into two outrages: post-1745 Jacobite Rebellion and the nineteenth-century Highland Clearances, in which landowners such as the Duchess of Sutherland enforced the removal of crofters from their land in order to farm sheep and grouse, in the process creating starvation and mass emigration to America. It is worth noting here the level of research and knowledge McQueen had in the pre-Internet, click-of-a-button-instant-information-era and the influence of his mother, Joyce, who was passionate about history and the family's roots. Interviewing her son for the *Guardian* in 2004, she asked him, "What do your Scottish roots mean to you?" Answer: *"Everything."* [23]

McQueen fitting Katy England, who joined him during the run up to "Highland Rape" and styled the show. She was his muse, and together there was a fusion of spirit to rebel, question and move fashion forward. The tartan is beautifully cut on the bias, not only for fit but to flatter the figure, the sleeves topped with the cloth to extend in a graceful cap over the shoulder.

"Highland Rape" was produced at the new Clerkenwell studio by McQueen and Groves (two interns from Central Saint Martins did all the machining) and with the first professional cutting table

McQueen possessed. He brought onboard the powerhouse that is Trino Verkade as his first PR (both she and McQueen were still collecting social security)[24] and Katy England was the fit model and, of course, stylist for the show. About thirty looks made it onto the runway (more were produced but did not appear, as is the norm when editing a collection for presentation), fewer than usual because of the time-consuming dexterity required in bias-cutting the tartan and matching each part of the check weave perfectly. Lace was bought at Barry's Market in Soho for £3.00 a meter, and jeweler Shaun Leane worked officially with his friend for the first time, creating "Albert" fob chains. For McQueen, the contentiousness of the show's title would also attract attention. Somehow, calling it "Highland Fling" would not have achieved the same impact.

For the first time, McQueen showed in the British Fashion Council's official tent outside the Natural History Museum in March during London Fashion Week. It was the hottest ticket of the week, and the crowd gathered outside was beyond capacity (Alice Smith remembers students trying to crawl underneath the bottom of the tent to get in). The invitation—a color photocopy of a man's chest—had been serially reproduced and shared en masse. Inside, the runway was strewn with flowers and heather. Then the models appeared, staggering uneasily and looking dazed, for all intents and purposes as if they had been attacked.

"It was," says Bobby Hillson, "overwhelming, a very powerful story that he was telling in *his* way, with a purely intuitive empathy. But, yes, it *was* shocking." Again there was androgyny, particularly in the traditional military "stocks" around the neck, edged with a Stuart-period frilled ruff. Other elements: a sleeveless steel bodice tooled like decorative armor; lace exposing breasts; silver fob chains delineating the distance between crotch and midthigh, adding a note on proportion (some critics erroneously thought they represented tampon strings); cutaway eighteenth-century style bodices; an

empire-line tartan bodice with transparent gauze floor-length skirt (developed from "Banshee") with sleeves cut on the bias, 1810-style. His bumsters went a step further, with frayed cloth hinting at flesh at the top of the thigh and underneath the buttock, knocking the "perfection" required in traditional fashion imagery. The clothes were about wear and tear, loving them so you wore them until they began to fall apart; garments that are part of a woman's identity. "The Politically Correct police were frozen like rabbits," observed the London *Evening Standard*, "the title alone was enough to make them gag." And yet—"there is something inescapably romantic about this collection. London Fashion Week has been starved of theatricals, which are a necessary ingredient to our fashion spirit. And how we all secretly crave to be saved from proselytizing moralists and their perceived good taste."[25] McQueen himself wanted his clothes to have a shock-and-awe effect, acting as a sartorial prophylactic—"When a woman came into a room wearing his clothes they shouldn't think, 'Cor, I'd love to screw her,' but 'She looks amazing but I couldn't go near her.'"[26]

The collection cemented his reputation as a genuine fashion talent, a man with new ideas for clothes that were popular with a buying public. "McQueen's new collection, tartan dresses and skirts with rips in them (wittily entitled the 'Highland Rape'), obviously a must for every discerning girl's wardrobe, along with a can of Mace," the *Evening Standard* commented wryly.[27] Katy England told the *Guardian*, "Those dresses in the 'Highland Rape' collection—the ones that were ripped at the bust—so many women I know raved about those dresses."[28] Though the collection may not have helped the Scottish independence cause, it was in the shops in time for the release of *Braveheart* in the UK that September. And the resulting publicity paid off. McQueen was approached by Japanese conglomerate Onward Kashiyama, who became his first backer, manufacturing his label with their Italian company Gibo,

along with Helmut Lang. Stockists grew to include Liberty, Saks Fifth Avenue and Bergdorf Goodman. Subsequently, McQueen was given the coveted finale slot at London Fashion Week for the following season.

The Hunger

Spring/Summer 1996

"I need inspiration. I need something to fuel my imagination, and the shows are what spur me on, make me excited about what I'm doing. When you start getting into the mind-set where this is a business and you've got to bring in money, when you're designing with a buyer in mind, the collection doesn't work. The danger is that you lose the creativity that drives you."

—Alexander McQueen

Based on the 1983 film by Tony Scott about vampires, death and insatiability, "The Hunger" was the designer's most commercial collection to date, with support from Onward Kashiyama. The average cost to stage one of his shows back then was £30,000 (models usually were paid in clothes), but this time he included "real" people, among them drum 'n' bass star Goldie (then dating Björk, who produced the sound track for the event) and Jimmy Pursey from punk band Sham 69. To hint at mortality, a molded transparent top in breastplate-style was made, the breasts sagging realistically, and worms purchased from a local fishing shop were sandwiched between the two layers of plastic. As they paced the runway, liberal

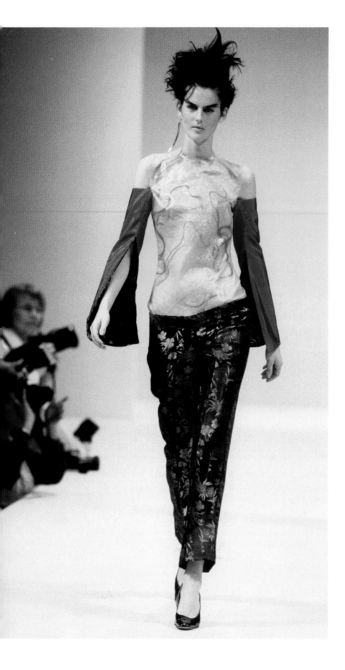

amounts of V signs and middle fingers were flicked toward the audience.

"It was," wrote British fashion writer Colin McDowell, a sign that "the new femininity is more about giving the finger than mincing along in court shoes like a 1950s deb."[29] Among his peers—Hussein Chalayan, Antonio Berardi and Fabio Piras (all Central Saint Martins MA Fashion alumni)—McQueen was singled out as a talent, albeit one that was hopelessly immature and childish but was spearheading the originality of thought that fashion so desperately needs at the moment. Any thoughts of misogyny were set aside in order to recognize McQueen's originality and ability to develop his ideas and move into the future. However, McDowell went on to describe the clothes as a "mess," and it was in retrospect one of McQueen's weaker collections, no doubt because the balance between commerciality—what is realistically possible—and "art" was not there. Clearly, the venue did not lend itself to drama but imposed the constraints of a conventional runway. Maybe he was tired…. "He told himself, as he waited back-

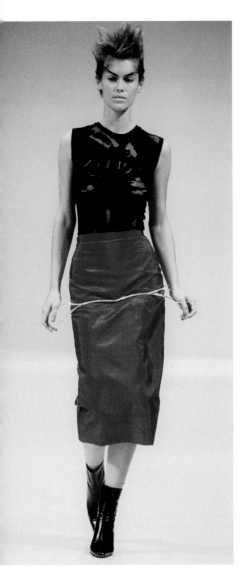

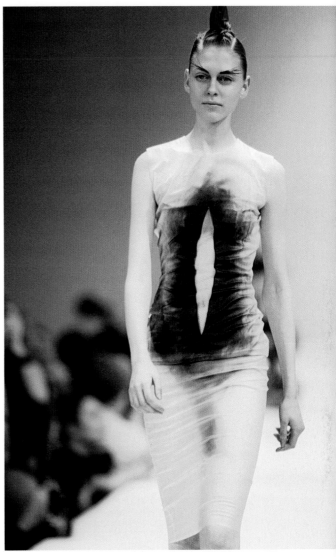

Above left: McQueen logo and pattern burned away, worn with red tailored skirt and wire handcuffs. **Above right:** Knee-length, sleeveless, two-layered dress cut to fit the contours of the body. The overlayer is cut away vertically and surrounded by black, bearing more than a passing reference to female pudenda. **Opposite:** Stella Tennant in a layered top with brocade bumsters and hanging sleeves. The title made reference to insatiability and death. It was McQueen's first collection since being financed by Onward Kashiyama and regarded as his most commercial to date. Bucking this, models flicked the finger at the audience, and nonprofessionals included musicians Jimmy Pursey of Sham 69 and Goldie. This was the first time he had menswear on the runway.

stage, with hardly anyone coming to see him apart from a few 'mad' shops, 'That was the end of the old, reckless McQueen.'"[30] Certainly it was the slough between the peaks of "Highland Rape" and "Dante," his next show.

By now, however, Lee McQueen was an important fashion figure. In November 1995, he joined John Rocha and Joe Casely-Hayford as judges of the Smirnoff International Fashion Awards in Cape Town. They flew first to Sun City, Sol Kerzner's African version of Las Vegas. Casely-Hayford remembers that first night:

> Lee and I had fallen out over a story in *i-D* [magazine]. During this trip, everything was forgotten and we had a good time. The abiding memory I have of Lee in South Africa is that on the first night we arrived, he had his wallet stolen, which of course contained all his cards and money. True to his nature, apart from the natural upset this would cause he also saw something positive in this and said, "It's probably been taken by someone who needs it more than me." We had a drink, and he discovered a couple of coins in his pocket. In typical style, he headed for the first "one-armed bandit" coin machine and of course won something like £2,500. I think this little episode sums up his compassion and all-or-nothing resourcefulness.[31]

And McQueen went further than this in his ability to empathize with a perceived underdog. When the winner—Linda Bjorg Arnadottir from Reykjavik—was announced at the press conference in Cape Town, there was a widespread silence and then titters from the mainstream South African press, whose idea of fashion up till then was almost certainly something out of *Dynasty*. Her piece was a dress of deerskins, bell-shaped like a crinoline, lit up from the inside

with lights. It was material—leather—not dissimilar to that worn by indigenous black South Africans. The judges looked uncomfortable—probably shocked at the behavior—and then Lee McQueen single-handedly took the press on. Immaculate in a handmade gray silk suit, he calmly explained how they obviously had no idea what fashion could be, that creativity was the most important element and how dare they be rude about someone who was just a student starting out on her career in fashion. It was masterly, it was brave and it was the truth (I myself was there to witness it).

Dante

Autumn/Winter 1996–1997

"I oscillate between life and death, happiness and sadness, good and evil." —Alexander McQueen

Meanwhile, Onward Kashiyama had licensed the McQueen name in Japan, and the resulting financial support was evident in his next show, entitled "Dante," which was held at Christchurch, Spitalfields, East London, designed by the architect Nicholas Hawksmoor. The church had links to McQueen's Spitalfields weaver ancestors and is next door to the Ten Bells pub, which featured large in the Jack the Ripper murders. Magnificently baroque, with ancient Egyptian references, nothing could be further from the anodyne British Fashion Council tent.

The links between Dante Alighieri, the Florentine fourteenth-century poet and author of *The Divine Comedy*, were implicit at first, but the strange fusion of the inferno of life with the inevitability of death gradually became obvious. McQueen had always harbored a

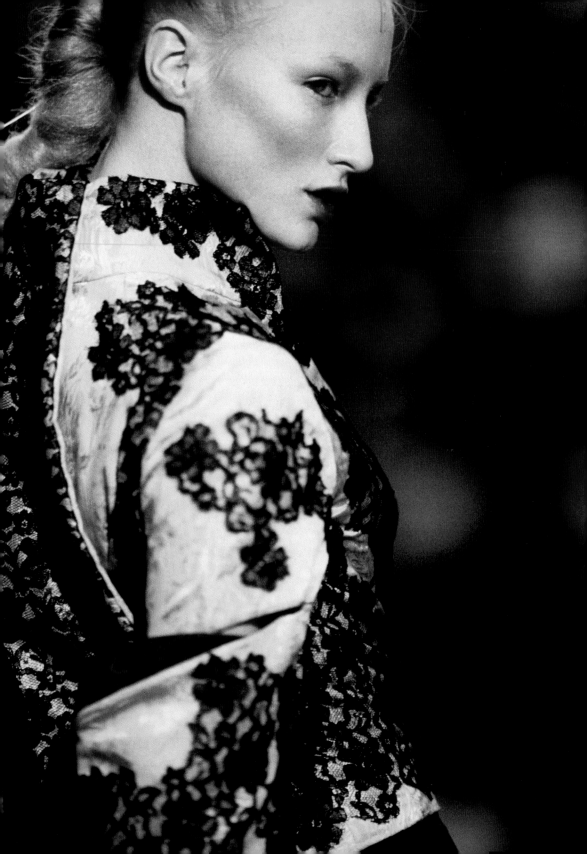

desire to become a war photographer like Don McCullin, so he used, without asking permission, some of McCullin's most famous images from Vietnam as prints for coats and jackets. A plastic skeleton sat in the front row, along with respected members of the press—an allusion to *Death and the Maiden* and the inevitability of the grave. Yet "Dante" was more than just an exercise in whimsy.

Male models were styled to resemble American gang members, denim skirts teamed with Don McCullin–print jackets and trouser-suits cut in new ways. Philip Treacy created the headwear, while Simon Costin made bird-claw accessories and a jet headpiece shaped like a widow's peak. For the first time, there was funding for the show, produced by Sam Gainsbury, and also for fabric: lavender silk taffeta (a traditional shade for half-mourning), specially commissioned white cashmere printed with a black fern design morphing into appliqué black lace. Mongolian lamb trimmed a full-bodied camel coat, while "nude" mesh was embroidered with flowers and crystals. With McQueen, it was luxury all the way. "I think people want that now," the designer later observed. "They don't want to look as though they bought all their clothes in a thrift shop. I'm the reverse of a minimalist. I like eclecticism. These clothes don't rely on accessories to make an impact," he told the *Sunday Times*.[32]

Writing in the *International Herald Tribune*, Suzy Menkes called it a "fashion moment"—an accolade indeed to which all designers aspire. "The show opened with brilliant illumination on a stained glass window, as organ music was drowned out by gunfire—and then by a

Side view of lilac silk brocade jacket with appliquéd black silk lace, the sleeves slashed above the elbow, with black moiré detailing providing interest; a straight edge contrasting with diagonal cut of the lower sleeve.

hardcore club sound track. Out came strong and sometimes disturbing images: dresses showing flesh through scars of chiffon, torn lace beneath a braided hussar's jacket, T-shirts photo-printed with children in Somalia or in the Vietnam War."[33]

The initial ideas came from Flemish fourteenth- and fifteenth-century paintings, McQueen's favorite period in art. Standing collars, slashed sleeves, the layering of clothes all drew from the paintings of Jan van Eyck, Rogier van der Weyden and Hans Memling. Blue-

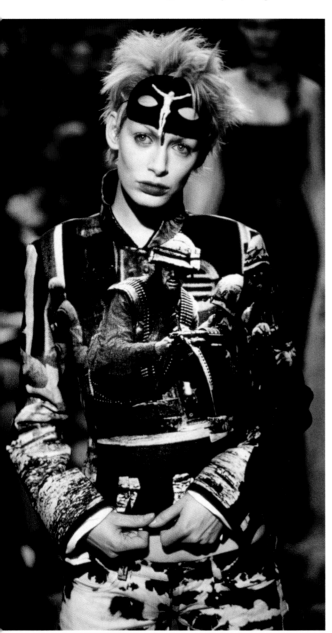

blooded Elizabetta Formaggia, Annabel Rothschild, Stella Tennant and Honor Fraser were among the models, whose hairlines were raised, makeup kept pale and austere. For McQueen it wasn't about death, rather that life and death coexist with one another. A stag's skull with great horned antlers was a headpiece by Philip Treacy, perhaps referencing Pisanello's *The Vision of Saint Eustace* (circa 1438) at the National Gallery in London. The hunter, surrounded by his dogs and wild birds (very McQueen), saw Christ crucified between the antlers of a stag and was therefore converted to Christianity. In a further reference to art, crucifixes were transposed onto black masks copied from the mask worn by an artist McQueen had begun to collect: Joel-Peter Witkin in his *Self-portrait* of 1984.

Here, it is worth noting that although she was begin-

ning to fade out of his working life, Isabella Blow was a still phenomenal influence—escorting McQueen to museums and galleries, filling his mind with images to which he referred in his work, taking him into the country and arranging for him to learn the ancient sport of falconry. In this, his latest show, Stella Tennant carried a hooded and tethered falcon on her wrist like a medieval lady in a hunting party—an allusion to the femme fatale, of course, but also autobiographical, speaking of McQueen's love of birds and of his childhood, when he would watch the kestrels that circled the high rises of Stratford, looking for prey.

Opposite: The theme of "Dante" was religion and war. Model wears a jacket printed with photographs from Vietnam by Don McCullin; bumsters are in bleached denim, skinhead 'style.' **Above:** The mask with crucified Christ figure is taken from Joel-Peter Witkin's *Self-portrait*, 1984.

This was the perfect collection—what Menkes calls a "fashion moment," in which the richness of research and imagination—McQueen's trademark—really came alive. "What attracted me to Alexander was the way he takes ideas from the past and sabotages them with his cut to make them new and in the context of today," Blow told *Harper's Bazaar*. She continued, "It is the complexity and severity of his approach to cut that makes him so modern. He is like a 'Peeping Tom' [the Powell and Pressberger film of 1960] in the way he slits and stabs fabric to explore all the erogenous zones of the body. His clothes are sexy to wear."[34] As if to belie this intelligent analysis, McQueen described Blow in the following way: "Issie is like Lucrezia Borgia mixed with a Manchester fishmonger's wife."

The now-familiar accusations of misogyny were lost in the critical acclaim for "Dante"—"These are clothes for strong women. I don't just touch on it; I really go for it."

"What made Lee so different was that he had integrity. In an industry that so often recycles other people's ideas, he never referred to other designers," says Alice Smith. "What Lee wanted was recognition of his talent, not fame," she believes. "He was uncomfortable with that. He'd say to us, 'Shows have got to be extravaganzas,' but there was always a drama to them that could be quite sinister—they were always pregnant with tension." His next collection—"Bellmer la Poupée"—was a case in point.

A high-collared cotton jersey coat with a print taken from a photograph of a colony of blind Native Americans.

SIMON COSTIN
JEWELRY AND SET DESIGNER
On "Dante"

"Dante" was incredibly exciting because the buzz about McQueen had started to kick off. He wanted to use the detail from the self-portrait by Witkin in the "Dante" show and wrote and asked permission from Witkin and McCullin. Both refused, but he did it anyway. (He had no money, so if they wanted to sue, they would not have received compensation.)

The church then was a ruin, with holes in the floor and models tripping over floorboards, a set in itself, but the "drama" was provided by the lighting designer Simon Chaudior. I provided the gold plastic skeleton, and it was Lee's idea to seat it in the front row, and I made the black widow's peak hat.

Bellmer la Poupée

Spring/Summer 1997

"For me, what I do is an artistic expression which is channeled through me. Fashion is just the medium."
—Alexander McQueen

Held at the Royal Horticultural Hall in London's Victoria, with a runway covered in black plastic rippling to resemble water, the black model Debra Shaw walked uneasily in a metal frame made by Shaun Leane, which was attached to her wrists and just above the knee. "No one really got it," says Antony Price, "It was a one-off piece, but it was interesting." In fact, it raised the question of taste—was McQueen now romanticizing slavery? As it transpired, the "shackling" was imposed to re-create the jerky movements of a mechanical doll, referring to

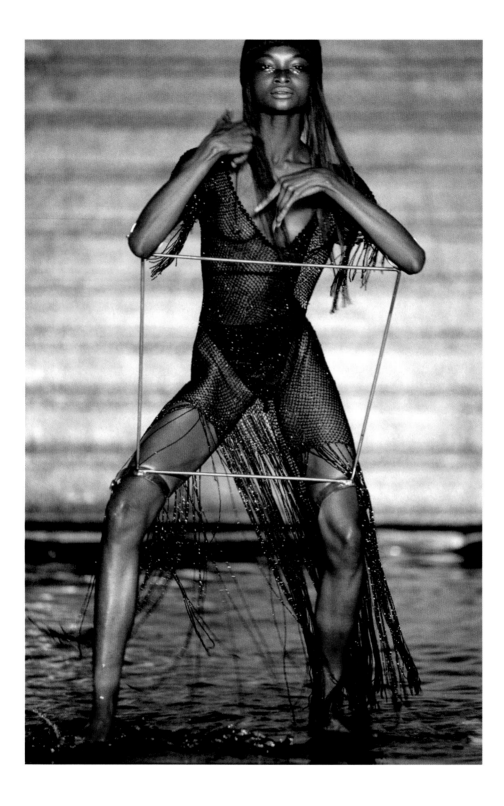

German artist Hans Bellmer's *Poupée, Variations sur le montage d'une mineure articulée (The Doll, Variations on the assemblage of an articulated minor)* of 1934, for which he took dolls apart and reconstructed them for a series of photographs. The work was a reaction to the Nazi theory of eugenics and perfect Aryan beauty.

For McQueen, it was his reaction to the body fascism of fashion—a continual theme in his work. "He reasoned that if you could provide a vision of different kinds of women in film and on the stage," explains Andrew Groves, "why couldn't they appear on the runway?" This interest in Bellmer also tapped into McQueen's childhood fascination with surrealism, when he drew displaced eyes—a popular motif, particularly with Salvador Dalí. While the surrealists took the idea of the "unconscious" from psychoanalyst Sigmund Freud, their avowed desire was to shock—a notion most memorably used in the designs of Elsa Schiaparelli. Looking at the rest of the collection, it was one that would certainly sell—extremely wearable, with silvery

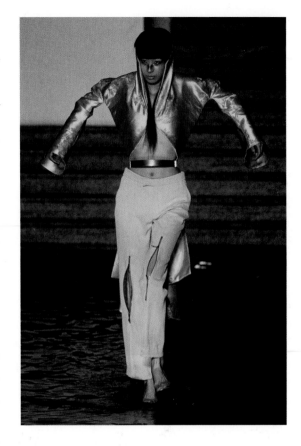

Above: Debra Shaw strides through water in zip-or-slash trousers and gold coat, cutaway and tailed in an exaggerated version of a mourning coat. The conventional nature of the raglan shoulder is subverted by the inserted shoulder and distorted sleeves, like a doll that has been pieced together from others. **Opposite:** Debra Shaw in net and fringed dress, shackled above the elbows and knees. The difficulty in walking was meant to look like the hybrid dolls referred to in the title of the collection. The reaction of the audience and press was that it referred to slavery.

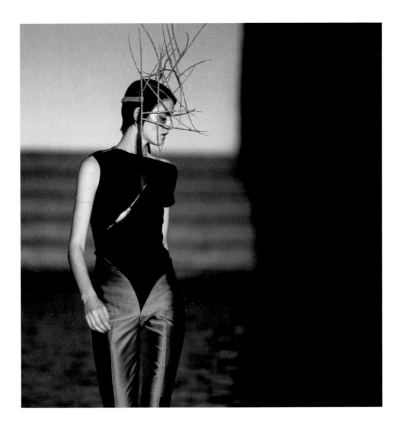

The models walked through water on this set designed by Simon Costin. Stella Tennant wears pink spiked headdress by Dai Rees, a zip-necked top reminiscent of the detailing used by John McKitterick in his "Manism 2" collection, on which McQueen worked in 1991, and asymmetrically cut, deep pink-and-black satin trousers.

organza dresses set above the knee, edged with fringing; black dresses fitted tight with zips à la Schiaparelli across the bust; and showpiece headdresses formed of twigs in shocking pink by milliner Dai Rees.

It was this independence of thought, this originality, that made Lee McQueen attractive to LVMH, the French luxury goods conglomerate. In 1995, Bernard Arnault, CEO of LVMH, began the search for a designer at Givenchy following the retirement of founder Hubert de Givenchy. He was looking for the energy and ideas inherent in British fashion at its best. Isabella Blow suggested McQueen

for the job, but he opted for John Galliano—"I chose English design-ers because, in France, we don't have the same level of creativity, we don't produce designers of that caliber … the modernity, the creativ-ity, the good taste."[35]

By 1996, there was a vacancy at Maison Dior as head designer. Arnault gave the job to Galliano but needed a replacement at Given-chy. Lee McQueen had talked about the Galliano appointment and couldn't understand why his fellow designer would choose to go to the seemingly antiquated Maison de Couture. "Why is he going to do this boring thing?" he asked John McKitterick. To him, Givenchy was exceedingly dull. So I explained to him it was the only way that Galliano could survive: fashion was going the way of the big brands and it would finance the fantasies for his own label. "He thought it was a sellout," recalls McKitterick. "But he was massively driven at the time, and he wanted to do his own work."

One autumn day in 1996, McQueen was at home with his boy-friend in Islington when he took a call from PR Trino Verkade, who told him that Daniel Piette from Louis Vuitton wanted to meet him and had asked if he would be interested in the role of head designer at Givenchy. McQueen took a moment to think about it, then said yes. Later, he changed his mind and said no, having discussed it with Smith and Pye.

"I told him not to do it—the place wouldn't suit him," says Smith. "He wouldn't be able to cope with the snobbery of Paris. He said 'Yeah!'—and then took the job in October." Bernard Arnault had persuaded him with the sweetener of a £1 million over a two-year deal. At twenty-seven, Lee McQueen became the second British designer to head up a French couture house in the twentieth century. He asked Katy England to work with him as creative adviser, but effectively left Isabella Blow in Britain with a degree of rancor—she had, after all, suggested him to Arnault and expected a cut but had not articulated this to either McQueen or LVMH. To McQueen, the possibilities of

SIMON COSTIN
JEWELRY AND SET DESIGNER
On "Bellmer la Poupée"

"Bellmer la Poupée" was the first time I designed a proper set for Lee. It was sponsored by Tanqueray Gin. We asked ourselves, "What can we do to challenge the audience?" Lee wanted the models walking through water, and I had wanted to use it for ages. My aim was to make the surface of the runway look like a sheet of glass. We built a frame of about 2 feet high and 150 feet long, like a giant shallow pool. To achieve the powerful reflection I wanted, the lining had to be black. It was about creating a reflection, but given the amount of water, we needed it to be held at a venue with a concrete floor so if there was leakage it wouldn't cause real damage.

a role at a major Paris couture house with experienced *petites mains* able to realize his every dream were enticing. "The thing to remember about Lee," says one friend of his, "is that he loved craftsmanship, he respected it. The first thing he did when he went to Givenchy was to welcome the *petites mains* into the salon [in which the collections are presented] from the ateliers—many of them had never been invited in before."

On October 22, 1996, Lee McQueen was named British Designer of the Year at the British Fashion Awards, held at the Royal Albert Hall. High up in the gods were Trino Verkade, Sam Gainsbury, Alice Smith and Cressida Pye. "We knew he'd won it beforehand, but we watched him down there, shuffling along in a big gray coat and sneakers, shyly showing his invitation to an usher to find his seat," recalls Smith. "He suffered from 'imposter syndrome'—very shy, very sweet, but not quite believing that he should be there. And he had won the most important award of all!"

Model in funnel-necked, pale pink brocade cheongsam. Devon Aoki was memorably photographed in a version of this by Nick Knight for *Visionaire* magazine's spring 1997 issue.

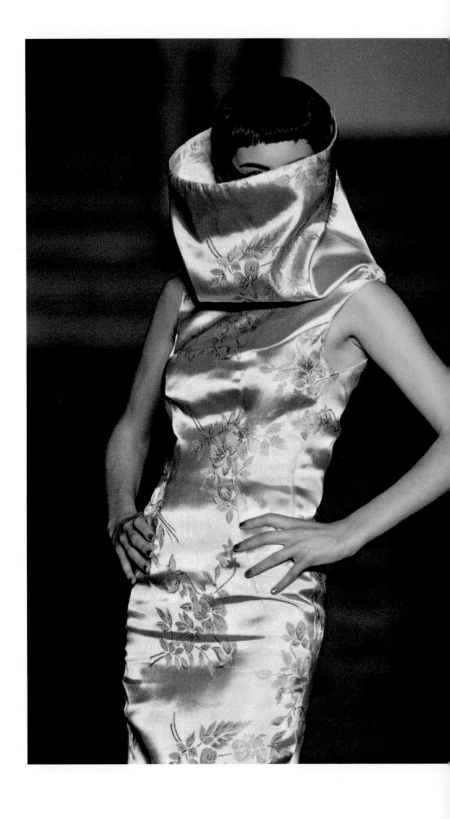

GIVENCHY

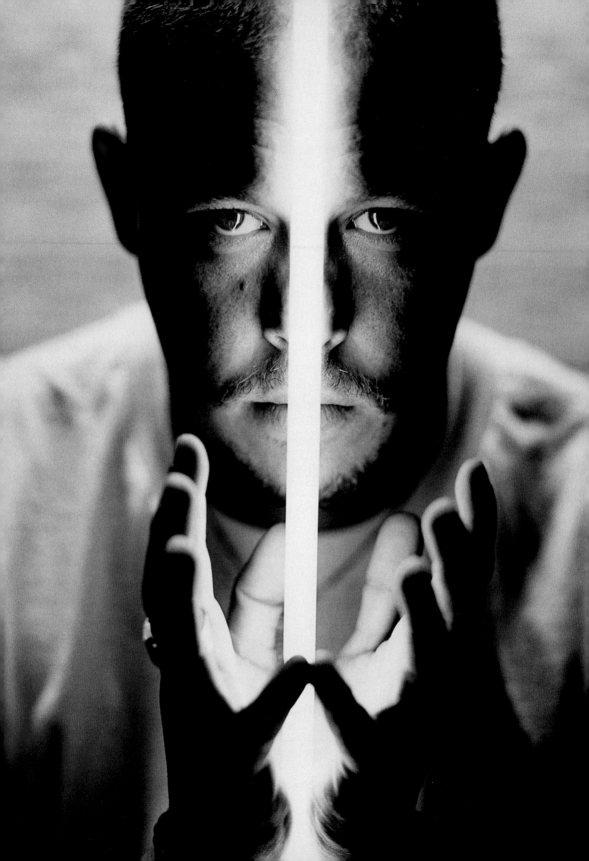

I t was Isabella Blow who persuaded her friend to accept the position of creative director at Givenchy. Much has been made of the fact that McQueen did not offer her either a position or a cut of his fee on signing the six-figure deal. The fact is, he wanted to work with the stylist Katy England, who is very practical and with whom he had a creative affinity. For him, Blow was a fantastic ambassador. Businesswise, though, it was down to LVMH to pay her a finder's fee. When McQueen didn't pay, this only served to compound Blow's sense of being "used," a complex that was to develop with perhaps some justification over the years. But for McQueen, the initial two-year contract, with a reputed fee of £1 million over two years, was truly life changing. It meant that he could finance his own line and position himself as a designer with international status. However, his instincts told him not to sell LVMH, who owned the Givenchy brand, a stake in McQueen. "When I first signed a contract

Portrait of Alexander McQueen. Photograph by Joseph Cultice, December 1999.

with Givenchy, I was also presented a contract whereby LVMH would buy my own company. I said no, and we went ahead, but for four and a half years, the man had been hounding me about buying McQueen," he admitted after signing with the Gucci Group in 2001. "I didn't like the way LVMH ran Givenchy, so I wasn't going to let them into my own company."[1]

In the fashion world, there had been huge excitement over who would be offered the post. Vivienne Westwood, Marc Jacobs, Jean Paul Gaultier, and Azzedine Alaïa had all been named as John Galliano's successor. On September 8, Antonio Berardi traveled to the Paris headquarters of LVMH, where he was interrogated by a psychologist who asked the designer why he had spray-painted the word *slag* across a tailored jacket [why not?] and how quickly he could produce a thirty-piece collection. That same evening, McQueen attended

Rifat Ozbek's show with Blow. The next night he was at Christian Lacroix as Blow stage-managed the hype around him. Surrounded by the French fashion glitterati, the "twenty-seven-year-old maverick of British fashion couldn't have looked more out of place," observed the *Independent*.[2] "I think it is ridiculous the way it is being handled," said McQueen, who was also preparing for his "Bellmer la Poupée" show. "They're telling designers not to talk, but you can't keep a secret in the fashion world. It's putting a lot of pressure on me that I don't need."[3]

The announcement that John Galliano was to join Dior as creative director and Alexander McQueen had been appointed for Givenchy haute couture and ready-to-wear was made on October 14, in a publicity coup that eclipsed much of the remaining French collections in the press. Like most young British designers, McQueen had not attended a Givenchy show. His knowledge of the venerable French label, founded in 1952, whose signature was cutting, genteel elegance and a notable lack of gimmicks, was based almost entirely on Givenchy's connection with Cristóbal Balenciaga and his dressing of actress Audrey Hepburn. While pundits searched for a link between the two designers at seemingly stylistic polar opposites, there was, however, a connection between McQueen and Comte Hubert de Givenchy (born 1927). Between 1947 and 1951, the latter worked for Schiaparelli, designing separates and coats for her boutique. Elsa Schiaparelli, that great iconoclast of French couture and exemplar of hard chic, had employed Savile Row's Anderson & Sheppard as cutters for her women's suits from 1935. The precise and figure-defining lines of her daywear had evolved while working with the same tailoring house that had later trained McQueen.

McQueen for Givenchy haute couture S/S 2000. Second Empire–style: giant moths printed on crinoline-style gown.

McQueen was not about to be intimidated by the Paris couture, though, as he told *W Magazine*: "They don't scare me, and I'll just tell them to [expletive deleted]. The British fashion industry is

the best in the world for turning out designers. Charles Worth was English, and he was the first person to do couture in Paris."[4]

Then sixty-eight, Comte Hubert de Givenchy had sold his company, founded in 1951, to Louis Vuitton in 1987, with the proviso that he would never design again. This, for the man who once claimed he wanted to die cutting a dress, was not without its compensations, but the idea of Galliano and McQueen following in his footsteps was risible. "I find it a total disaster and I suffer, but what can I do?" Givenchy said.[5] Though Blow was told that she could style Givenchy campaigns, this was not within McQueen's gift. The result was a lack of connection between mainstream marketing images with the hard-edged runway collections.[6] There was also the precedent that should have sent out warning signals: Galliano's two collections for Givenchy had produced so few orders, there was not enough work for the *petites mains* in the atelier at 3 Avenue George V.[7]

Givenchy Haute Couture

Spring/Summer 1997

"Structure and finesse is what couture is all about. I don't want to embroider everything in s-ight or play around with loads and loads of tulle."[8] —Alexander McQueen

Unable to speak French, McQueen managed to find an apartment where he and his British team—Katy England, art director Simon Costin and design assistant Catherine Brickhill—stayed, and where

he was provided with a chauffeur. With only eleven weeks to go before launching his first haute couture collection, McQueen had already planned Givenchy's ready-to-wear show for March. He was contracted to design four collections a year for Givenchy, on top of the two for his own label, with Gibo poised to set up licensing agreements under the Alexander McQueen name with his company, Birdswan, and two stores planned.

A cutting on file at Central Saint Martins from the *Independent on Sunday*'s Ideal Home column, November 3, 1996, with an anonymous note expressing disbelief in his new position at Givenchy.

For the couture show, McQueen combed the Givenchy archives and settled on the fashion house's characteristic clean lines as a reference, backed up by his own great technical abilities. His aim was, as he said, to "bring back that sophisticated wearability. They need more day suits and daywear for the couture and certainly for the ready-to-wear."

His precollection shown to Simon Ungless was, according to the latter, "very bad." Indeed, Ungless told his friend to start again. So, evolving from Givenchy's gold-and-white label, with its Grecian insignia, McQueen settled on a theme from Greek mythology, which was, in the circumstances, autobiographical: Jason and the Argonauts, focusing on the epic hero capturing the fleece of the golden ram on the island of Colchis against terrific odds. Like Jason, he had seized a golden trophy. In a statement to the *Guardian* that spoke volumes about the British and class, he said, "I am a working-class kid and stick to my roots. That's what gets me the press. [But] couture is beyond beyond. It is where the dreams of your life in fashion become a reality."[9]

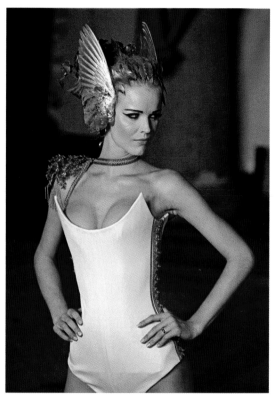

Above: Erickson Beamon's design for a headdress and winged-ear decoration, and the resulting final piece: gilded feather headdress with a boned corset as worn by model Eva Herzigova. **Opposite:** McQueen's first haute couture collection for Givenchy, January 19, 1997. McQueen was inspired by the myth of Jason and the Argonaut's quest for the Golden Fleece, so the color palette is mostly white and gold. The gilded horns are from one of the Blows' Soay rams at Hilles; the white suit exemplified the tailoring skills that LVMH wanted to bring to the esteemed French couture house.

Detmar Blow, husband of Issie, was instructed to select one of their horned rams at Hilles, their mansion near Stroud in Gloucestershire, for sacrifice. Its horns were painted gold and worn by Naomi Campbell. Maison Lesage embroidered gold bullion oak leaves (a symbol of the French Republic from the days of Bonaparte) onto corsets and floor-length coats; skilled fingers layered feathers onto a catsuit and dresses; rose petals were layered between white organza; molded bodices draped with silk sculpted like molten gold.

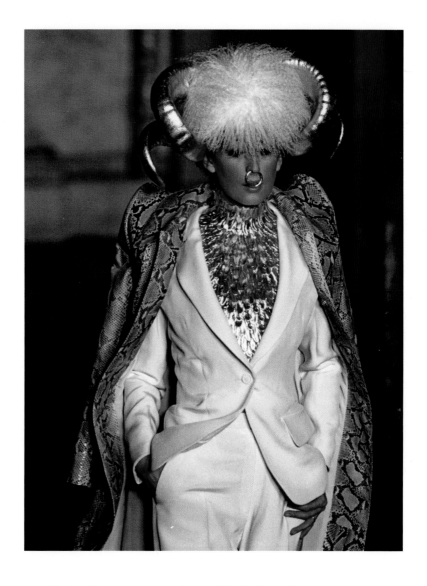

On January 19, McQueen presented the S/S 1997 collection of fifty-five pieces at the Ecole des Beaux-Arts, a neoclassical venue suited to the event. Model Marcus Schenkenberg, the epitome of blond beauty, was dusted in gold and wearing enormous wings, presided Icarus-like over the proceedings. Running an hour late, Azzedine Alaïa, American *Vogue*'s Anna Wintour and Hamish Bowles, photographer Peter Lindbergh and Issie Blow faced a row of couture clients, including Anne Bass and Mouna Al-Rashid. The

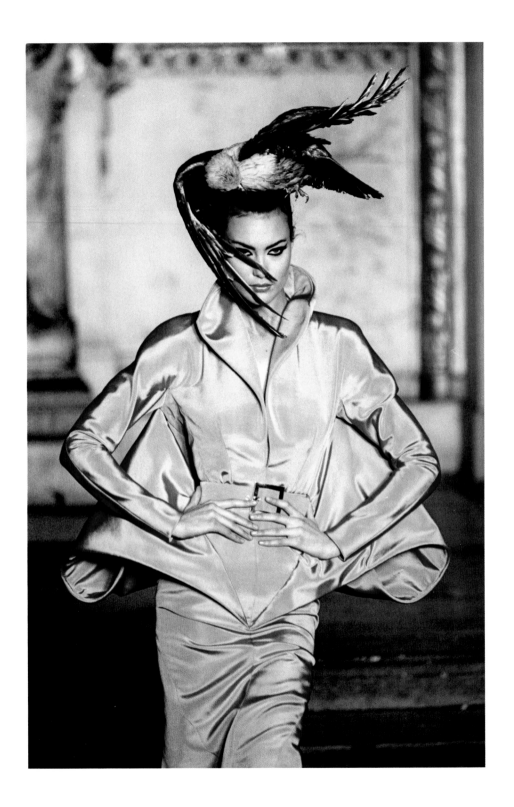

show began with the sound of thundering hooves as Jodie Kidd swept onto the runway in a white embroidered coat that was fluttering meters behind her. Its classical theme was obvious—gladiator corsets fitted over chiffon one-shouldered dresses—but the undercurrent of female menace, embodied by Jason's deadly lover, Medea, was also there. McQueen twisted this in paying homage to Greek diva Maria Callas in her role as the sorceress in Pasolini's *Medea* (1969), the model dressed in white brocade, cut with a sixteenth-century square neckline, her sleeves a pastiche of Givenchy's famous "Bettina" blouse. Naomi Campbell, part shape-shifter in golden ram's horns, presided over models dressed in feathers and snakeskin, wearing Minotaur nose-rings with hair coiffed into horns and towering lacquered plumes.

Teamed with this opulence were superbly cut jackets, cashmere coats and structured dresses that would improve the shape and posture of the wearer. At £20,000 a dress, it was, he recognized, for the chosen few. Yet according to the *New Yorker*, the ladies of couture were somewhat taken aback by the *newness* of what they were seeing. "Ooh la la!" whispered one French journalist. "If he continues with this styling, he will lose them." As the fashion pack mingled outside the Ecole des Beaux-Arts, some of them shared their views. "Disaster!" said one. However, Adrian Joffe, the CEO

Gold silk suit with eighteenth-century-style draped back; winged headdress by Philip Treacy.

of Comme des Garçons, thought it was beautiful. He and his wife, designer Rei Kawakubo, had already booked McQueen to model in their menswear show scheduled for the following Friday.[10]

No longer just a designer, Lee McQueen was now also a celebrity—the one thing he did not want to be. Worse still, he was working for a house whose style was not his own, and he couldn't tell the critics to get lost—"I would never even think of using white and gold for my own collection. It was purely out of respect for the house's logo."[11] He was responsible for promoting sales of beauty

and perfumes for Givenchy, with atelier staff who had given their all. For all intents and purposes, it was what LVMH wanted: an injection of life into a moribund label from a designer with a contemporary voice.[12] Or, as Amy Spindler suggested in the *New York Times Magazine*, Galliano and McQueen could eclipse the power of Karl Lagerfeld at LVMH's rival, Chanel.[13]

The next day, McQueen had four appointments with clients, among them a Saudi princess requesting a wedding dress and a female French journalist who asked whether he thought the "penis and bollocks should be restrained in fashion."[14] It is worth bearing in mind that the blueprint for cutting around the male crotch is to enhance the equipment and make it look bigger, not smaller. No wonder McQueen was for once rendered speechless! Meanwhile, the critics' response was lukewarm to hostile. "He likes to call his rivals 'pretentious,'" said the *Daily Mail* in its somewhat patronizingly titled piece "Couture of a Cabbie's Son." According to the newspaper, the designer's arrogance was "his own worst flaw, second only to his ignorance."[15]

Issie Blow defended her old friend in *Vogue*: "Alexander is dealing with an old albatross.

McQueen takes his bow at the end of his debut couture S/S 1997 show for Givenchy.

McQueen and Givenchy are like a love affair, and we've got to give them a chance."[16] After the show, McQueen quietly took tea with his mother and then went back to the peace and quiet of his apartment and his boyfriend, fashion producer Murray Arthur. He couldn't wait to get back to London because he missed his dog Minter, and his hometown was a source of inspiration. "I am working in France with my hands, while my legs are on the beat in London—this is where my life is," he said.

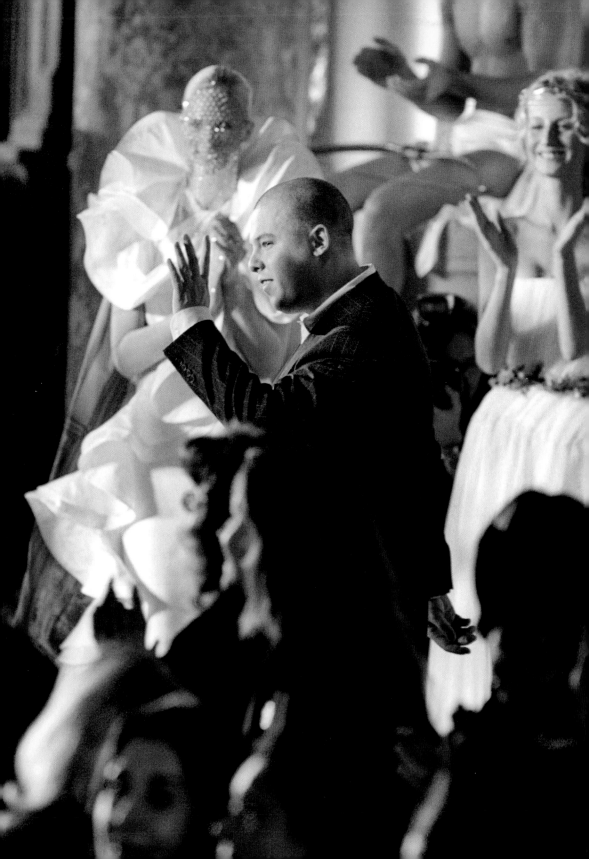

Animal Instincts

Now commuting between London and Paris, McQueen was following his Givenchy contract to the letter. His McQueen A/W 1997–98 collection was designed and in production, so he headed home to a new house in Islington and the head office in Amwell Street, EC1. On February 28, he presented "It's a Jungle Out There" at Borough Fruit Market—situated in the unsalubrious south bank of the Thames, the site of "stews" (brothels), bear pits and theaters in Falstaff's day. It was as far in spirit from the elegant Ecole des Beaux-Arts as McQueen and his team could find. The theme reflected the way he was feeling: torn between French couture and London's streets; 40-foot screens of corrugated iron riddled with "bullet holes" and two cars placed on either side of the doors poured out dry ice. Seated outside on hard benches amid the stench of drains, the audience was lit up by red lighting. Described by *Time Out* magazine as "part rave, part riot," models walked like urban warriors dressed in treated hides and bleached denim, black leather decorated with Chinese flowers; Prince of Wales check with pony skin.

Cheetah-print, floor-length coat with McQueen's distinctive shoulders and *Blade Runner*–style wig for Givenchy ready-to-wear, A/W 1997–98. The idea of Givenchy being inspired by prostitutes was not received well; McQueen saw it as bringing the house up to date.

Wearing silver finger extensions, the models' hair was backcombed and tousled, eyes kohled up at the outer edges like the punk Jordan, star of Derek Jarman's *Jubilee* (1978). What made this makeup unique, though, was that the eyes themselves were blackened with contact lenses, the black eyeliner extended down at the inner corners to imitate the eye markings of the Thomson's gazelle, a beautiful creature that rates low on nature's food chain.

It was the flip side of McQueen's elegant allusions to woman as half-beast at Givenchy. This time, the docile gazelle was empowered by women with attitude. "That's how I see human life. You know,

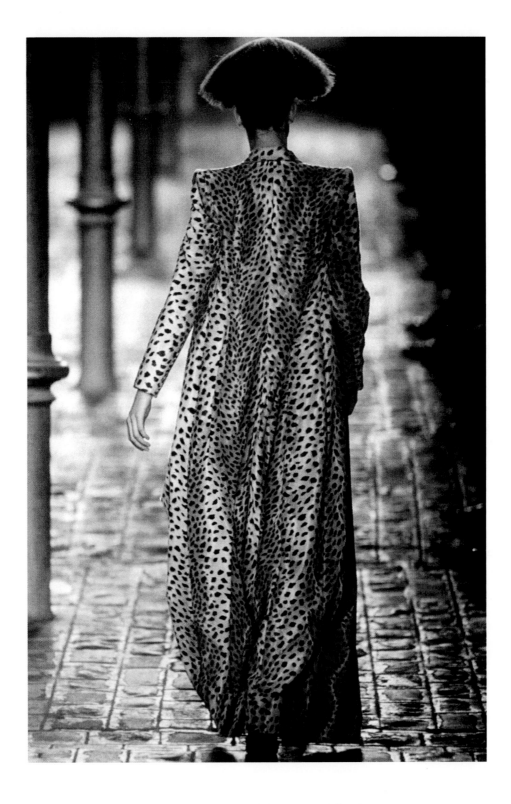

SIMON COSTIN
JEWELRY AND SET DESIGNER
On Setting the Scene

"It's a Jungle Out There" was the first and only time that the show had been bigger than the sum of its parts, the germ of an idea spreading out into the immediate environment and chaos ensued.

There was gatecrashing, the photographers cut slits into the curtains around the changing rooms and got in; the security guards beat them up. The implicit violence was palpable. His theme—about the lowest creature in the food chain—was specific. Lee and I loved the film *The Eyes of Laura Mars* (1978) and chose to imitate the fashion shoot with the car pileup [and models fighting in fur coats—the survival of the fittest]. I scoured salvage yards looking for Mercs used in the famous fashion shoot scene in New York. We got five of them, smashing the windows. We wanted the atmosphere to be edgy, for people to be unnerved. The last scene of *Bonnie and Clyde* (1967), with the big shootout and the barn doors riddled with bullets, letting light through—we wanted that effect with the sheets of corrugated iron. Simon Chaudior placed ten thousand lights behind them. Most of the money from Amex went on security, because the site was in the open Borough Market, screened only by black curtains, so guards had to be in attendance for the days we were setting up. The runway was edged by front seats, and for lighting we placed catering-size baked bean cans along the edges; just before the show began we lit the firelights and wood inside them. At the last minute (in the bunfight outside) a group of Central Saint Martins students stormed the barricade and ran along the runway to find a place to stand; one of them kicked a lit can toward the pile of cars. I nearly had an embolism watching an impending inferno. Fortunately, a security guard caught it just in time. Everyone thought it was part of the show and started applauding. The air of angst and tension in the air was tangible.

Opposite: The installation of cars for the McQueen A/W 1997–98 collection, "It's a Jungle Out There," was based on the crash scene in the film *The Eyes of Laura Mars* (1978), the corrugated iron riddled with imitation bullet holes. The set designer was Simon Costin.

we can all be discarded quite easily," he said at the time. With hindsight, he was more specific: "Animal instincts in the natural world contrast with hard animal aggression in the urban jungle—leather dresses with traditional fabrics. The show was mad, total mayhem, dangerous. I had just finished doing my first show for Givenchy and was under a lot of pressure. This show reflected my state of mind; it really was a jungle out there."[17] Indeed, it marked an ideological alignment found only in London and was influenced by the theatrical spectacles epitomized by *Les Misérables*. The young London fashion mob wanted bread and circuses; it was eager for entertainment.

McQueen was praised for being a "showstopper," though not for his designs. The mainstream fashion press might criticize—"his designs seemed to lack the finish for which he has become renowned"—but the young designers like McQueen, Hussein Chalayan and Antonio Berardi understood, as did their predecessors Antony Price, Bodymap and Vivienne Westwood in the 1980s, that a show could make a cultural statement. As the millennium and the upcoming general election, which was to end eighteen years of conservative rule, approached, "who wants clothes that are poor copies of thoughts of couturiers that have been dead for forty years?"[18]

McQueen's ready-to-wear for Givenchy A/W 1997–98 was a further divergence from the original restraint of the house. Staged at the disused Halles aux Chevaux (horsemeat market), with an audience of twelve hundred, the one-hundred-piece collection opened with Sparks's cult hit, "This Town Ain't Big Enough for Both of Us"—a favorite of Andrew Groves, who played it repeatedly when he and McQueen were together. "There couldn't have been a clearer message sent to Galliano, could there?" Groves chuckles. Models, including the actress Beatrice Dalle were dressed in black PVC and lolled against street lamps similarly to Brassaï's streetwalkers in *Blade Runner*-style wigs and towering heels. It was futuristic and touched on McQueen's favored theme of prostitution. "I want to take Given-

chy on to a new platform; it is the sexual energy that is important," the designer told the *Sunday Telegraph*.[19]

Enhanced crescent-moon shoulders redefined the silhouette; sharp lapels were repeated as before on long military-style coats in glitter stripes. Thigh-high-split pencil skirts, long leather coats (and one in baby-pink snakeskin) and a fake cheetah print jacket were loosely inspired by Marilyn Monroe.

"We've had it with minimalism. McQueen is trying to push fashion in another direction now, and in order to do that you have to be extreme," observed Hilary Alexander in the *Daily Telegraph*.[20] However, fashion writer and editor Sally Brampton saw something else—a collection that lacked soul, "dangerously polite," which erred on the wrong side of commerce and came from his head, not his heart.[21] That you cannot please all of the people all of the time was evident, and McQueen expressed this view somewhat floridly in an interview for *Newsweek* magazine: "It's like Hitler's Holocaust. He destroyed millions of people because he didn't understand. That's what a lot of people have done to me because they don't understand what I do."[22]

So, what was it that made McQueen so fascinated with skin, bones and hair? "It was a respect for things with beauty," says Simon Ungless. "He was honoring that beauty, the idea of a collector obsessed with it. And he was always out to make people feel that, and challenging their idea of what beauty is."[23] Invariably, this was combined with something historical—an excuse for the designer to look beneath the veneer of glamour that is often painted over nasty realities, stripping "romance to the truth."[24] McQueen decided to investigate this further for his next collection for Givenchy haute couture, known as "Eclect Dissect."

Eclect Dissect

Autumn/Winter 1997

"Beauty can come from the strangest of places, even the most disgusting of places." —Alexander McQueen

The Givenchy couture A/W 1997–98 collection was staged at the Université René Descartes medical school on July 7, 1997. McQueen and art director Simon Costin decided on a theme of eclectic dissection, which brought together costume and fauna tinged with the fin de siècle gothic of H. G. Wells's 1896 novel of animal-human hybrids, *The Island of Dr. Moreau*, which became a catalyst for the antivivisection movement. Costin, who worked with memento mori themes, had created a story that subliminally marked similar anxieties as another century ended and a new millennium approached. He brought together McQueen's research into late-nineteenth-century dress with the sixteenth-century anatomical drawings of Andreas Vesalius.

The inspiration was a dark tale of a doctor who collected women, killed them and created hybrid creatures, formulated by Simon Costin with McQueen. Unbeknownst to them, it chimed almost exactly with H. G. Wells's *The Island of Doctor Moreau*, which explores the same horror. Model wears horn-effect hair pads decorated with crystal, Burmese Kayan neckpiece and shawl-collared jacket with lace sleeves.

"Dressing" the drawings of skeletons and apparently sexless, flayed bodies in corsets and skirts led to a fantastical tale of a surgeon in the 1890s, who traveled the world, collecting women, costumes, textiles and animals. The women were killed and dissected (shades of "Jack the Ripper Stalks His Victims" and "Bellmer la Poupée"), then reassembled in his laboratory—manmade hybrids, both erotic and unique, dressed in exotic and fashionable costumes.

"Eclect Dissect" was about the women, who returned to life, stalking the Givenchy runway as a series of spectral "cut-ups" to haunt their killer. It was set against bloodred curtains, the floors

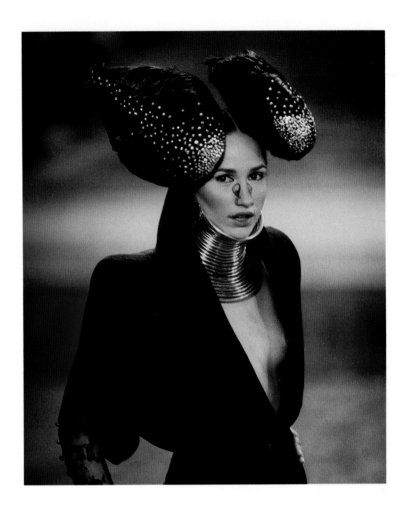

covered in Oriental rugs and tiger skins; decorated with medical specimens. Softly lit and pregnant with Edgar Allan Poe–style gloom, homage was paid to the romantic-era poet's *The Raven*:

And the silken sad uncertain rustling of each purple curtain
Thrilled me–filled me with fantastic terrors never felt before...
Ghastly grim and ancient raven wandering from the nightly shore.

At either end of the runway were huge cages containing marvelous live ravens, mythological symbols of impending death. McQueen's cinematic sense of the spectacular, for the first time given

rein, allied him with cult director Tim Burton (whose first film, *The Island of Dr. Agor* in 1971, was based on *The Island of Dr. Moreau*) and presented his audience with questions about how fashion can create new notions of beauty and man's interference with nature.

Rumor had it that human body parts would feature in the narrative (Bernard Arnault said this was a story started off by LVMH's competitors, though it smacks of McQueen), but anyone disappointed by the fact that they were not there would soon have been overwhelmed by the sound of a bird screeching loudly and played at full volume as the fifty-piece show began. Interestingly, Givenchy used real fur—denied by a spokesperson, but the reality—when it was incredibly contentious, showing a golden fox box jacket and silver fox wrap, the "mask" of the fox perched low over the model's forehead. Further allusions to beast-women hybrids were made with a porcupine-quill hat and a knee-length horsehair coat. Not only had the fiendish medic traveled to West Africa but he had also "collected" in Japan and China. As if the "doctor" had given his creations pet names, McQueen also had monikers for his looks. Honor Fraser, the face of Givenchy, wore "Peregrine Lovat," a Chinese-silk dragon robe decorated with ermine tails, and carried a hooded falcon on her hand while boasting a blond traditional Korean-style wig. There was also "Lady Blow," a knee-length black crinoline, and "Black Narcissus," after Powell and Pressburger's eponymous film of 1947, a suitable febrile look with bustle and feathers. A kimono, updated and worn with a leather obi drawn tight over a corseted bodice, made refer-

The literal eclecticism of the collection allowed McQueen full rein to explore his interest in anthropology and history: fringed Chinese-style jacket and raccoon-tail muff.

SIMON COSTIN

JEWELRY AND SET DESIGNER

On Inspiration: McQueen and *The Cabinet of Dr. Caligari*

The set was influenced by *The Cabinet of Dr. Caligari* (1920), with threads of the romantic gothic of Mary Shelley's *Frankenstein*.

A wealthy collector and anatomist puts girls he collects into a trance and cuts them up. The extra body parts are fed to ravens and crows.

Above the show was a room, which staged the museum's collection of anatomical abnormalities; sadly Lee was too busy to go and have a look. Lee's part was the cutting and splicing together of tribal women. This was very much part of the punk aesthetic—cut it up and start again.

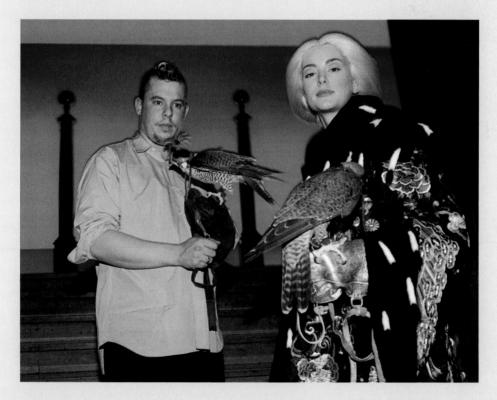

Honor Fraser wore "Peregrine Lovat," a Chinese-silk dragon robe decorated with ermine tails, carrying a hooded falcon.

ence to McQueen's time working on *Miss Saigon*. One model wore a pleated bodice, which extended to cover her face; her headdress was a small black birdcage containing a live bird. But every item of hair styling, wigs and headdress was key to the story: they were simply incredibly dramatic. Tailored tartan all-in-ones, an Asian model in a crinoline covered in luscious roses, waists corseted, jet beading on black lace and 1890s beaded choker collars were featured.

The atelier staff had apparently quaked at the task being set. "When I sent the designs to the atelier staff, they freaked out and said it was too complicated. I said, 'This is couture, darling. You've got to be able to do it.'"[25] The *Guardian* said it was "McQueen at his brilliant, anarchic best,"[26] but Suzy Menkes of the *International Herald Tribune* was more critical: "What exactly is the British designer doing, letting rip his obsessions in haute couture? Its fundamental point is to make women look wonderful, not weird. Needless to say, the only territory he did not visit was the future."[27] As Issie Blow once admiringly told the doyenne of fashion journalism, "Suzy, you don't lick arse!" No one had spotted that it was the centenary (bar one year) of H. G. Wells's comment on a dystopian future. It was a clever "hook," though not superficial—McQueen and Costin were commenting not only on the past but also positing on the future. Of course, just how many members of the audience had undergone the intervention of plastic surgery or Botox cannot be determined, but given its prevalence during the latter part of the twenty-first century, McQueen was pretty spot-on about the desire to achieve "perfection." This show had to be set against changing ideals: the icon of beauty was now Kate Moss from Croydon, stained and nubile in the work of photographer Corinne Day, not the Amazonian supermodels of the late 1980s and early '90s. Jake and Dino Chapman's *Zygotic Acceleration, Biogenetic, De-sublimated Libidinal Model* (1995) was shown at the "Sensation" exhibition, which opened three months later at the Royal Academy in London. "Should the Royal Academy present

art even if it shocks and causes offense?" posed the press release. McQueen collected works by the Chapman brothers and *Zygotic Acceleration*, with its take on genetic engineering and pornography, touched on some of the same themes as "Eclect Dissect." Lee McQueen was never a slave to the past, though. Deeply personal it might be, but his work always spoke to the present. It was, said the so-called Damien Hirst of fashion, time for Givenchy to "*move on.*"[28]

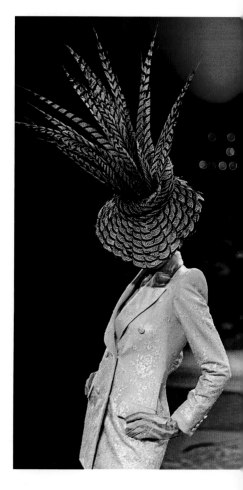

Pheasant feather hat by Philip Treacy.

American *Vogue* published its feature, "McCabre McQueen," based on an interview with Alexander McQueen on the set of his first Givenchy advertising campaign (shot by Richard Avedon) and viewing of the "Eclect Dissect" Givenchy show in July 1997.[29] It pinpointed the generation of hype around each forthcoming show at that time but failed to state this was now a machine that did not require an operator. A *Sunday Times* article, "McQueen Chills the Blood of the Fashion World," had inaccurately suggested the designer was using human body parts—it was the museum that housed them—and wrongly ascribed his inspiration to Dr. John Dee, the Elizabethan scientist and necromancer.

The sittings editor for the story was Isabella Blow and she was working with photographer Sean Ellis. When they last worked together, they had achieved *the* most expensive shoot—and one of the finest—for British *Vogue*. The story alluded to a Jekyll and Hyde split personality as Givenchy public relations desperately tried to control McQueen's reaction to the *Sunday Times*'s editorial. His distrust of the press was palpable. In what can only be described as a gesture, he had wrapped his face

in plastic wrap, S&M-style, and grinned broadly for his Ellis portrait. *Vogue*'s Katherine Betts wrote that watching a McQueen show was like driving past a car crash and looking although you don't want to; thus the account of fashion doyenne Suzy Menkes closely inspecting two ravens (four more on their way, courtesy of the animal handler) in her sneak preview of the set for "Eclect Dissect." Disingenuously, McQueen told Betts that they would all be set free after the show.

Indeed, McQueen told Betts post-show that he didn't see his work as "macabre" but more sexual and sensual. It was about the "passionate" side of fashion, the shows engendering an emotional response from the audience. The article described art director Simon Costin's lush set as "dreary" and quoted Menkes on couture, not wanting "weird." More interestingly, when McQueen was questioned about the model in a boudoir-red chador, seamed into a 1770s-style bodice and finished with Marie Antoinette–style mules and suggested misogyny, he pointed out that he had got the idea from *National Geographic*. Apparently, the look was all about disguise, the consumption of Western fashion by rich Islamic women; the modern sensuality concealed by traditional dress.

McQueen's motivation was not to dress women to look frail and vulnerable but to empower them. Yet he was the one that was also vulnerable to a fashion press dominated by women justified in desiring an honest explanation for their readership and, inevitably, to the market he was attempting to secure. His carefree statement of pre-Paris 1996—"At the end of the day, fashion is a windup. Don't take it too seriously"[30]—no longer applied. One can imagine his reaction when he read "McCabre McQueen," in which he was likened to Dr. Jekyll and Mr. Hyde, shortly before his next London show. It may explain his reason for wanting to symbolically urinate on the runway from a great height for his next McQueen show ("Untitled," S/S 1998, see page 142)—Dr. Jekyll driven to Hyde-like behavior.

The Great Divide

Given that McQueen invariably tapped into some element of his own life through his work, it would have been worthwhile for someone to research Hubert de Givenchy and make the link, however tenuous, between the two designers. Gentle, subtle and elegant Audrey Hepburn, endlessly cited as the Givenchy woman, was not in any shape or form McQueen's type, and try as he might, he could not make the visceral connection with her that he needed to. In contrast, boyish Bettina Graziani was his own muse, no shrinking violet she. One of Givenchy's first couture clients was Marlene Dietrich (also dressed by Schiaparelli and Anderson & Sheppard). Ballsy and androgynous, she had just the "look, but don't touch" persona that informed McQueen's attitude to dressing women. Moreover, the young Givenchy also faced criticism from the press when he presented his first couture collection in 1952, age twenty-four. "The couture models were so poorly cut and made that, even when the germ of talent was obvious," wrote American *Vogue* editor Bettina Ballard in her memoir, *In My Fashion*, "it was hard to judge them as couture. It was a full year before the fashion magazines did more than give Hubert de Givenchy lots of advice and compliments on his ideas. This shy but arrogant young man knew all along that he was a powerhouse of talent."[31]

Red pressed leather sculpted bodice trimmed with white leather, from the Givenchy ready-to-wear A/W 1999–2000 collection. Molded on a woman's body, the finish was intended to look like the patina on a cyborg's "skin." The collection was an homage to Stanley Kubrick's film *2001: A Space Odyssey* (1968).

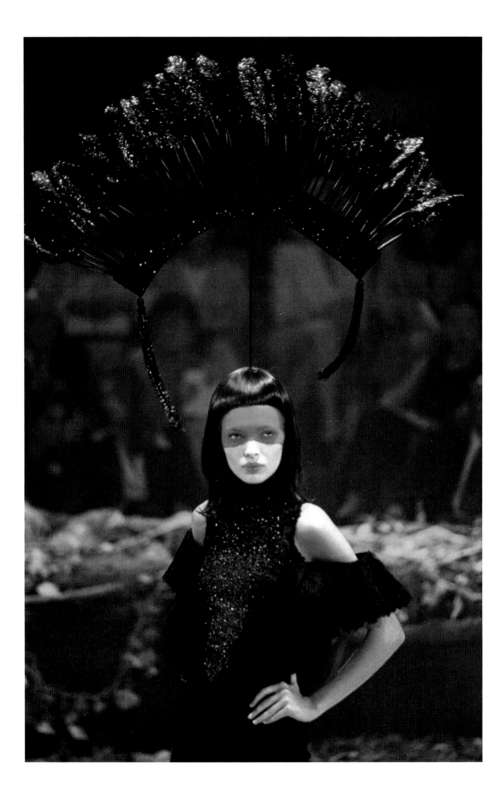

Givenchy, who had been taught the art of couture post his 1952 launch by Balenciaga, leveled the same criticism toward McQueen: "It is necessary for each garment to be absolutely impeccable. The hidden bits inside have to be every bit as perfect as the externals. And making dresses which are unsellable or at least unwearable, what good is that? It is the road to destruction. To want to make things which are simply fantasy is disastrous because it is not a representative of good taste in France."[32] There was the rub: the clash between innovation and originality, with the crushing notion of Gallic good taste, the great divide between Paris and London, which McQueen was simply inherently unable to bridge—never mind the fact that the finish under McQueen, Savile Row trained, a lover of craftsmanship, was immaculate.

While the McQueen line went from strength to strength (he was named Designer of the Year by the British Fashion Council for a second time in 1997), his work at Givenchy failed to please buyers. The response to his ready-to-wear line from Ester Scaglierini, owner of the eponymous boutique in the southern Italian town of Lecce, was typical: "I think the collection should be a little more classic, a little more sober. The Givenchy name is so high-end, so elite, it doesn't need to be turned upside down. As far as my clients [are concerned], they are choosing the styles that aren't too out there, too fashion-forward. This is the direction that Givenchy needs to go in."[33] And the traditional Givenchy clientele? Socialite Ivana Trump likened the house to Coca-Cola, which discontinued the "New Coke" moniker and then went back to the old one when the decision proved unpopular. "Quite frankly," she told *WWD*, "if I were in charge of Givenchy, I would seek out a designer who feels that the soul of Givenchy lives in him."

In a forerunner to "Irere," McQueen looked at the indigenous cultures of South America for Givenchy haute couture A/W 1998–99. It was not traditional Givenchy.

For Givenchy's executives, there was no coherent signature as McQueen floundered, perhaps from a lack of direction, with themes

ranging from cowgirls to space aliens, basketball and, in 2000, punks. His ready-to-wear for A/W 1998–99 was in homage to the 1982 movie *Blade Runner*, with the models styled as the iconic android Rachael,

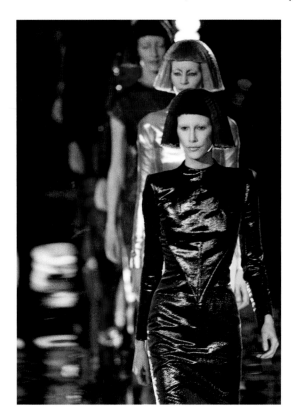

played by Sean Young. The idea came about after a holiday with Simon Ungless in San Francisco. "He'd taken the 'Ding Dong,' the F train, over and over again—a trolly [tram] all shiny red and chrome," recalls Ungless. "He thought it was very *Blade Runner*, and that's where the initial idea came from. And a lot of gay men are addicted to 1940s fashion, the inspiration for costume designer Charles Knode's wardrobe for Rachael."[34] Indeed, this particular femme fatale was also one of his friend Trixie's drag style. None of which connected with the one generic point of Givenchy reference: Audrey Hepburn in *Breakfast at Tiffany's* (1961).

Opposite and above: Inspired by *2001: A Space Odyssey*, the Givenchy A/W 1999–2000 ready-to-wear collection featured LED, a neon creature from the future and models as cyborgs.

The straw that finally broke the camel's back, though, was the Givenchy chauffeur, who ferried McQueen around for five years but never once spoke to him. "For Lee, who came from a family of cabbies and loved the banter, it was the most painful thing," believes Alice Smith. "He just couldn't understand it." In 2001, he therefore brokered a deal with LVMH's archrival, the Gucci Group. Revenge is a dish best served cold.

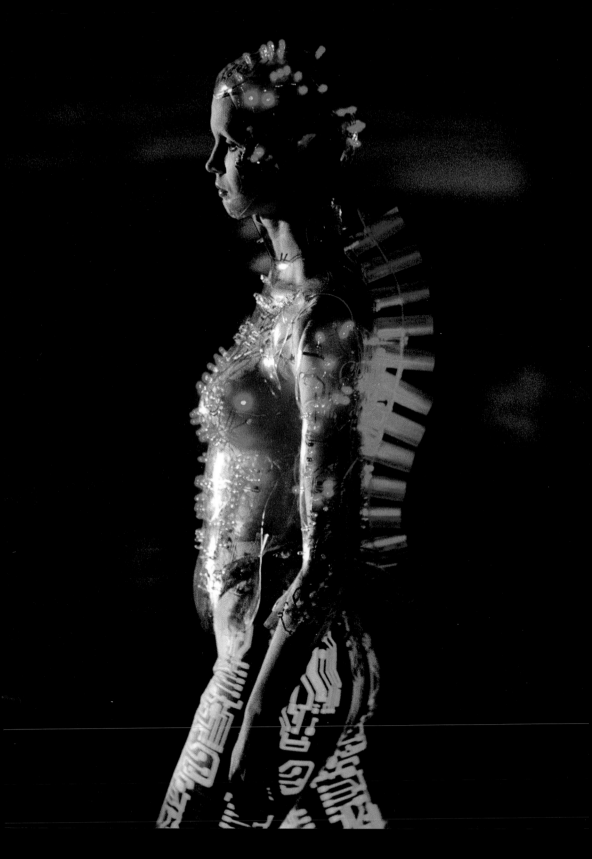

THE LONDON
COLLECTIONS

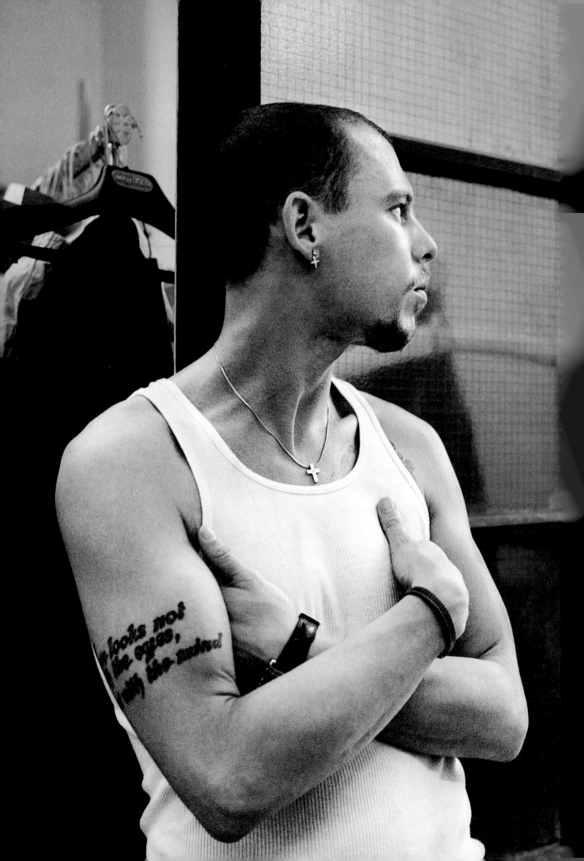

M cQueen won his second award **137**
from the British Fashion Council as co–Designer of the Year in October 1997, shared with John Galliano. He had helped to make London once again a fashion destination for industry press and buyers alike, and together, the two designers were spearheading British design talent in Paris. That autumn, he had launched his first menswear range and following this, his old friend John McKitterick had approached him to design a "Billy Doll" outfit, along with seventy designers, including Versace, Calvin Klein, Christian Lacroix and Jean Paul Gaultier for a charity auction on behalf of the AIDS charity Lifebeat at the New Museum of Contemporary Art in New York on June 2, 1998. "He gave his doll the same Thai tattoo as he had—a blue koi carp on his right breast," recalls McKitterick.[1] Over $425,000 was raised at the auction. Ever subversive, "Lee was into body decoration before it was popular," says his friend, Alex Hanson. "He loved the tribal connotations, wearing wide black studs in his ears and rings on thumbs."[2]

Portrait of Alexander McQueen by Steve Pyke. The tattoo on his right upper arm is from Helena's soliloquy on love in Shakespeare's *A Midsummer Night's Dream*: "Love looks not with the eye but with the mind."

Simon Ungless explains the complexity of his friend's self-generated references and ideas, so often ascribed to the patrician Blow but engendered by McQueen's extraordinary mother. "He had that working-class reverence for history and knowledge, which was in

conflict with his working-class antiestablishment attitude—it made him a real dichotomy. He read absolutely everything, always had a view on things happening worldwide and had a huge wealth of history that he would draw on. His ideas were not about fluffy colors."[3]

Between 1993 and 1997, London Fashion Week had grown from sixteen shows and fifty exhibitors to fifty-four fashion runway presentations and more than 150 static exhibitors. Colin McDowell of the *Sunday Times Style* likened it to a kindergarten nativity play, where every child got his moment in the spotlight, regardless of talent. Quite rightly, he was alarmed to hear inexperienced newcomers hyped as "the new 'Alexander McQueen' when we have not even got an old Alexander McQueen yet."[4] It was a UK business estimated at £600 million, with £264 million worth of export. Other designers showing that season, and in the process making London a center for experimentation, were Andrew Groves, Tristan Webber and Hussein Chalayan. McQueen, however—presenting his ninth show under his own label—had the edge when it came to experience and ideas. "The collection is about precision," he announced before it began, a look he had patently mastered.[5]

Above: Billy Doll, wearing skin-head-style waistcoat and jeans by McQueen, the designer's koi tattoo on his chest. **Opposite:** Katy England, photograph by Zanna, 2000, one hand suggestively at her crotch, the other gloved, in bias-cut tartan one-shouldered dress by McQueen.

Untitled

Spring/Summer 1998

"I like to think of myself as a plastic surgeon with a knife." —Alexander McQueen

On September 28, 1997, McQueen held his S/S 1998 presentation, again sponsored by Amex to the tune of £30,000.[6] He had visualized another water-based display, this time with sprays of golden water—hence his desire to call it "The Golden Shower"—a none-too-subtle allusion to *urolagnia* in S&M sex (urinating on the body or in the mouth of a sexual partner). As far as the sponsors were concerned, this was a no-go, and so he compromised by retitling the show "Untitled." Thanking American Express Gold Card, McQueen sensibly stated, "British designers need sponsorship support to ensure London remains the creative powerhouse of world fashion."

"Untitled" was held at a bus depot in London's Victoria in front of an audience of two thousand. The venue was on the opposite side of the Thames from Borough Market; this was close to upmarket Sloane Square and the designer boutiques on Sloane Street. Nevertheless, the setting was stark and industrial, a foil to the eerily lit drama of the fifty-foot-long runway—a Perspex tank, half-filled with water and illuminated by ultraviolet light, with materials and technicians provided by ICI to build McQueen's biggest set to date. A crack of thunder and a lightning crash signaled the start, and, like 1960s ingénues, models in fringed long wigs and false eyelashes walked in sets of four to relieve the pressure on the flooring. "It's a Jungle Out There" was based on the survival of the fittest on the plains of Africa; this collection also concerned nature red in tooth and claw, but the element was water and the emergence of amphibious creatures from primeval mud onto land.

Jewelry designer Shaun Leane's spine corset with curled tail hinted at evolution, and reptiles were represented by a body-con python dress, its skins set in spiral bias winding closely about the body as if to cut off the model's lifeblood. Pieces like Leane's aluminum jawbone mouthpiece, worn by a male model (McQueen had studied remedial plastic surgery on soldiers during World War I and II) were fitted with surgical precision. This was a signature look and continued with sheer white chiffon draped over molded bodices, skimming the thighs with transparent froth or jet and bronze beading. Equally short was a tailored jacket that had morphed into a dress, the lapels cut into a cowl neckline, and silhouette-defining trousers.

Model du jour Stella Tennant revealed her breasts in a suede bodice sliced into strips—hardly radical, but it earned the opprobrium of the *Evening Standard* as more of McQueen's "boring degradation of women." Strangely enough, the *Standard*'s three pictures were all breast shots

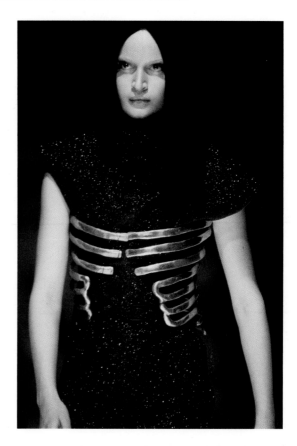

Above: Shaun Leane's "Spine" corset in aluminium and black leather worn over a sleeveless black belted suit flecked with silver. **Previous spread:** McQueen zip dress, left, S/S 1998; right, spiral zip dress, Antony Price. Styled by Alister Mackie, photograph by Zanna, April 1998.

for the delectation of readers.[7] Male models, harking back to Mr. Pearl's appearance in "The Birds" show, wore corsets and skirts, as the designer raised the question not only of the evolution of men's

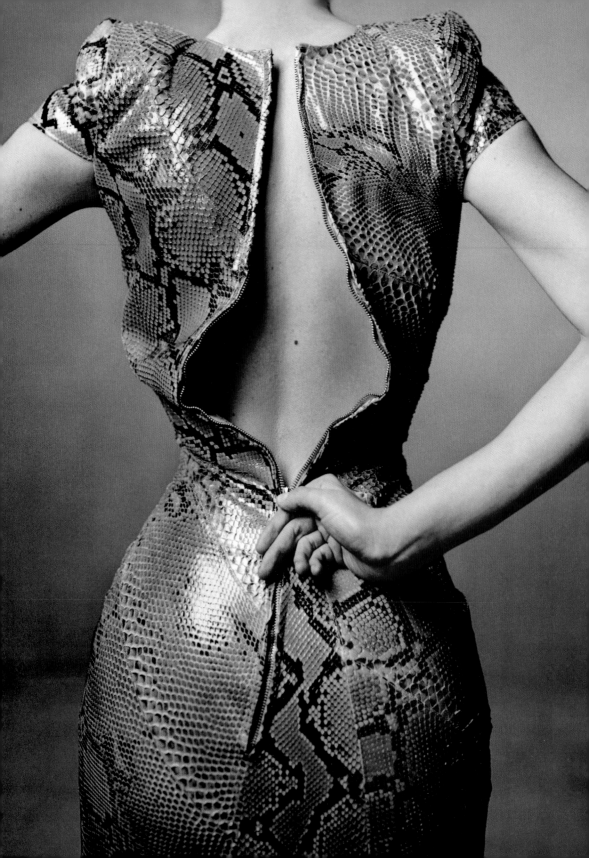

fashion but also of gender, too. Sharp silver-plated runway jewelry by Sarah Harmanee spoke of a fusion of bones and blades. "I Can't Stand the Rain" by Ann Peebles blasted out until, halfway through, the thunder rolled again, black ink swirled into the tank and golden rain poured from the roof. Then the models, makeup streaking down their faces, walked out in white; Kate Moss in white muslin, the train pulling through pools of water and the clothes becoming increasingly transparent.

The last time London had been presented with a vision of soaked white muslin dresses was John Galliano's S/S 1986 "Forgotten Innocents" show, but, as McQueen said, "John was all about pure romance, while my feet are firmly rooted on the ground and my clothes are more in-your-face."[8] Meanwhile, Isabella Blow defined the collection as being as "chic and simple as it was beautiful."[9]

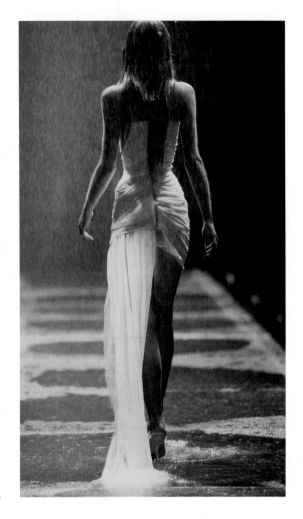

Above: Called "The Golden Shower" before sponsors American Express allegedly threatened to pull out, Kate Moss walks down the runway, flooded with black ink, to the sound track of Jaws (1975), rained on by jets of golden water. She wears a white chiffon corset dress with train. The set was designed by Simon Costin. It was the last time he and McQueen collaborated. **Opposite:** The theme included transformation in nature as well as transgression. Hence woman as predator in clinging python-skin spiral dress.

SAM COSTIN
JEWELLERY AND SET DESIGNER
On Working with Lee

"Untitled" was the first time that I did a show when I had my own "moment," because Lee by this time was so incredibly busy. His instructions were—"I want the catwalk to turn yin and yang—it's all about yin and yang, Simon"—so it had to start off white and halfway through turn black. At that point he suggested, "Let's piss on them"—he wanted symbolic golden rain on the models in the second half. Katy England did the test run at the rehearsal. There was not one specific theme in the collection that gave me direction, and in the end, the runway became a piece of sculpture. This we did from using sixteen of the largest plexiglass sheets available at 1.5 inches thick. ICI gave us the plexiglass and Hamar Acrylic made it up, laying it on a scaffold rig. Simon Chaudoir [director of photography] laid two hundred tubes of fluorescent lighting underneath, which ran off a flicker switch. As the second half began, black ink was let into the tank. "We've gotta have *Jaws*, Simon," said Lee, who loved the Spielberg movie, so John Williams's predatory two-note introduction to the score from *Jaws* (1975) played over the PA, the thunder rolled and the models walked in white on a black catwalk with water pouring down on them. To get the rain effect, we had to set up a sprinkler system above, which released heated, colored water. For me it became installation art.

Lee was happy for everybody in the "family" to be recognized, but when Givenchy happened, everything was "upped," everything shifted. He began to believe his own press; for the first time, really, he began reading it all and being bothered by it. It all started to change, became a different beast and it didn't feel as happy. Because of the shows. Personally, for me, they became onerous because of the shift of world attention onto him. We couldn't go out anymore without being followed by photographers. Originally, Lee had liked the fact that I had exhibited my work with Joel-Peter Witkin, but when McQueen became a brand, you couldn't be seen as having a life outside it.

Joan

Autumn/Winter 1998–1999

"I don't really get inspired [by specific women]....It's more in the minds of women in the past, like Catherine the Great or Marie Antoinette. People who were doomed. Joan of Arc or Colette. Iconic women."
—Alexander McQueen

Following the urban minimalism of "Untitled," "Joan," shown on February 25, 1998, was a surprise. Like other designers, McQueen had referenced history before, but no one in fashion had gone back to this strange corner of the early fifteenth century and the story of Joan of Arc, burned at the stake in 1431. It demonstrated an informed mind and one that could draw on something at once obscure and universally painful. "I'm about what goes through people's minds, the stuff that people don't want to admit or face up to," he had told *Time Out* the previous September in a far more empathetic article than "McCabre McQueen." "The shows are about what's buried in people's psyches," he said.[10]

"I remember that show so well," says Alice Smith of Smith & Pye, "because I was so tense. I had never felt so tense at one of Lee's shows, and I never felt that way again. I chain-smoked throughout the entire thing!" With the added theme of Mary, Queen of Scots, and the doomed Romanovs, the sense of impending tragedy throughout was palpable. Never again could anyone pigeonhole McQueen as an ignoramus, a master of "Cabbie Couture"—the heckling stopped after this.

No picture of the "Maid of Orleans," the virgin-girl warrior who led the French troops against the English during the Hundred

Years War, exists. Did the idea come from Issie Blow? According to Alex Hanson, though, McQueen loved falconry because of its "poetic notions of ornithology. His obsession with death was there early on—the morbid, the afterlife, themes related with death fascinated him."[11] Together, the two would visit museums and galleries, particularly the Wallace Collection, where McQueen would study not only the ornate armor but also the "nature mort" paintings *Still Life with Lobster* (1643) by Jan Davidz de Heem and *Dead Roe* (1721) by Jean-Baptiste Oudry, with their themes of memento mori.

For this collection, he had seen a painting rife with eroticism and religion: Agnès Sorel, mistress of King Charles VII of France, portrayed as the Virgin Mary in *Virgin and Child Surrounded by Angels*, by Jean Fouquet (c. 1450). With breasts straining against the opened bodice and her hairline plucked back, Agnès is surrounded by red and ash-gray angels. It was painted approximately nineteen years after Joan of Arc died and encapsulates a delapidated beauty unlike anything else that was happening in fashion. And with a fabulous twist, McQueen took the notion of Joan's androgyny one step further by appearing on the cover of *The Face*'s April 1998 issue in a look inspired by the Sorel painting and shot by Nick Knight. He was photographed in advance of London Fashion Week. So was it Sorel or McQueen? With thin, ash-blond plaits over a naked pate, he replicated the loop under the crown that sits on Sorel's forehead— "Joan . . . the fire in my soul is for the love of one man, but I do not forget my women whom I adore as they burn daily from Cheshire to Gloucester."[12]

The running order lists ninety-one styles for the show held on February 23 at the disused bus depot in London's Victoria. McQueen's runway was 100 feet long in Perspex, lit with floor lights and covered in "volcanic ash." Models included Karen Elson, Erin O'Connor, Honor Fraser and Jodie Kidd; wigs were blond, skin pale and eyes glowed red with ruby contact lenses. In an overall color

palette of burgundy, black, gray and red, the show started with a short cowl-necked dress in silver chain mail, followed by a long silver chain mail dress, accessorized with a veil. Textures varied from raffia, knitted leather and snakeskin to tartan, black denim and butter-soft black leather, with sequins and beading. Tailoring was there, with frock coats (shoulders softer than usual) and a sequined jacket printed with black-and-white images of the murdered children of Tsar Nicholas II (1868–1918). Following the Edwardian theme, there were boned, high-neck chiffon blouses, pintucked on the bias and slim maxiskirts.

Again there was an androgynous tone to the menswear; one male model wore a tartan corset dress with an over-the-shoulder train. As the collection built toward its crescendo, red

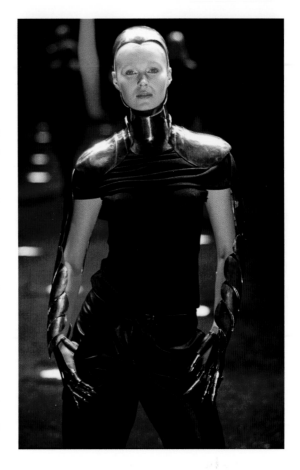

Based on the story of Joan of Arc and her martyrdom, a model is clad in medieval-inspired burgundy leather armor, gauntlets and black leather trousers. She wears red contact lenses and is dressed in a leather coif, a look that McQueen was to pursue in later collections. This was a less-rigid version of the silver-plated armor made for "Joan" by Sarah Harmanee.

became dominant and the notion of imminent execution apparent, with the hooded figures of Erin O'Connor and Debra Shaw in lace and snakeskin respectively, Honor Fraser and McQueen's muse, Annabelle Neilson, building up to the finale—"Joan," masked and glowing in a red beaded dress, surrounded by a ring of fire.

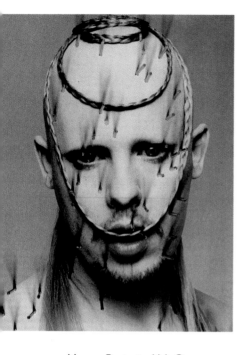

Joan

Deep inside of me I have no regrets of the way I portray myself to the General Public.

I will face fear head on if necessary but would run from a fight if persuaded.

The fire in my soul is for the love of one Man but I do not forget my women whom I adore as they burn daily from Cheshire to Gloucester.

A. McQueen x 98

Above: Portrait of McQueen, styled in the spirit of "Joan." Photograph by Nick Knight for *The Face*, April 1998. **Right:** McQueen's letter to Joan, who "burned" from Cheshire to Gloucester.

For *Women's Wear Daily,* if it didn't have quite the same drama as the "Untitled" thunderstorm, "the collection it delivered was stronger" and identified frock coats, denim maxis and "Edwardian influence" as a strong London trend.[13] Fire was the third of the four elements in nature that McQueen had used subliminally so far in his shows. "The following year, French director Luc Besson began filming *The Messenger: The Story of Joan of Arc,* with Milla Jovovich—pale and androgynous, encapsulating the "strong woman," ultimately vulnerable yet striving to live life on her own terms and so admired by McQueen.

No. 13

"With me, metamorphosis is a bit like plastic surgery but less drastic. I try to have the same effect with my clothes. But ultimately I do this to transform mentalities more than the body. I try and modify fashion like a scientist by offering what is relevant today and what will continue to be so tomorrow." —Alexander McQueen

McQueen's thirteenth show was called, with a sublime lack of superstition, "No. 13"—a lucky number because the collection was hailed his best ever, a balance between hard-core avant-garde and femininity. Presented at the Victoria bus depot in London on September 27, 1998, these were clothes "that almost any woman would want to wear." [14] Its theme was the Arts and Crafts movement and new technology. "Let me not forget the use of my own hands, that of a craftsman with eyes that reflect the technology around me," he told *i-D* magazine in 1999. [15]

In the frame this time were questions about the perfect body, and McQueen used several disabled models, including Aimee Mullins, who had her legs amputated below the knee as a child, due to a medical condition, and is a world record–holding athlete. The theme of disability followed the designer's guest editorship at *Dazed & Confused* (September 1998), in which he featured a number of disabled models. "The intention is not to be controversial," wrote editor Jefferson Hack, "rather, this is a joyful celebration of difference."

Mullins opened the show wearing a pair of varnished wooden lower legs designed by McQueen and made by craftsman Bob Watts, clearly inspired by the English baroque sculptor and wood carver

Grinling Gibbons (1648–1721), teamed with a frock coat softened at the back with a panel of chiffon, worn over a simple black draped dress. Arts and Crafts influences mixed with contemporary technology: frock-coat suits in striped silks had skateboard buckles at the knee, a woven raffia and leather skirt was worn with a backless leather top trimmed with blanket stitch, molded leather body armor set on a spiral with bias-set Chantilly cream lace, with masterpieces of draping; from the bias-cut silver metallic leather skirt—long, like last season—and a silver bias-cut cocktail dress, bare-shouldered and backless. A nod to Elsa Schiaparelli and the surrealists was there with a transparent dress, the body encircled by a glittering ring of spirals.[16]

As for the shoes...a mix of 1890s bootees with heels set at the center, 1730s-style, but at angle of 45 degrees, all in shiny midbrown to match the leather corsetry, with cream leather bias binding. Playing on volume, from the articulated wooden skirts that stood out from the body to the crinoline-twist at the end, was new to McQueen. "A play on hard and soft," decreed *WWD*, and a beautiful collection, played in sets, with models standing on revolving circles to music played low, sometimes even in silence. The finale was orchestrated to the strains of "The Dying Swan" by Camille Saint-Saëns as Shalom Harlow, wearing a white strapless circular-cut skirt-dress belted over the bust, stood on a turntable and was decorated with black and green fluorescent ink by two industrial paint sprayers from Fiat. The idea initially came from *Painting Machine* (1988) by artist Rebecca Horn. "It was my best show," McQueen told writer Sarah Mower, "that moment with Shalom!"[17] For Mullins, it wasn't about disability but diversity. "People want strong women; they are looking for personality and strength," she said.[18]

152

Aimee Mullins in "Fashion-Able," the September 1998 issue of *Dazed & Confused*, guest-edited by Alexander McQueen and styled by Katy England. Photograph by Nick Knight. Mullins modeled for McQueen in "No. 13," wearing a pair of wooden prosthetic legs decorated with Grinling Gibbons–style carving, having had her legs amputated at age one. Here she wears a crinoline and intricate imitation-lace wooden bolero.

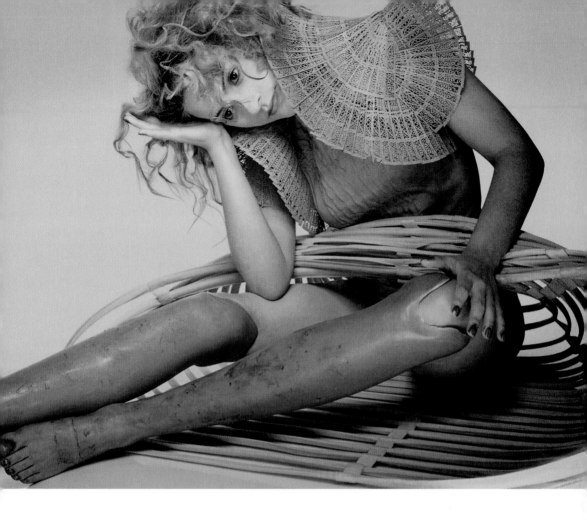

This was, McQueen told the *Guardian*, the only show that had made him weep with emotion—"The idea is to show that beauty comes from within. You look at all the mainstream magazines and it's all about the beautiful people. I know that I'm provocative. You don't have to like it, but you have to acknowledge it."[19] His latest work was dedicated to Juice, his English bull terrier, and Minter, his Staffie, with whom he touchingly took his bow.

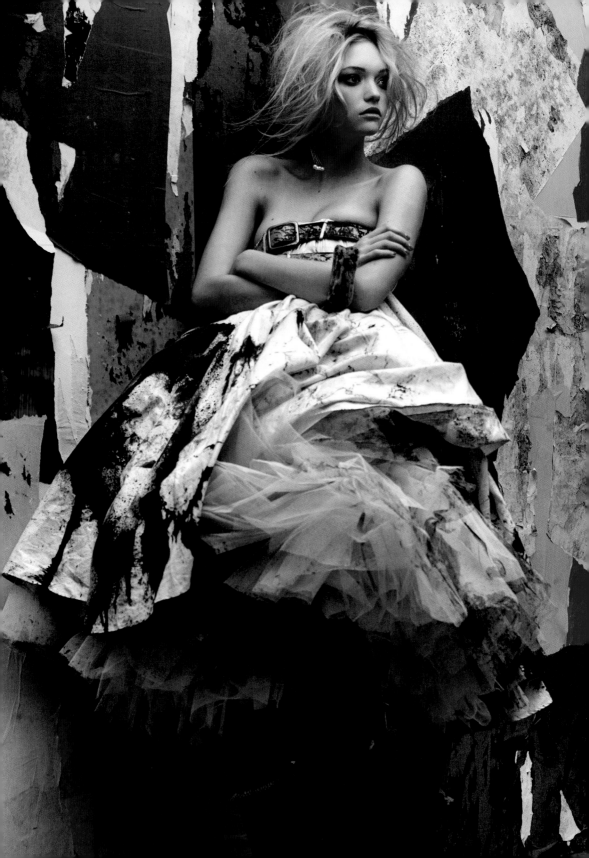

The Overlook

Autumn/Winter 1999–2000

"I spent a long time learning how to construct clothes, which is important to do before you can deconstruct them." —Alexander McQueen

Such was the praise for "No.13" that Anna Wintour, editor of American *Vogue*, attended McQueen's next own-label show for the first time on February 23, 2000. As Lee himself had said regarding "Dante," he was eclectic rather than minimalist, and his A/W 1999–2000 collection continued to demonstrate his breadth of vision.

Called "The Overlook," the title referred to the hotel, built on a Native American burial ground, in Stanley Kubrick's film *The Shining* (1980). The snow-covered runway, with its thousand scented candles, was set behind plexiglass walls, a sound track of howling wolves and whistling wind creating the atmosphere. The chilling refrain, "All work and no play makes Jack a dull boy" was brought to mind by the effort put into the presentation, but it had paid off. It was a romantic spectacle, charming rather than menacing, with ice skaters performing in white, with giant wooly knits, stiff-netted full skirts in heavy lace, patchwork leather and plaid, or

Gemma Ward wearing McQueen's finale dress from "No. 13," worn by Shalom Harlow at the show and sprayed with paint by two robotic machines. Photograph by Craig McDean, New York, 2006. It was the only collection, said McQueen, that made him cry, because it was so beautiful.

a leather dress painted with voluptuous roses. Shaune Leane's coiled aluminium tribal corset referenced the high beaded necklaces of the Ndebele of South Africa and Zimbabwe, but stripped of "ethnic" connotations, it was called "Cossack." This, along with Kees van der Graaf's rock-crystal draped bodice worn with bumsters, touched on the theme of warrior women.

Yet there was a magical vulnerability to the tribal Native American–inspired wigs and silver-white face paint, stretched over the eyes, and the two identical red-wigged girls, like the murdered sisters in *The Shining*. The vermilion hair was vibrant in the white landscape and imitation snow. "Redheads are interesting, aren't they?" said McQueen in *AnOther Magazine*. "They're a unique group of people." The palette was primarily black and white with a theme of dusky pink. Padded and quilted coats trimmed with fur, shoes with spiked heels and a coat cut with a fantail bird silhouette continued his fascination with asymmetry. With a view to his soon-to-open shop on Conduit Street, there were enough commercial ideas to ensure good sales, with pinstriped suits and pleated skirts, a quilted shrug jacket, drop-waisted all-in-ones and parkas in pink. At the end, McQueen appeared to the tune of Frank Sinatra singing the unconsciously avian anthem, "Come Fly with Me."

Based on Stanley Kubrick's film *The Shining*, "The Overlook" was staged behind Perspex walls, with falling snow and a spookily charming set. Lace skirt, fur coat, the hair and makeup in generic Native American style.

Some pronounced it his best show, but was it? It demonstrated a real cohesion of aesthetic, but the real magic was to come eighteen months later with "Voss." What he'd done, of course, was to hint at the chilling and presented charm; the relief that there were no rivers of blood, as in Kubrick's masterpiece of terror, must have been tangible.

Above left: Two models in identical red wigs are the ghost sisters in *The Shining*. Gray wool tunic dresses and gray shirts give a sense of the controlled severity McQueen applied to his work. **Above right:** Shaun Leane's aluminium coil corset, inspired by the beaded neckwear of the Ndebele women in the northeast part of South Africa, was developed to cover the torso. Leane made a cast of the model's body and fitted the corset, coil by coil, around it. The piece was then screwed into place at the fitting. **Opposite:** Transparent circular skirt with gothic script and scrolls, fitted top. This was the first collection to be sold at his new stand-alone shop on Conduit Street. An installation in the window referred to "The Overlook."

The Eye

Autumn/Winter 1999–2000

"It's almost like putting armor on a woman. It's a very psychological way of dressing." —Alexander McQueen

The following season, McQueen made the somewhat controversial decision to show in New York and present his own-label collection to the fashion editors and buyers who had historically bypassed London Fashion Week. He was not going to be, in Wintour's words, one of London's "hot designers with no money." In the wake of tropical Hurricane Floyd, "Eye" was held in Manhattan on September 16, 1999, at Pier 94 on the West Side Highway. Other designers had been rained off, but McQueen, now faced with mere drizzle, was exultant about bringing British weather to New York Fashion Week—"It's brilliant! It would take more than a bit of wind and rain to stop us," he said.

The show was sponsored to the tune of £600,000 by American Express, for whom he had designed their limited-edition Blue credit card (with an image of his own eye at the centre). McQueen praised the company, saying they wanted to "embrace art and design, not just the capitalist dream,"[20] before rather spoiling his rebellious stance by adding that the launch of the collection in New York was essential to the development of his global business. In an extensive interview with *WWD* during the run-up to the presentation, he told the paper that he was not "this enfant terrible, or whatever it is—stupid word. I'm not like that at all, but sometimes I act like that." It was, from a company point of view, a means of getting

McQueen's second show at New York Fashion Week was an investigation of the conflict between East and West, Christianity and Islam, tackling the theme of female disempowerment. Shaun Leane's Swarovski crystal–decorated body armor for "Eye" brings together the armor of the crusaders, the concealed faces of Arabic women and sporty boxing briefs with the McQueen logo in Arabic.

across his seriousness and commercial acumen. "I've always been a business person, it's just that the way that I do my business is different from most," he explained. As for gay culture, he didn't like to be labeled; he wouldn't be any kind of stereotype. He was an individual, monogamous and romantic.[21]

With Islamic and nomadic overtones (inspiration originally came from listening to Turkish music on a taxi's radio), "Eye" again tackled the theme of female disempowerment—and the fight back. The 100-foot catwalk was filled with a layer of ink-dyed black water (a development from "Untitled"), through which the models waded.

For the finale, numerous ranks of hefty spikes rose upward to a phallic "10," risky for the models floating above, suspended from ropes and pulleys. There were hipster trousers with keyhole cutouts below the knees (front or back), boxing shorts with buckles emblazoned with "McQueen" in Arabic script, beaded frock coats, lacework trousers and draped dresses in red jersey. A magnificent horned headdress of wire and clinking silver coins by Philip Treacy spoke of ceremonial "Oriental" dress.

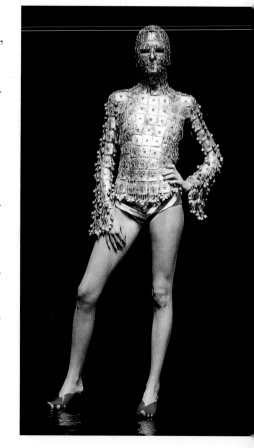

Clear reference to the exotic was made by yashmaks, transparent harem pants, the opposing Occident, by medieval-style armor; a sleeved top with attached helmet hood was a masterpiece of the jeweler's craft by Shaun Leane. Such symbols of the opposing religions and cultures of the crusades were a pointed reference, perhaps misunderstood by those present, to American foreign policy and followed in the wake of the Al-Qaeda bombing of the U.S. embassies in Nairobi and Dar es Salaam in August 1998; a drama that would be played out on 9/11 and in the resultant War on

Terrorism. With a figure in red, white and blue and another in a float-ing black burka suspended over metal spikes, this was a remarkably contentious card to play in New York and calculated to cast the other shows in the shade.

"Religious, social or sexual manifesto? Or the defiant self-indulgence of a major talent intent on leaving his audience talking?" asked *WWD*. Less showmanship, more content was its verdict.[22] "Fuck 'em," McQueen told the *Evening Standard*—he wouldn't be coming back. "England is where it's at. It's where all the most cre-ative, cutting-edge people are. It'll always be my home."[23] He took the applause at the finale by dropping his bleached jeans to reveal Stars and Stripes boxer shorts—a present from his boyfriend.

Eshu

Autumn/Winter 2000–2001

"I want to be honest about the world we live in, and sometimes my political persuasions come through in my work. Fashion can be really racist, looking at clothes of other cultures as costumes.... That's mundane and it's old hat. Let's break down some barriers."
—Alexander McQueen

What McQueen would have learned, in part from Romeo Gigli, was the importance of travel, cherry-picking images and dress from differ-ent cultures and using them as ideas in collections. Although he didn't have the luxury of time to do this, his quest for ideas was constant: if he couldn't travel, he read books and magazines on anthropology.

This approach was evident in "Eclect Dissect" and patently so in his own later collections.

"Eshu," presented on February 15, 2000, was another collection inspired, in the final analysis, by death. McQueen had studied the ancient Yoruba peoples of Benin, Niger and southwest Nigeria. Like many sub-Saharan African cultures, the Yoruba believe in ancestor worship and the spirit world, what was called in parts of its diaspora "vodun" or "voodoo." Èsù, or Eshu, is an Earth-cult deity who represents a messenger of death, linking other *Orishas*—the creator Olódùmarè's spirit helpers—with living humans. The Benin masks and figurines had inspired Picasso in his painting *Les Demoiselles d'Avignon* (1907), which spoke of modernity infused with "pure" primitivism; now McQueen looked to the idea of the primitive again, incorporated the influence of colonialism and translated it into his current interest: volume.

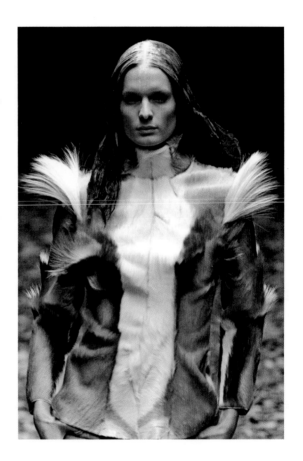

Springbok-skin jacket, the stomach of the antelope forming the center-front panel, long hairs cleverly placed to give shoulder emphasis.

"I try to push the silhouette. To change the silhouette is to change the thinking of how we look. What I do is look at ancient African tribes and the way they dress. The rituals of how they dress. There's a lot of tribalism in the collections," he explained.[24]

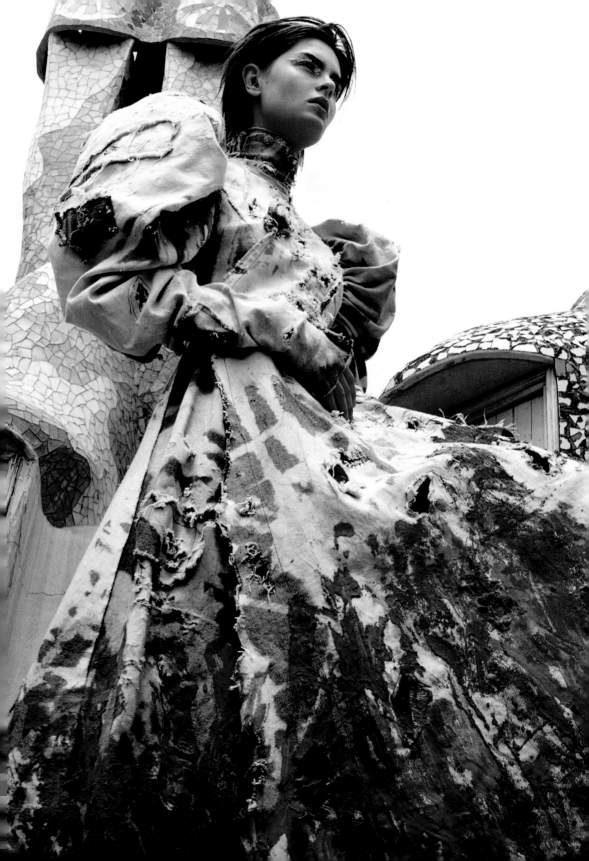

Early twentieth-century photographs of the Yoruba show ceremonial figures dressed in layer upon layer of decorated strips of cloth, but for everyday, the silhouette of Yoruba women's clothes is essentially based on nineteenth-century female dress: balloon sleeves, accentuated waist, full skirts. The clothes of female missionaries blended Yoruba fetish objects—hair, skins, earth, fur, metal and wood.

The collection was presented in a north London film studio; the runway covered in gray shale, without the theatrics but with all the content associated with a McQueen show. Correction: the theatrics were courtesy of antifur demonstrators who had broken into the space and daubed slogans on stage backdrops and attempted to booby-trap the runway. So the start of the show was delayed by an hour as the guests and

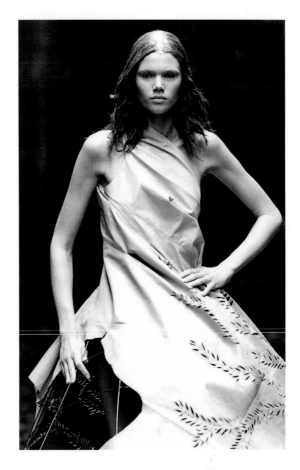

Above: One-shouldered dress in beige leather with laser-cut feathered decoration, set asymmetrically over a metal cage crinoline. **Opposite:** Denim dress in the style of an Edwardian missionary in West Africa, with great leg-of-mutton sleeves and Queen Alexandra high collar, modernity further added with the bleached and distressed effect, and daubed in red to imitate the red earth of Africa.

space were searched, subjected to the shouts of the placard-waving protestors, held back by the presence of about fifty police officers. McQueen had used farmed fur for Givenchy, but until now his own line had used skins and some rabbit, all, argued the team, a by-product of the food industry. The skin he used was reindeer, cut into

a frock coat, worn with a wrap skirt and reindeer boots. This was not "Nanook of the North" but more a demonstration of how McQueen's mind worked. One idea incorporated appropriate texture and look, a hirsute option to what would, had it been anthropologically correct, leopard. Other fur used was rabbit, panels of which were sewn into leather dresses and lamb shearling coats.

The collection featured McQueen's signature bumsters, frock coats, low-slung trousers and, inspired by a Yoruba totem, a spiked mouthpiece by Shaun Leane. Overall, it was about the tension of tribal cultures and colonial interventions. The models' hair was smoothed and shone with applied gold powder, representing the historic source of West Africa's wealth; the makeup pale and natural. There was a monumental coat in synthetic black hair, kinked, tufted and groomed to look like giant astrakhan. Also a collared and figure-hugging sleeveless dress, the top made up of sulphurous greeny-yellow glass beads applied three-dimensionally, which gave the effect of an aerial view over rain forests, grading into flickers of color over a natural brown-black horsehair skirt, a belt of equine bridle leather cinching the waist.

This shape was echoed with another look; a long white gauze dress, the bottom plastered with Africa's red earth, the top a corselet of horizontally draped wooden beads. A one-shouldered beige leather dress, ruched at the waist, draped asymmetrically over a swaying metal cage–crinoline, was laser-cut in a swirling feather pattern, its hem uncut, revealing the outline of the beast from which it came. A gray leather dress with a natural shoulder line, worn with 1890s-style "Gibson Girl," was cleverly cut without a waist seam and ballooned over a knee-length crinoline, the skirt decorated with mud. Whereas "It's a Jungle Out There" had played with the fauna of southern Africa to a backdrop of urban warfare, the models in "Eshu" were not feral creatures but romantic innocents dabbling in the rituals and language of voodoo. The show over, there was not a protester in sight.

Voss

Spring/Summer 2001

"Birds in flight fascinate me. I admire eagles and falcons. I'm inspired by a feather but also its color, its graphics, its weightlessness and its engineering. It's so elaborate. In fact, I try and transpose the beauty of a bird to women." —Alexander McQueen

The "Voss" show has gone down in McQueen legend as one of his most memorable presentations. Again sponsored by American Express, it was, he said, about "decay [and] oppression." And yet again, he deftly combined showpieces and set for impact, with commercial looks and inspired, innovative tailoring. Held on September 26, 2000, at the Victoria bus depot, at its heart was an installation based on Joel-Peter Witkin's *Sanitarium* (1983), with chronicler of the transgressive writer Michelle Olley, plump and naked—reclining, like Witkin's figure, on a chaise longue, masked. In her mouth was medical tubing, and she was surrounded by hundreds of fluttering moths. The name "Voss" hinted at what was to follow: the Norwegian town is famous for being a wildlife habitat, particularly for its birds. And so "Voss" was to be a celebration of birds and nature; also, given McQueen's track record, a confrontation. "I am what most of them fear most—fat," Olley noted somewhat wryly in her diary.

The *tableau vivant* was to be the finale. As the audience entered the space and seated themselves, they faced a runway that was a large glass chamber as with "The Overlook," but now featuring reflective surveillance glass for walls. As the show ran an hour late, everyone was forced to gaze at their own reflections in the glass box, while listening to a heartbeat and heavy breathing blaring out over the PA.

"Ha! I was really pleased about that. I was looking at it on the monitor, watching everyone trying not to look at themselves. It was a great thing to do in the fashion industry—turn it back on them! God, I've had some freaky shows," McQueen declared to fashion journalist Sarah Mower.[25] So what was inside the glass cube? Anything was possible, for McQueen had already referenced the monstrous kraken in "Banshee." At 8 p.m., 100,000 megawatts of lighting illuminated what resembled a room in a psychiatric institution, with pristine

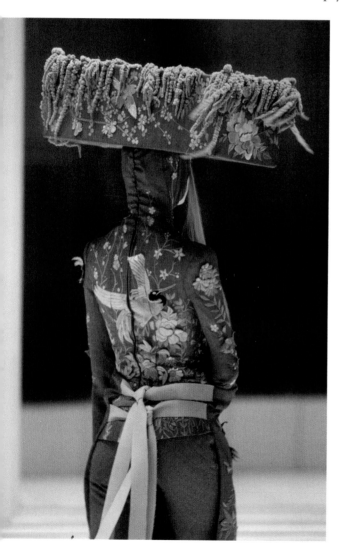

white tiles on the floor and white padded walls. The audience became voyeurs. They could see in, whereas the models (led by Kate Moss) could not see out. The idea was for them to stumble, look dazed and claw at the glass. Each head was covered in a medieval-style coif framing the face; makeup produced a look of scrubbed purity reminiscent of Vermeer's iconic *Girl with a Pearl Earring* (c. 1665).

What followed was a seventy-six-look collection split into themes and broken up by showpieces, which became increasingly organic. At first, there were asymmetrical dresses with black ruffles placed to look like tail feathers; ruffles and pintuck pleats ran throughout. Suits in pale pink, khaki and black, with high-waisted trou-

sers and high at the ankle were a classic McQueen look reworked; then an extremely commercial black sleeveless dress with knee-length circular skirt appeared (one for the buyers). Then look Number ten came on—a gray Chinese-style frock coat, tight-sleeved arms fastened as in a straitjacket, the "mad" model's hat, an embroidered box filled with overhanging fronds. Eleven more commercial looks followed in the form of suits, bleached jeans, shirts and ties worked into dresses.

Suddenly, out came Jade Parfitt, looking like a Nordic shape-shifter—half-woman, half-bird, wearing an ostrich feather skirt, her headpiece, a mew of stuffed hawks surrounding her head. "The show is about nature and the elements," McQueen had told writer Susannah Frankel. "I've used shells, feathers and pearls."[26] More suits, then a green silk, Jacobean-style with ostrich ruff; the back decorated with a thermal image of McQueen's face, modernizing the antique. More clever tailoring, then Erin O'Connor in a floor-length gown of razor clam shells gathered from a beach in Norfolk and applied like paillettes. As she walked, she rubbed them with her hands and some fell onto the floor—like a snake sloughing off its skin. More suits and dresses, then a gothic castle shoulder-piece applied to a minidress, the model's legs wrapped in bandages.

McQueen's team had painstakingly gathered four thousand mussel shells from Norfolk; half-human, half-shellfish, the heads of the models wrapped in white and resembling pearls. There was more reworking of the suit before a new twist on a dandy's great-coat: high-collared, with capes and skirted. Then a raffia coat with applied embroidered chrysanthemums in red, pale gold and edged with black, followed shortly by a princess-line bias-set version backed with nude mesh; its front and train in black ostrich—a red-carpet showstopper-cum–fin de siècle femme fatale.

Hooded coat, cut long and wrapped at the front, cutaway at the back, in gray bird's-eye cloth with a pink floral design. At the rear, the image of a stork in flight has been embroidered in silk thread. The coat is wrapped with pink ribbons, the trousers are in gray cloth, and the hat is trimmed with amaranthus.

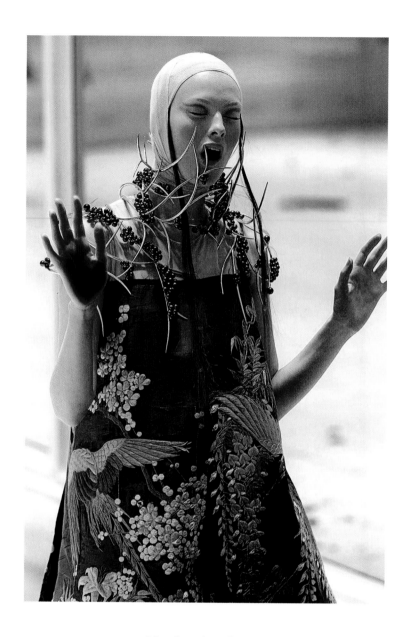

Number sixty-five had been planned as the final piece. Worn
by Karen Elson, the overdress was made from McQueen's own
nineteenth-century Japanese screen. Intensely fragile, it opened to
reveal an underlayer of gunmetal gray oyster shells, varnished and
gleaming, applied onto a flesh body. Topping it off was a neckpiece
by Shaun Leane of silver branches holding "berries" made from

gray Tahitian pearls. Leafless, it was a plant from the freezing Voss landscape. Ten looks later came the final outfit: Erin O'Connor in red—silhouette-hugging shiny paillettes made from medical slides, lozenge-shaped, while the razor-clams, painted red, right down to the hip (like the designer's torso-elongating bumsters), then a frothing matte ostrich feather skirt in red and black—a trademark McQueen combination.

O'Connor swished out and the lights went down, then on again, at which point the sides of the brown glass box in which Michelle Olley had been waiting, motionless (apart from cutting open the bag that held the moths and popping the tube in her mouth for over two hours) crashed down, smashing glass and releasing some very large moths indeed. Others had been stuck to Olley's body. She moved her head slightly. It was, pronounced the *Observer*, like a scene from the 1991 thriller, *The Silence of the Lambs*. Others saw Leigh Bowery's portrait by Lucian Freud. What made his version of *Sanitarium* a McQueen "moment," and not a Witkin, however, was the context of the fashion audience and the final touch of fauna—the moths, doomed to a short life on a fashion runway.

As with "No.13," McQueen was using fashion to challenge aesthetic judgment. All his shows were in some way autobiographical, and the man who had been held as outsider, who had been described as "chubby" (*The Sunday Times* that December nastily called him "the podgy *elephant terrible* of British fashion until he resorted to liposuction"[27]), had now slimmed down and was entering the peak of his power.

Karen Elson clings to the glass walls of the "asylum," facing out at the audience. The coif means no hair can detract from the impact of her look; the silver neckpiece of thorns and Tahitian pearls is set upon her shoulders, under which she is wearing an overdress made from the fragile silk of an embroidered nineteenth-century Japanese screen. Underneath is a magnificent dress decorated with layers of gunmetal gray oyster shells.

"These beautiful models were walking around in the room, and then suddenly this woman who wouldn't be considered beautiful was revealed. It was

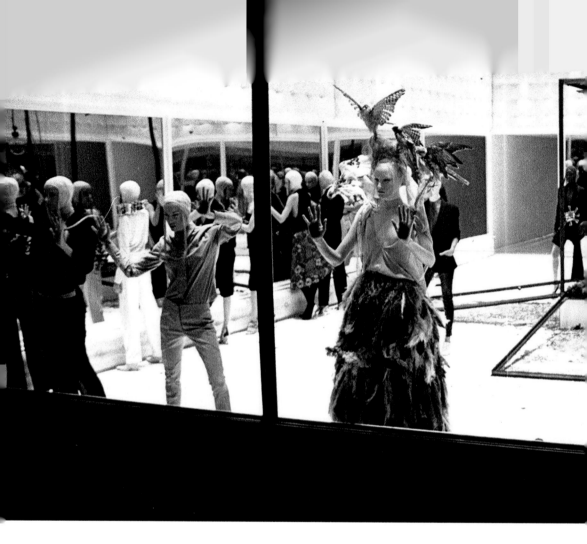

about trying to trap something that wasn't conventionally beautiful to show that beauty comes from within."[28] It was a deeply personal statement.

Olley put on a dressing gown and made her way through to the emotional McQueen backstage, standing with his parents. "Meet the star of the show!" he said, hugging her, elated. His mother told *WWD* that she thought it was his best show ever; he told *The Independent* the same. McQueen had put more looks on the runway that season not only than the London designers but also Galliano, Dior, Balenciaga—and even outdid himself at Givenchy. The ambition to establish his house as a major fashion label was palpable. The rumor

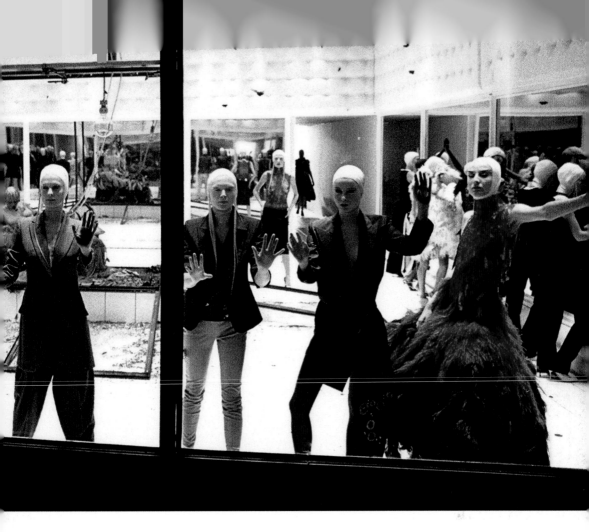

The finale of "Voss," with Michelle Olley in the background. Jade Parfitt with ostrich feather skirt and silk top is framed by taxidermied hawks in "flight" and, on far right, Erin O'Connor is in a red dress, the top made from painted slide film, the full skirt in red ostrich feathers. Moths fly around the enclosed space, and there are glimpses of the superb tailoring that was a major part of this collection.

mill about his future at Givenchy had already started, and his post-show interview with *WWD* was full of double-meaning. Fashion was a career he wanted to pursue. "I've realized that if I'm going to do something, I want to give it 100 percent. If I'm going to do the job, I should treat it as my own house. Things at Givenchy are only going to get better until my contract runs out next October, then we'll see."[29]

What a Merry-Go-Round

Autumn/Winter 2001–2002

"There is a hidden agenda in the fragility of romance."
—Alexander McQueen

"What a Merry-Go-Round" was Alexander McQueen's London swansong, his final show at the bus depot in Victoria. It was held on February 22, 2001, two days after he was presented for the third time with the title Designer of the Year by the British Fashion Council. He intentionally held himself back with the collection, feeling that he had given away too many ideas before. Now he was on the cusp of a new stage in his career—"This is a consolidating collection, the calm before the storm," he said.[30]

The theme was not "all the fun of the fair," but rather a fairground inspired by the German vampire movie *Nosferatu* (1922), the innocence of children and the predatory motivations of adults. He also cited the 1968 musical *Chitty Chitty Bang Bang*, featuring the sinister "Child Catcher," played so brilliantly by Robert Helpmann. It came out the year before he was born and fired his imagination as a small boy (Helpmann's Victorian gothic black suit and battered black hat surely fueled McQueen's idea of Jack the Ripper).

At the center of the set was an eight-horse carousel, the horses covered in patent leather, the accompanying sound track being the laughter of children. He continued his military theme with khaki shirts and ties, gold braided coats inspired by the military and civic uniforms of the French Revolution designed by the artist Jacques-Louis David, transposed to a woman's body with scooped collars; later,

there were French tricolors in black leather. A completely original wrap-jacketed suit developed from the previous season, the feather-cut leather skirt developed from "Eshu" and a bias-set black leather skirt developed from "Joan." As he said, this was a consolidating collection, with commercial bias-cut jersey dresses, asymmetry and masterfully cut trousers: slim or wide, cropped to long. He also made a feature of the white skull and crossbones on black in knit that was to become a ubiquitous brand motif.

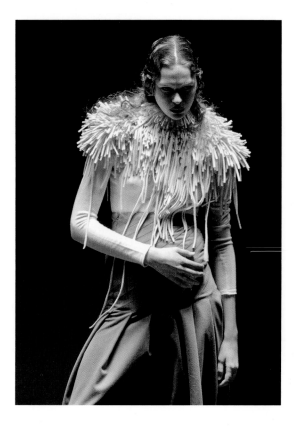

A knitted cream jumper with huge fringe neck detail, over a beige bias-cut pleated skirt.

As the finale approached, there were black leather versions of the Ruritanian-style uniforms in *Chitty Chitty Bang Bang*. McQueen had also been fascinated by the Pierrot and Harlequin figures in Jean-Antoine Watteau's *Voulez-vous triompher des Belles?* (c. 1716) at the Wallace Collection in London, visited with Alex Hanson, and there was a black leather dress and trousers with green harlequin intarsia diamond shapes. "Watteau really made an impact," Hanson observed. "Harlequin's face in mask looked like blacked-up Leigh Bowery." Toward the end, the lighting dimmed and came up again as childhood toys were revealed and a model dressed in black lace appeared from behind the curtain, with a clown face and three-pointed wig (shades of Leigh's wig worn at Kinky Gerlinky), dragging a gold plastic skeleton around the set. More sinister "clown-women"

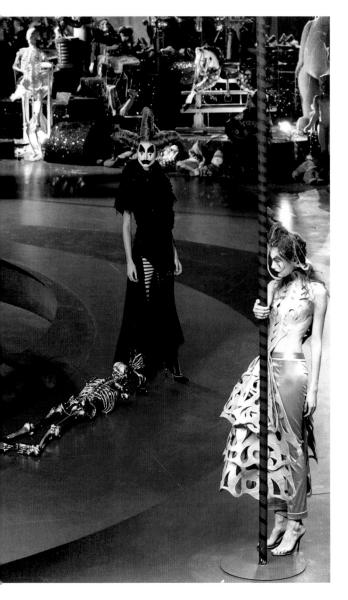

appeared in increasingly exaggerated makeup. "Clowns are supposed to be funny," McQueen told *WWD*, "but they're not." For him they were ugly, scary—"It's a man behind a mask."

The coup de grâce was his "Marianne"—based on the painting *Liberty Leading the People* by Eugène Delacroix (1830)—ruffles about her neck, bare-breasted bar a thin layer of gauze, the silver bias-cut dress clinging to her form. It was autobiographical on two counts: a pointed gesture to French LVMH (in his own words to Koji Tatsuno, "Fuck French Fashion!") and "Marianne" became an emblem of liberty during the revolution of 1848, at the heart of Cameron Mackintosh's *Les Misérables*, for which McQueen created the costumes in 1989. "Even the invite was in the colors of the French flag!" he joked to *WWD*. "When I design, whatever is happening in my personal life comes out in my work."[31]

Coming out to take his bow to the sound of Julie Andrews singing of "A Spoonful of Sugar," he shook hands with a smiling Domenico de Sole, CEO of Gucci Group. Despite his anti-Gallic stance, McQueen was to show in Paris for the rest of his career.

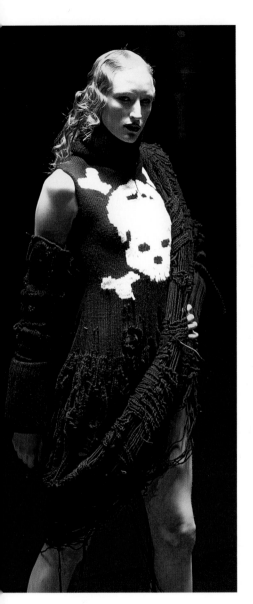 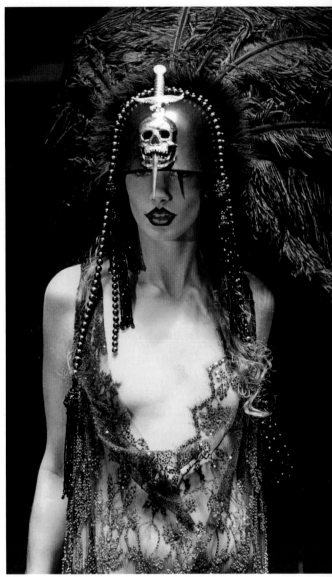

Above left: McQueen took a firm line on knitwear; nothing too feminine or unsubstantial. Black knitted dress with huge white skull and crossbones, the knotted and knitted train slung over the left shoulder, swashbuckler-style. **Above right:** Hell's Angel meets showgirl: the helmet with McQueen skull is edged with purple ostrich feathers. Sheer purple tulle dress is embroidered with flowers in the same colored silk thread. **Opposite:** The finale sequence of models in clowns' wigs and makeup. The central figure in a black bias-cut dress forlornly drags a gold plastic human skeleton clinging to her hem, like a nightmarish dominatrix with a spectral client.

THE GUCCI YEARS

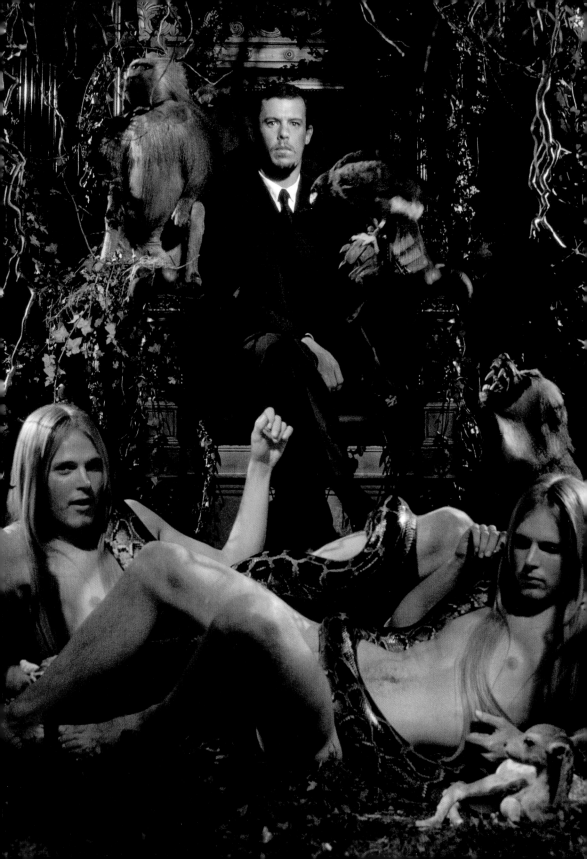

M cQueen had already laid the blocks of his business empire: master of a couture house in Paris, head of a team that produced headlining shows, a wholesale business that now ran to £1 million a year[1] and collaborations with photographers Richard Avedon and Nick Knight positioned him as a designer whose creative ability took him beyond fashion. Now he was looking at retail.

Plans to open a store in New York City and in Japan (where he had a concession in the Isetan store in Tokyo) with business partner Onward Kashiyama were already in motion. In late October 1999, McQueen's first stand-alone shop opened at 47 Conduit Street, around the corner from Savile Row, just twelve years after starting as an apprentice at Anderson & Sheppard, three doors up from Vivienne Westwood (who had called him a measure of "zero talent") and diagonally opposite Yohji Yamamoto, whom he admired. "He had a hard work

Portrait of McQueen by Sam Taylor Wood, *New York Times*, 2003. Dressed in an immaculate suit, he is seated on a throne in a Garden of Eden, naked boys with Eve-style wigs cavorting with snakes at his feet.

ethic and loved fashion," says Hanson, who attended the opening of the Conduit Street store and remembers his friend standing outside the building, "so proud of his name spelt out in marble."

The 2,000-square-feet shop displayed his entire collection; menswear, womenswear and licensed products including watches,

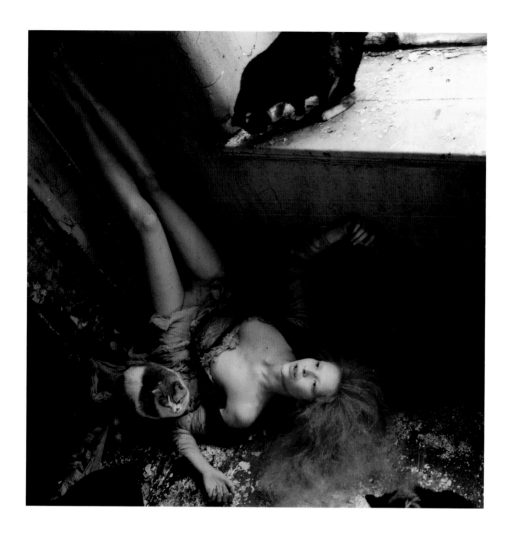

sunglasses, scarves, ties, footwear and leather goods, until now not
seen outside Japan. Architects Azman Owens had transformed the
Georgian building into a futuristic space. "I didn't want a boring
beige shop, with everything placed around the walls," Lee explained.
"I wanted it to be more interactive." In the window was a huge glass
box, which was filled with snow, referencing his A/W 1999–2000
snowstorm extravaganza "The Overlook"; each season it would
change according to the theme of his shows. The space also oper-
ated as a gallery. Two huge frames displayed Knight's portrait of
McQueen's "Joan" split down the middle, the proprietor as icon, and

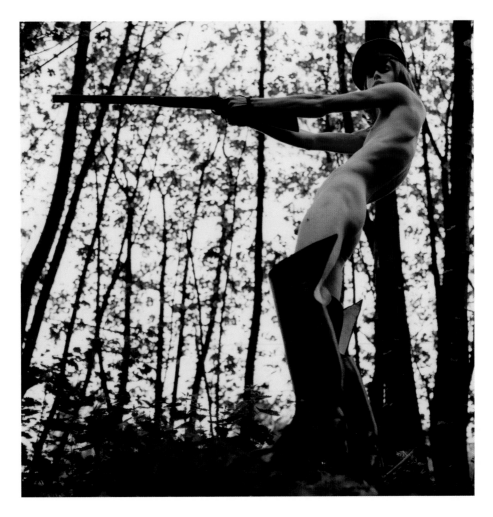

Centerfold story in *AnOther* magazine, A/W 2002. Photographed by Sam Taylor Wood with McQueen as creative director. The theme is a fairytale—he Dick Whittington, nude but for boots and a cap, she Puss Without Her Boots, wearing a Marie Antoinette–style chemise from A/W 2002–03.

another case held the prosthetic carved wooden legs for Aimee Mullins from the spring 1999 show. The idea was to connect the narrative of the shows with the customer. "I wanted to bring the conceptual ideas from my shows into a store. It's to explain the idea of the collection and what I was thinking. I wanted the customer to be able to interact with the store as well as the clothes," McQueen said.[2]

The Move to the Gucci Group

Lee had been in discussion with the newly formed luxury conglomerate Gucci Group, a lead originally suggested to him by Issie Blow (in May 1999, she had dined in London with Gucci's new creative director, Tom Ford). Following its purchase by PPR in 1999, the Gucci Group had £1.8 billion to invest in new acquisitions. Blow told Ford that he should think about purchasing Alexander McQueen; in response, Ford allegedly told her that he quite fancied McQueen, and of course, she had subsequently called her friend and advised him to think about joining LVMH's rival.[3]

In June 2000, McQueen spotted Domenico de Sole, CEO of Gucci Group, at a *Vogue Italia* party in Monte Carlo—"I went for him. Some sort of arrangement with Gucci was on my mind," he said. According to de Sole in an interview with *Forbes*, as they parted, McQueen called over a photographer and asked him to take a picture of the two of them together. What, de Sole asked, was he going to do with it? "I want to send it to Arnault," replied McQueen. "I thought to myself, 'This is my kind of guy,'" said de Sole.[4]

In McQueen's view, Gucci believed in design and provided a manufacturing base. LVMH, however, was "more interested in investing in the Internet or makeup companies."[5] McQueen's company Blueswan and Gucci came to an agreement in December 2000: Gucci would take 51 percent interest in McQueen and invest a reported $54 million[6] and pay the designer a salary of a reputed £1 million a season. He would have complete creative control and retain the remaining 49 percent interest. Gucci would manufacture McQueen's womenswear and menswear, expand eyewear and denim lines, launch a perfume and back new boutiques. And after his February 2001 show in London, McQueen would present either in Milan or Paris.

"It's hard to build a major business here [in Britain]," he said, after criticizing the government for not financially supporting the

British fashion industry (in January 2001, Hussein Chalayan, twice winner of Designer of the Year, had gone into liquidation), comparing it with the infrastructures for manufacture and marketing in Italy. In London, he accurately noted, there simply wasn't that backup.[7] With the opportunity to become a global brand, McQueen formally signed with Gucci in February 2001 on the eve of his A/W 2001–02 show, "What a Merry-Go-Round."

The Dance of the Twisted Bull

Spring/Summer 2002

"Women should look like women. A piece of cardboard has no sexuality." —Alexander McQueen

McQueen's first own-label show in Paris, "The Dance of the Twisted Bull," was sponsored by American Express and held on October 6, 2001. He had said that it didn't warrant the "theatrics" of one held in London—"I spent the summer looking at the ladies in the Med. I was quite new to the label and needed to be more accessible." Based on an apparently innocuous theme of young Spanish women holidaying by the sea, the backdrop was a film of a bullfight. The idea of each show was mapped out around four months in advance by the designer and his team, and so the concept evolved before the bombings of 9/11; the ritual fight between bull and toreador was therefore unrelated to the tragedy that had taken place in New York just as its own fashion week was beginning, but there was an air of melancholy in McQueen's

presentation that was right for the moment. A gust of red smoke flooding the back of the stage at the end proved an apposite touch.

In all the fashion capitals, it had been a season when designers veered toward the gently romantic, a feminine prettiness, and

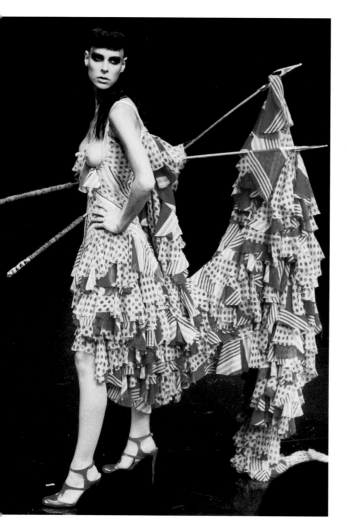

McQueen was on trend. In an interview with the *International Herald Tribune*, he described his collection: "It's ultra-feminine, not momsy, hot and sexy but not so clingy."[8] McQueen never "did" pretty. The show was a sharp, contemporary take on sportswear, with a layering of fabric on the body, cutouts on torsos inspired by the architecture of Gaudí, along with traditional Spanish costumes based on performance—flamenco dresses and slim-hipped, male toreador outfits converted to carapace-shouldered, jet-beaded womenswear.

The models' hair was a combination of Vargas's pinup and tousled rockabilly, makeup night-club vamp; colors the beige-gold of sand, the reds, grays, whites and blacks of Goya. There was a subtle shift toward eighteenth-century corseting in two all-in-ones, the corset set into trousers and slashed sleeves. Dresses set low on the bust had front "aprons" set into loop-hemmed, double-layered skirts, crisp white corsets worn with white cutoff pants,

bordello-style and ruffled polka-dot dresses set with semicircular ruffles were intrinsically organic in feel. The centerpiece was a spotted flamenco-style dress worn by model Laura Morgan, apparently shot through with two banderillas, over which the train was extended to resemble the tail feathers of an exotic bird. Behind her, at that moment, a sex scene appeared on the screen. It was reminiscent of a drawing of a fishtailed girl impaled by an arrow that McQueen had made in 1990 and presented to Carmen Artigas (see pages 34–35). He worked the one-breasted suit, fetish-style trouser laced at the side, and a pair of black silk and wool full-bottomed breeches, an adaptation from de Alcega's *Tailor's Pattern Book*.

Showpiece from his first collection under his own name in Paris. Model Laura Morgan appears apparently pierced with banderillas. Being screened during the show were scenes from a bullfight and erotica. Bias-cut dress with semicircular ruffles and train.

The models all looked as if they might have just crawled out of bed and thrown on something from the night before. "I had this lady in my head, and these very sexy pieces with the laced-up sides that she wants to wear to a club. It wasn't so much about me, but the person who was buying it. I was thinking on a business level," he later explained in an interview. "The show was quite simple for a McQueen show, but I always like to put my big toe in first before I strike. So next time I'm going to strike."[9]

Celebrity Clients

McQueen was now dressing a number of celebrity clients, among them Gwyneth Paltrow and Liv Tyler, who wore a McQueen version of a red-carpet outfit: a red tie-waisted suit consisting of a jacket with inner ties to hold it to the waist, full-leg hipster trousers and a red sleeveless top for the London premiere of *The Lord of the Rings: The Fellowship of the Ring* (December 11, 2001). Tyler's first *Lord of the*

Rings' red-carpet suit by the designer was specially made and fitted on her by McQueen himself, with his new, broader shoulder. Joan Collins was also a fan, saying that while she used to think Yves Saint Laurent was the "best cutter, McQueen cuts better than anyone." "I want to be the purveyor of a certain silhouette or a way of cutting, so that when I'm dead and gone, people will know that the twenty-first century was started," McQueen said at the time of his S/S 2002 collection.[10]

Isabella Blow describes the experience of having a dress fitted by McQueen in an *Observer* article in the run-up to the Design Museum exhibition, "When Philip Met Isabella" (2002). She talks mainly of herself and Philip Treacy—the importance of his hats not only to her but also as works of art. However, her closeness to Lee McQueen is apparent in this snippet: "I had a fitting with McQueen for a ball dress, and he was slashing away, and it was like Jack the Ripper. The fitting is, 'Turn round, you stupid [expletive deleted], get this way, go backwards!' And you can hear him like a pig snorting. You'll have the whole of the Marquis de Sade fitting you because there are so many different animal noises."[11]

The resulting fallout from Blow introducing her friend to the Gucci Group and the subsequent lack of fee was grating, however. In her view, she and McQueen were "family," but she was sure the close-knit team around him (also "family") found her irritating. She was convinced he used his clothes—which she desired and were not necessarily given—as a means of control, demonstrating his "power" over her. What *he* will have found irritating is this outpouring to a national newspaper and her statement, "He's become a multimillionaire, he's got it all stashed away. His nest is all piled up with stuff. Everything is money." Tragically, Blow's obsession was increasingly with money, or the perceived lack of it—and what she saw as ingratitude in some of those whom she undoubtedly helped.

Isabella Blow wearing clinging cream cocktail dress by McQueen and hat by Philip Treacy. Photograph by Zanna for *Liberty*, 2005.

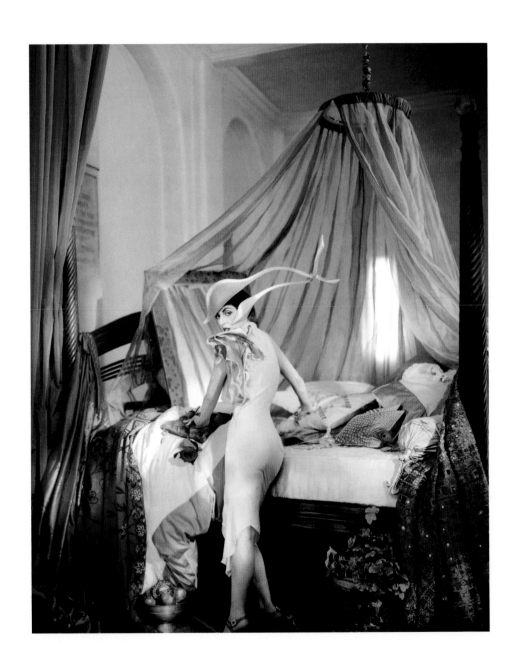

Supercalifragilistic-expialidocious

Autumn/Winter 2002–2003

"I like things to be modern and still have a bit of tradition."
—Alexander McQueen

McQueen's next show was held on March 8, 2002, at La Conciergerie, a medieval building in Paris where the last Queen of France, Marie Antoinette, had been imprisoned during the final terrible days before her execution in 1793. Its vaulted roof and columns stripped bare set the scene for a collection that touched on fairytales, the French Queen (nicknamed "Madame Deficit," whose addiction to fashion caused her to become doomed), adolescent schoolgirl erotica and a touch of "droog" millinery from the film *A Clockwork Orange* (1971). On a platform were wolf-hybrid dogs, caged and pacing.

The show began with "Little Violet Riding Hood" leading two of the "wolves" down the runway, wearing an eighteenth-century-style leather hooded, double-layered cape; lace patterned in laser cutting. And how to top that brinkmanship? With lighting by film director Tim Burton, the designer presented models with black versions of his "Voss" coif and introduced a broader, double-headed shoulder to consolidate a McQueen look. "God knows how many years I've come up with new ideas, and now I want to get those pieces exactly right, the shape of a suit or shoulder line. I want to make them mine," he told *WWD*.[12] He presented immaculately fitted, streamlined suits decorated with subversive leather harnesses and belts, leather corsets and fetish-style leather stock. Stripped of these accoutrements, they were super-smart, feminine trouser suits in tweed

and leather: McQueen's version of Yves Saint Laurent's "Le Smoking."

The show began with the new—in homage to Marie Antoinette's favorite portraitist, artist Elisabeth Vigée Lebrun, who painted her in a scandalously transparent muslin *chemise a la Reine*. It was the inspiration for McQueen's high-waisted *mousseline* chemise tops and dresses in oxblood voile and leather running like a reprise through the collection. These narrow silhouettes contrasted with full skirts in denim and jeans with a reprise of side lacing from "The Dance of the Twisted Bull." Then came models looking like St. Trinian's schoolgirls—tousled hair worn with *Clockwork Orange* hats, New York Dolls' makeup—in blazers, shorts and just-below-the-knee pleated skirts and skin-tight silver leather bumsters. In contrast to his narrow line, neat-waisted, full-skirted coats followed, the models dressed as incroyables and masked highwaymen, one in a billowing Marchesa Casati–style cape and bumsters. What was to be developed into a McQueen signature—dresses tight to the body, billowing in

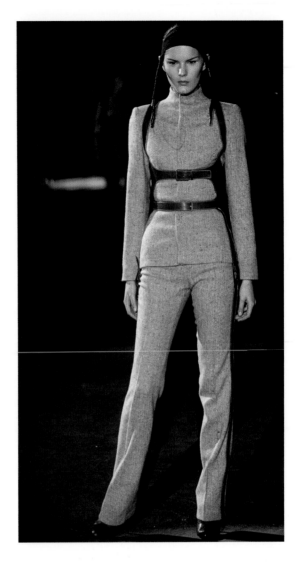

Marcelle Bittar in tweed suit with leather harness detail. The collection experimented with tailoring and couture-standard eveningwear, while also presenting a very commercial range of denim.

ruffled swags—led to the finale piece: a raven-black evening dress in the Marie Antoinette style, with corseted torso and bias-cut panels. McQueen's collection was inspired by one of the most fascinating periods in the history of fashion, but he was never tempted to make it "costume." Ideas were made modern by a versatile use of material and his cutting skills. It was desirable to an expanding Alexander McQueen market, catering both for "statement" outfits or something more conventional and, therefore, commercial.

McQueen saw his new flagship stores as ways of getting his ideas across to the public and as a means of marketing to the buyers, too: "I've always had a following here, but no one has ever bought the full story. And if you don't buy the whole story, you can't understand what I'm about." Following the opening of his new store in Tokyo in August 2002, a further shop opened at 419 West 14th Street in New York's fashionable meatpacking district. Designed by architect William Russell, the store was vaulted with curved walls and gray tiled floors set with Tahitian oyster shells and carved busts. Cubby-holes holding accessories helped to make the shopping experience a voyage of discovery. According to McQueen, the effect was intended to be "ethereal," like entering a church: "The idea of calmness where you're not faced with too much design theory."[13]

McQueen's overall collection had increased from 120 to 600 pieces. Domenico de Sole told British *Vogue* that sales from the designer's first collection with the Gucci Group had gone up 400 percent. Buyers for his A/W 2002–03 collection were in "paroxysms of ordering" and de Sole praised the marriage of "creativity and commerce, the biggest orders placed for the Marie Antoinette frocks, the suits with leather detailing and the corseted jackets."[14] McQueen had, said de Sole, "great talent, intensity and, last but not least, a comprehensive understanding of his business."

Irere

Spring/Summer 2003

**"I have always loved the mechanics of nature, and to a
greater extent, my work is always informed by that."**
—Alexander McQueen

The métier of water as inspiration continued with "Irere," shown in
Paris on October 4, 2003. McQueen loved to spend holidays diving
in tropical islands such as the Maldives. Spontaneously jumping into
a large transparent tank of water during a shoot with *Vogue* in 2002,
he told the magazine's fashion features director Harriet Quick that,
"Underwater, I feel most at peace."[15] Previously, water had given flu-
idity to the runway; now the amphibious designer used it as part of
a spectacular background, commissioning a film by John Maybury.

The director—who had made iconic videos for Neneh Cherry
and Sinéad O'Connor, as well as *Love Is the Devil* (1998)—has his
roots in the creative gay subculture of early 1980s London, filming
the shows of Antony Price and Bodymap. McQueen may have told
WWD that he had turned his back on the more subversive elements
of gay culture, but the reality, in terms of his ideas and collaborations
at least, was something different. The film was the narrative of the
collection split into three sections: in the second half of the sixteenth
century, a shipwrecked girl—possibly joined by what looked like one
of the most beautiful boys in the world (he spirals underwater with
her)—swims to the shores of Guyana. She lives in a rain forest before
the Spanish Conquistador invaders—sinister black-dressed mavens
resembling new romantics at the Blitz—arrive. In the last sequence,
she has escaped them and is dressed in the feathered costumes of
the indigenous people. She has the innocence and freedom of an
exotic bird.

Just before the first model appeared, the audience saw a girl purportedly drowning, dressed in what became known as the "ship-wreck dress," its chiffon strips floating like the fronds of a jellyfish. "Irere"—*jerere*—is the Amerindian word for a duck, specifically the white-faced tree duck of Suriname. McQueen had woven his entire collection around the verdant upper reaches of the Amazon, with its exotic colors, the feathers of the red macaw and the costume of the native Wai-Wai tribespeople.

The first twenty-piece section—on a buccaneer theme of Sir Walter Raleigh "discovering" Guyana in 1595, searching for gold—showed development of his harness and corsets over chiffon, artful layering and Elizabethan-style leather-sleeved and sleeveless jer-kins with pinked shoulder wings, as well as leather minis, frogged doublets, broad leather hipster belts and breeches as cropped trou-sers. There was a magnificent frock coat decorated with a koi carp based on McQueen's own tattoo. Ruffled and draped chiffon tops, loose or fitted over a corset evolved into his first "oyster" dress, one-shouldered, with more than 200 yards of café au lait chiffon cut into circles set on the bias skirt emulating a crinkly oyster shell.

The eighteen-piece black sequence that followed was made up of the same cut and shape, with the mask-like black makeup echo-ing the claustrophobic conquistador story on the screen, with a little black dress, black lace teamed with cutwork leather and a pair of sculpted black feather earpieces. The final eighteen-look section was exuberant and tribal—set against a film that played green "thermal" images pulsating *Predator*-like through the rain forest.

The feathers of the red macaw, which inhabits Guyana, inspired the chiffon dress, with its corseted bodice and flowing skirts. On the right, a fitted jacket is based on an Elizabethan man's doublet, with ruff and frills at the cuff, worn with a skirt printed with the colors of the blue and yellow macaw.

"Irere" was a story about being lost and found. Redemption was through nature: floating dresses in prints of the plumage of the scarlet, the red, the blue and gold and the cobalt blue hyacinth macaw,

hot yellow and electric green all-in-ones, ruffled scarves like garlands, a spectacular feathered fascinator and a showpiece Wai-Wai ceremonial headdress by Philip Treacy and an oyster dress in rainbow colors. The key trend from the shows for S/S 2003 was color, with Balenciaga showing body-conscious shapes with tropical fish prints; John Galliano's was an exuberant, perhaps excessive, nod to the exotic—Japan and Hindu Indian cultures, garlanded with tinsel. Neither de Ghesquiere for Balenciaga or Galliano was relying on ideas deep in their psyches. What McQueen did here was to explore an intimate side of his life. The McQueen who dived, who swam with sharks to get away from human beings, who pored over copies of *National Geographic*, who

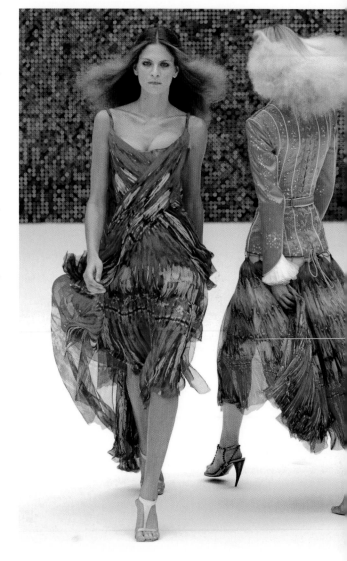

went back to well-thumbed history books—and who, in an incredibly disciplined way, was able to present an essentially personal collection through working with one of the most transgressive of British film directors. McQueen could "do" self-controlled excess like no one else.

The problem now was that McQueen was raising expectations about the spectacle every time he showed. "If people think some of the menace was missing from the last one, they should wait for this

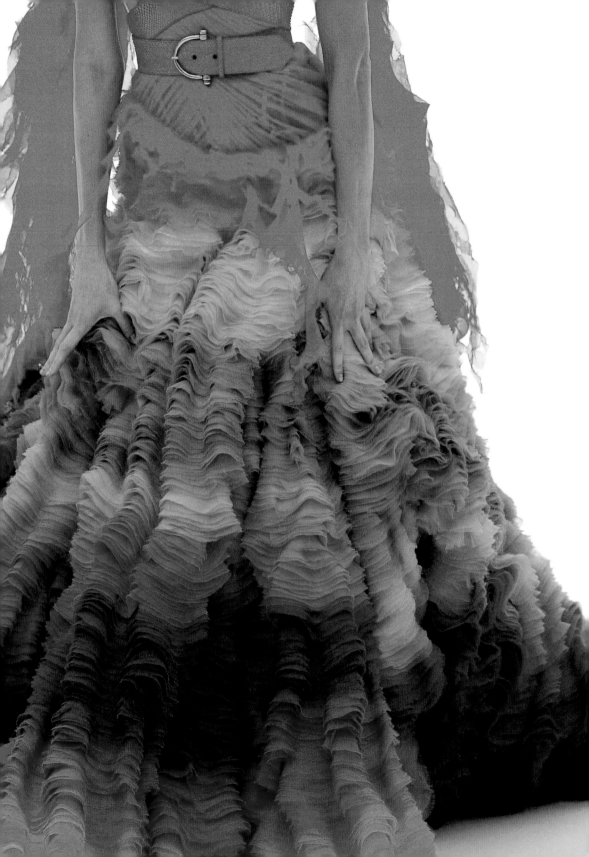

one," he "cackled" to the *Times* on the eve of "Scanners," his A/W 2003 collection. He underrated himself and undermined his achievements by stressing the Sturm und Drang he thought was expected of Alexander McQueen. His work was, of course, now less raw, more polished, but the "world" of McQueen seldom disappointed. Lisa Armstrong of the *Times* saw some of this as the tension between the corporate man and the opinionated boy who had shocked his audience years before; ergo more "menace." Now every interview was conducted in the presence of his PR Amie Witton, because she needed to keep the "mouthy" McQueen in control. With the new Alexander McQueen shop about to open on his birthday, March 17, on Bond Street, historically London's smartest fashion thoroughfare, and his next show only five days away,

Above: Karen Elson in black body suit in cut leather with a nose piece. A film by John Maybury played throughout and formed the narrative backdrop; this outfit belongs to the black-clad conquistador-women who are absorbed by the jungle and transformed by nature. **Opposite:** A detail of silk chiffon rainbow dress, the volume provided by hundreds of frilled layers. This is the collection that featured his "Shipwreck" and "Oyster" dresses.

he was focused on being the one young British designer to build a major international brand. He dressed what Blow called his "mermaids" to his "Poseidon"—Annabelle Nielson, Daphne Guinness, Plum Sykes and Blow herself, but acolyte status was not assigned to all.

Ulrika Jonsson wearing a dress from "Irere"? He pulled a face: "She didn't get it from us [meaning that it had not been lent via his press office as a promotion]. Customers? Bring them on. He could maintain his design integrity while building a global brand. It was never about the money. If I can't keep honest, then I'm not going to do it." [16]

Scanners

Autumn/Winter 2003–2004

"I wanted it to be like a nomadic journey across the tundra." —Alexander McQueen

If "Irere" was a summer collection based on an equatorial rain forest, "Scanners" was the opposite. Set in the frozen tundras of northern Europe, "Scanners" traversed the Land of Darkness—so named by Norse traders—eastward to the Land of the Rising Sun; literally from the first fox-trimmed Samoyed-style coat worn by model Adina Fohlin, her hair in a topknot powdered scarlet, to the finale, a giant wedding kimono attached to a nude (bar a pair of men's underpants) Ai Tominaga, standing in the Perspex wind tunnel facing a blast of air and fake snow, looking like the "Winged Victor of Samothrace."

The presentation was held on the primary slot, the night of Saturday, March 8, 2003. "I wanted it to be like a nomadic journey across the tundra," he said. "A big, desolate space, so that nothing would distract from the work." The silhouettes were recognizably McQueen: broad-shouldered, full A-line skirts, high-waisted empire lines, body suits, layering, leather and tailoring. The same tropical red of "Irere" continued, with rich Oriental brocades. The kimono-base for robes ran on from Givenchy, and there was a distinct military feel, with both

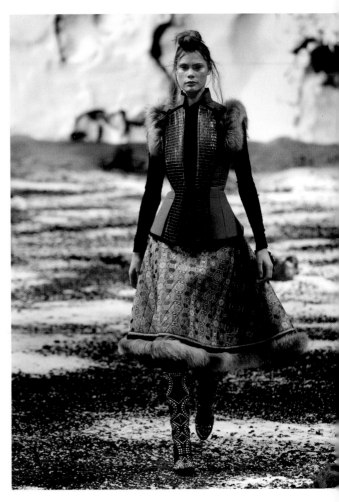

Left: A traditional look of a fur patchwork hooded jacket trimmed with what appears to be coyote, complete with a green miniskirt trimmed with gold and pink Aran-style legwarmers.
Right: Neoprene waistcoat with sequins, a black bandage top worn beneath, shoulders edged with fur, Nordic-influenced green and gold brocade skirt and studded black boots.

quilted and plain khaki green, a range of checks in black and white and red and white, and a fantasy on the "diced" trim on the Glengarry cap of the Scottish regiments. The black-and-white check theme extended through to form-hugging body suits combined with black leather, the second version shown in the wind tunnel with model Adina Fohlin carrying a huge inflated plastic "parachute" behind her.

Textures ranged from undyed jute in a bias-cut dress embroidered with peonies to ruffled chiffon pom-poms in a bubble-shape coat and a number of coats and jackets (controversially) in fox and mink, printed to look like lynx.[17]

Samurai armor was developed into carapace dresses, a Norwegian snowflake knitwear motif became brocades and two tailored Glengarry wool cloth dresses were real triumphs of tailoring. There were two touching homages to Issie Blow, an exotic character who was now part of this cavalcade of adventurers: a black peaked hat with a spray of plucked black spear-tipped feathers by Philip Treacy, a development of the one worn by her in March 2001's issue of the *New Yorker*, and a Tibetan brocade version of Treacy's pope's hat, worn by her in a portrait with McQueen at Hedingham House, photographed by David Lachapelle for *Vanity Fair*'s March 1997 issue.

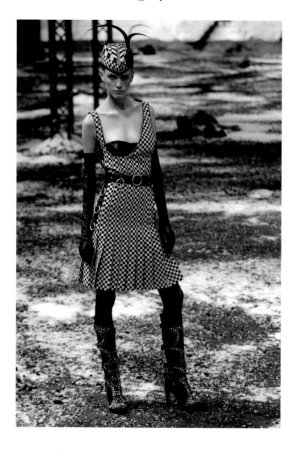

McQueen took his bow to the ringing applause, looking sharp, slim and blond, a "thin white duke" of Albion. As reported in the *Guardian*, it was the British designers who now dominated Paris: John Galliano, Stella McCartney and Vivienne Westwood. "Scanners" demon-

Above: Black-and-white checked pleated dress worn over black leather bustier, with a black-and-white Glengarry plumed cap by Philip Treacy.
Opposite: Natalia Vodianova in red bandage top, red and black bolero with kimono-style embroidered collar, green quilted skirt, red bandage boots and a feather hat by Philip Treacy.

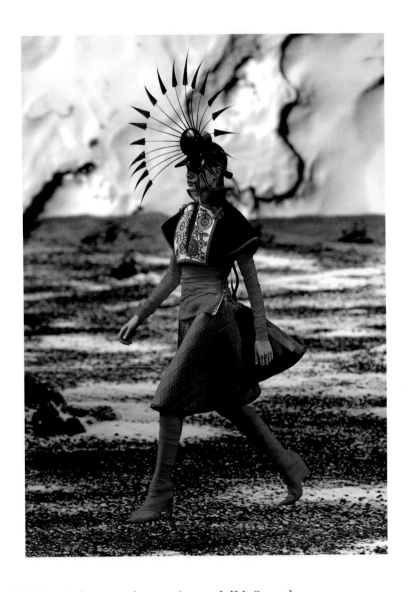

strated that the "high level of concept that goes into each [McQueen] presentation is as important as the attention to detail of the clothes themselves." [18] McQueen explained his motivation: "I do these really complex showpieces to push myself. I have to keep myself on the edge." The downside was that it felt like telling hundreds of people about his personal life, most of whom did not deserve to know. "And I wonder, was it worth it? I feel abused, yes, but then that's what I'm about. I wouldn't do it any other way," he said. [19]

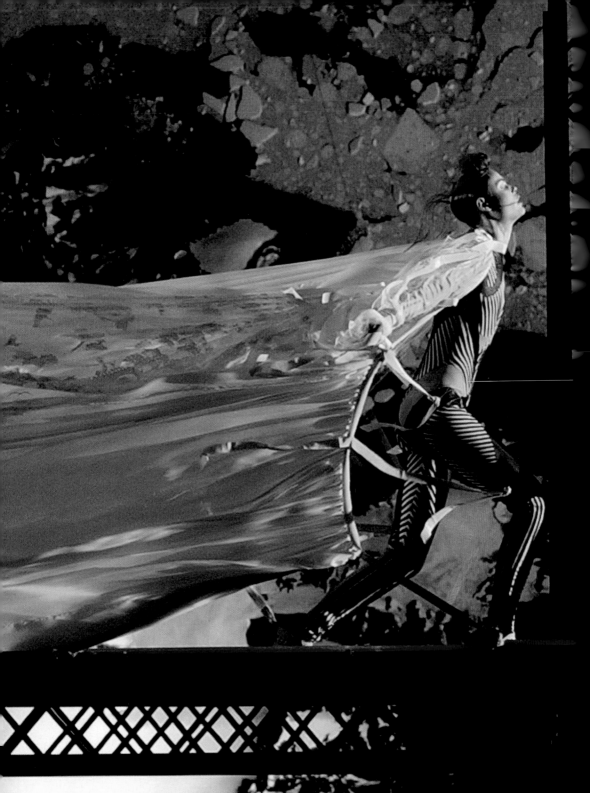

Accolades

On June 2, 2003, McQueen was honored by the Council of Fashion Designers of America with the Best International Designer Award. In the CFDA brochure, Kate Moss described him as "Anarchist, fun, thin, controversial, friend, loyal, charismatic, innovative, dark, determined."[20] The runway full of extraordinary clothes was the showcase for his abilities and for a collection of couture clients; the collection aimed at retail was made up of eminently commercial day dresses, separates, suits, eveningwear and accessories, ranging in retail price from $280 for blouses to $10,895 for evening dresses. That he was responding to the inner fantasies of American women—American fashion is more commercial than "creative"—was indicated by the orders placed at the trunk show held at his New York shop after the presentation of the award—$1.2 million spent on the "Scanners" collection.

A grander honor followed: he was awarded a CBE—Commander of the Most Excellent Order of the British Empire—in the Queen's list of birthday honors announced on June 16. The then chairman of the British Fashion Council, Nicholas Coleridge, was full of praise, likening him to the Beatles (awarded an MBE—Most Excellent Order of the British Empire—in 1965), claiming he was just as influential as the iconic British group, "probably more so." In a formal statement, McQueen was gloriously sensible, saying, "It is a great privilege to receive this honor. I now formally urge the British Government to match this recognition by investing in manufacturing and new talent—the foundation of British fashion."

Opposite: Kate Moss and McQueen by Mark Harrison, 2004, the year he was awarded a CBE by Queen Elizabeth II. **Previous spread:** Standing in a wind tunnel high above the runway, Adina Fohlin braces herself as the giant parachute-coat extends behind her with the blast of air.

McQueen, who admired Elizabeth I for being an "anarchist," was at first hesitant about accepting his CBE because of what it represented (the Hanoverian succession, English genocide in Scotland, the status

quo) but attended the investiture of this order of chivalry that October, "I got if for my mum and dad," he said. Dressed in the McQueen tartan, kilt, sporran and Glengarry with raffish falcon feather, standing in the queue at Buckingham Palace, the other recipients "looked at me with a 'Who the fuck are you? You're just a skinhead with a kilt on' look on their faces."[21] Her Majesty, of course, had better manners. It was a bit like falling in love, he said, as they locked eyes and both began laughing. "How long have you been a fashion designer?" she asked. "Quite a few years, m'lady." Afterward, there was lunch with family and close friends at Claridges. That September, he was made Designer of the Year for the fourth time. "I always try to be innovative, original and new, and I suppose I'm doing it right if I won," he said modestly in his acceptance speech, beamed by satellite from Milan, where he was opening his first McQueen shop.

Deliverance

Spring/Summer 2004

"There is no way back for me now. I am going to take you on journeys you've never dreamed were possible."
—Alexander McQueen

In the broad scheme of things, McQueen was not as influential as the Beatles, but in the fashion world he had achieved celebrity status. While his childhood had featured physical and mental abuse and he had wished he was as free as the kestrels he watched, now it was worse: "I'm in a glass box," he said.[22]

"Deliverance," which showed at the Salle Wagram, an old dance hall, was suggestive in title and expressive in content. Based

Models at the end of the show. The concept provided an opportunity to show the breadth and variety of the womenswear collection, from sportswear to the showpieces. The male dancers wear McQueen men's collection.

on Sydney Pollack's film *They Shoot Horses, Don't They?* (1969), its theme was about expectation and exhaustion. Choreographed by dancer Michael Clark, the three-part show showed new McQueen ideas, particularly distinctly 1930s bias-cut evening dresses in lamé, heavy with embroidery and encrusted with sequins; a vampish glamour more often seen by Galliano. It suited the story, set in the Depression, and the extravagant pieces were tempered, as part of the narrative, with plain little day dresses with white Claudine collars, patchwork coats, duchesse satin lingerie and sequinned leggings. Sportswear appeared in cutaways, Day-Glo pink trainers, denim skirts and jeans. Because the models had to be able to dance, the restriction of strict tailoring was abandoned. There were reprises of

LES CHILD
DANCER AND CHOREOGRAPHER
On Collaborating with McQueen

Choreographer Les Child is one of the UK's leading dancers and choreographers. He collaborated with Alexander McQueen on "Deliverance"—when he was assisting Michael Clark—and later on "It's Only a Game," McQueen's S/S 2005 show.

The brief was to interpret one of Lee's favorite films, Sidney Pollack's *They Shoot Horses, Don't They?*, based on the dance marathons held in America during the Depression. Lee said he wanted to find a way of using the film in his work.

The auditions were held on September 21, 2003, at Hampstead Town Hall. It was a big casting and we chose twenty dancers, mostly from a contemporary modern dance background with a few ballerinas. We were looking for professionals who could take on

choreography and deliver: dancers! I remember the rehearsals were unusual in the sense that the McQueen team provided bags and bags of shoes, whenever we wanted them. They were not familiar with the process of auditions and rehearsals, the process required to make a dance show, and sometimes looked bemused.

Lee had seen me dance for Michael Clark; I'd been dressed in women's clothes and had to wear stockings over character shoes to create an unbroken line, so I cut off the toes and heels and gave them a stirrup strap; anyway, this idea appeared on the runway with a pair of sequinned tights cut off at the toes.

We had a week to prepare for the show in Paris with the models, each partnered with a professional dancer. We had no time to rest; it was absolutely manic and I had to put the models

through their paces. A lot were very nervous because it was something they hadn't done before, but others were very keen, like Karen Elson, who was brilliant, all for it. It was only Lily Cole's second show. For the models, it exposed a weak point because they were out of their comfort zone. The boys would lead them so they had no control, and it was very challenging; the idea was that they were dancing themselves to death.

We had to interpret the film in three pieces, opening with the dancers in a ballroom, loosely in 1930s style, which showed the clothes really well. They moved as if they were presenting themselves with twirls, like at a fashion show, but dancing as if at a ballroom, doing the foxtrot. Then came the marathon, with the dancers running with ankles tied together, and the third section was the "finalists," moving individually as though they are broken and tired. It was a fashion show but a performance at the same time, and the reaction was incredible, people standing up at the end and screaming, saying they'd never seen anything like it before, and both Michael and Lee took a bow at the end.

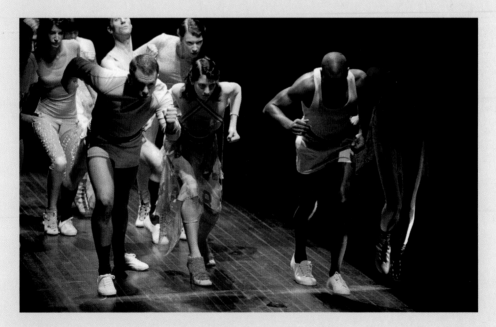

Above: The models get ready for the race. In the center, a pink-and-green chiffon sport-print bow dress is worn over pink embroidered tulle all-in-one; far left, tulle embroidered Swarovski crystal all-in-one with jersey sleeves, with a silver leather watch-strap shoe with diamanté crystal flower. Both could be made to order. **Opposite:** Toward the finale of the reenactment of the dance hall marathon, Lily Donaldson falls to the floor. Peach slipper satin and chiffon dress is set over a T-shirt.

his more recent collections: a diamond-piece bias dress with ruffles and lace-tied hipsters from S/S 2002, a chiffon Marie Antoinette top from A/W 2002, a black chiffon all-in-one and moss-green breeches developed from S/S 2003. His new menswear range, inspired by author Jean Genet in an amalgam of *Querelle* (1982) sailors and the pimps and hustlers from the book *Our Lady of the Flowers* (1948), was debuted. The sense of decay in the latter (when a Paris drag ball is described in detail, as secondhand frocks are ripped on the dance floor) was prevalent in this unique presentation.

Pantheon as Lecum

Autumn/Winter 2004–2005

"I've never aspired to mass production. Because of my training as a tailor, my work involves lots of love and care, which is why so many of my clothes are made by hand here in London. Not to wow the crowd during a show, but because I love it." —Alexander McQueen

On November 4, 2003, Domenico de Sole and Tom Ford announced that they were leaving PPR, parent company of the Gucci group, citing artistic differences. It was a blow to McQueen. He had been supported creatively and financially by both men, who had put their faith in his talent, whereas LVMH had not. Without them, Alexander McQueen would not have become a global brand—with all the positives and negatives that impacted his life. And they were his friends, in an industry riven with ambition, where it is all too often every man for himself. Anyone who compared his "Pantheon as Lecum"

with Dior's overreferenced, excessive show that season could see a designer who was self-disciplined, and who was allowed to follow his own vision. PPR was looking for speedy expansion so offered McQueen the role of creative director of Yves Saint Laurent when Ford resigned from the post.[23] He sensibly turned it down in order to focus on his own label. "Pantheon as Lecum" with its implicit reference to the gods of Greek mythology and "bread and circuses" interpretation, was about abandoning extraneous drama.

Unfortunately, the audience wanted to be entertained; he had given the fashion press, hungry for new ideas, bread and circuses. Clothes with a theatrical setting that titivated the tired senses were expected. What he presented in "Pantheon as Lecum" was largely a range of silk jersey evening dresses draped, wrapped and tied in a way that owed a huge debt to Madame Vionnet. This artful simplicity demanded a skill that went beyond bias cutting; it required sensitivity to and an understanding of the body and how fabric works on and *with* it. That was the art. Some critics panned the show; others, like Susannah Frankel, saw its cleverness. He had lovingly created "second skins" that concealed, suggested and protected a woman's frame rather than exposed it.

Models, pale and ethereal, androgynous in their curled kouros wigs, appeared to have landed from another planet and were stepping out of the mother ship. The runway was circular, lit from below; the rigging above looking liked the base of a hovering spaceship. A film of lunar surfaces, the flames of the sun and rockets at takeoff set the scene. Gemma Ward came out first in what was to be the initial section of the fifty-five-piece show: a flesh-toned theme of silk jersey, cashmere, tweeds and soft leather. Continuing on from the influence of "Deliverance," there were references to the later 1930s with pussy bows, broad shoulders and a tweak of asymmetry to mismatching collars and hems. Two brilliant tweed jumpsuits with draped collars, the first with culottes like Elsa Schiaparelli's radical divided skirts of 1931

and the second with swinging palazzo pants, were a first for McQueen. Cinched waists morphed into body-molding tops and paneled skirts. Number twenty marked the next section in the narrative, grading from flesh colors to sand and earth hues. A jacket and coat padded and structured in a diagonal inverted V-shape to look frankly phallic, then shearling coats and jackets, a yoked jumpsuit in tweed and leather and a coat and jacket with an embossed design reminiscent of the "extraterrestrial" Nazca lines in Peru. Then followed floating chiffons that included jaguar-print, feather and glass-studded shoulder capes, Amerindian in inspiration. The penultimate section, at number forty, was highly sophisticated eveningwear—dresses, jumpsuits, short and long-hemmed, in Vionnet-style duchesse satin that simply spoke of the female body and celebrated it. The palette morphed from midnight blue to black, with digitalized prints of febrile tiger lilies and orchids. Emphasis was on the hips: McQueen was experimenting with a new silhouette that was not based on the waist.

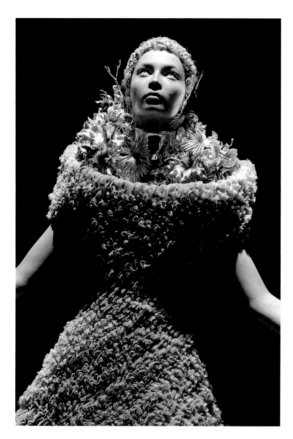

Model Tiiu Kuik wears a pale gray, ruffled lace gown and silver floral neckpiece by Shaun Leane and a wig in *tête de mouton* style. She is lit by overhead lights that signify a spaceship.

Number forty-eight had its reference in Sir Edward Burne-Jones and the medieval-nouveau of the pre-Raphaelite artists—sinuous women in "kirtles" (a tunic-like garment). This work had become

familiar to him while staying at the Blows' Arts and Crafts house, Hilles in Gloucestershire, which featured work by William Morris and Burne-Jones. "McQueen would take ideas from many different places and make them his own. He was a romantic," believes Bobby Hillson, "and a one-off." From alien landings to a Victorian idealization of an Arthurian England: a curiously sane response to the maelstrom of fashion-industry politics. The final four looks were about the future—silvery shapes that created a shell around the body, presented in the dark and illuminated by LED lighting. "There's more beauty at night, when the lights are off," he said.[24] The finale piece, a wasp-waisted, crinoline-widened dress worn by Tiiu Kuik, was made from hundreds of strips of flat man-made yarn. Before he left the runway, McQueen, in a white suit and bare feet, embraced de Sole, a measure of his affection and gratitude to the man who had turned him from a British designer on a small scale to a global fashion brand in four short years.

The First Menswear Collection

By getting manufacturing systems for ready-to-wear up and running (back at the Novara factory, where he started at Romeo Gigli) and building relationships with the companies that made the shoes, leather goods and menswear, McQueen had been focusing on establishing his company as a multinational label. By mid-2004, he could call the situation "stable" and was proud of the fact that he was one of the few British designers who had never filed for bankruptcy. He wanted the brand to keep growing. "It's either onwards, or nothing at all. Otherwise what's the point of doing it?" he said.

He had presented his first menswear collection, "Texist" for S/S 2005 on June 24, 2004, in Milan. A military-inspired range, the show

incorporated models painted blue, like woad-stained ancient Britons, hot pink and red, with henna-tattoo motif T-shirt and leggings, wrapped fabrics, a feather-boa scarf and Glengarry caps—all integrated into a series of finely tailored drape jackets. He had brought references from his womenswear into masculine territory, which was only just; he had played the masculine/feminine game with his women's collections enough times. It was personal, too, as if he had taken a walk around Brick Lane and absorbed the different "tribes," from city-types to boxers at the Bethnal Green gym to local Indian boys, just like in "Dante." Writer Tim Blanks accurately noted that there was more "sensuality" in his menswear than womenswear. It was simply lashings of sex; clothes for blokes and done well. "I designed them for myself," he said simply.

Long-sleeved nude T-shirt printed with red tattoo-style design, camouflage trousers and Glengarry cap in khaki, trimmed with floral ribbon: a feminine decorative aesthetic combined with traditional military style.

Preceeding "Texist," his first menswear range in 2002 was a collaboration with Huntsman of Savile Row. He'd made the mistake of designing with a customer in mind, when what he needed to do was think about what he would want to wear: "Men don't like being dictated to by women, so they're not going to like being dictated to by a queen," he said. Which raises the point about his women's clothes; without the sexual interest—his womenswear may have achieved sexual allure, but it was more about power—he was far freer to be imaginative and basically "creative." So why do gay men make such good fashion designers? Alex Bilmes asked him for *GQ*. "Because they're scared to be plumbers," he replied.

McQueen said he'd only become confident about his talent over the past few years,

Long-sleeved cotton jersey T-shirt with high-waisted dark gray cargo trousers, lace-up boots and exotic woven scarf from "Texist," 2005. McQueen's inspiration was himself; these were the kinds of clothes he liked to wear.

stopped going through magazines, checking his own work against other designers, and allowing his own ideas to emerge. His uniqueness was already apparent, but it took him time to see it. So this was the interview he gave to a highly responsive journalist *before*

"Pantheon as Lecum" and the lukewarm response to it from some quarters. It will have knocked him. He was delighted when, in September 2004, Jonathan Akeroyd, who had spent fifteen years at Harrods, working his way up from the shop floor to top management, joined Alexander McQueen as president and CEO. In the next collection, McQueen underlined his strengths: a show staged as theater, unique showpieces that were part of a narrative would appear as promotion in the press and be presented as installations in his flagship stores. They could be specially ordered by certain clients and made up in his London workrooms. Then there were the commercial pieces that would go into the shops and sell along with his ranges of accessories, the staple suits, knitwear and separates that carried the colorways and spirit of the collection; along with his black ranges. The latter he celebrated in a charity event called "Black," held to raise money for the HIV/AIDs charity Terrence Higgins Trust on June 3, 2004—a reprise of his best black pieces (including his now ubiquitous white skull print on a dress worn by Kate Moss).

McQueen playing with figures in a miniature maze. Photograph by John P. Midgley.

It's Only a Game

Spring/Summer 2005

"That's what I'm here for, to demolish the rules but to keep the tradition." —Alexander McQueen

McQueen's S/S 2005 collection, "It's Only a Game," was held on October 8, 2004. Staged as a game of chess, with thirty-six models playing opposing queen, bishop, rook, knight and pawns, the idea was inspired

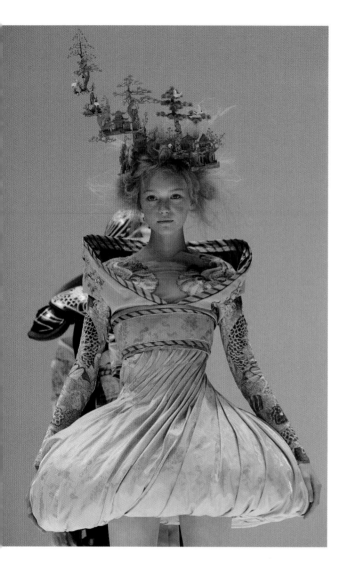

by the magical chess match in the film *Harry Potter and the Philosopher's Stone* (2001). It was his development of the colonial costumes in *Picnic at Hanging Rock* (1975), worn by models playing pawns. Eminently feminine, the colors were soft Edwardian hues, primrose, eau de nil, violet and dusky rose; the jackets waisted, skirts short and full, with pretty party frocks.

As with *Picnic at Hanging Rock*, there was a threat to the idyll, expressed in an updating of some of his favorite looks. These were powerful chess pieces, two in molded fiberglass armor with horsehair hems and swinging hairpiece-ponytails. One queen was a Marie Antoinette–meets-rococo in shell pink, panniered short skirt and spiked crown; her opponent wore a carved chinoiserie landscape as a headpiece. The knights were dressed in American football–style ensembles printed with Japanese koi tattoos; shorts and bodice in Leon Bakst–derived prints, rooks in motocross jumpsuits with a big

Above: One of the "queens," in a kimono shape twisted and set into panniered-style short skirt, an underbody embroidered with a Japanese tattoo design. She wears an intricately carved japonaiserie crown. **Opposite:** One of the "knights" in a horse's-tail hairpiece, a molded fiberglass bodice with natural-shaped breasts, cutaway at the front, with military-style stock framing the face, laced at the back, over a dress depicting a carousel in appliqué and embroidered detail. Her shoes would have jingled like the trimmings on a pony.

Q emblazoned on the chest. Among them were kimonos, Japanese prints, cinched waists and a floaty empire-line ivory silk dress with appliqué carousel horses in a nod to "What a Merry-Go-Round" (see also page 174).

Then the lights dimmed and went back up again. The audience saw the "chessboard" and the game ensued: an all-female standoff choreographed by Les Child, in which opposites—redheads, Asians, Americans, blondes—were the two sides. As the game progressed, some were played off while others remained. For the finale, McQueen came out to the strains of Elvis singing "Suspicious Minds."

To escape from business, Lee McQueen spent time at his country home, near Hastings, finding comparative tranquillity through solitude and nature. "What money buys me now is comfort," he told *GQ*. "My life is so stressful, I work so fucking hard!" With an average of a week off between the end of one collection and the start of another, his ideal form of transport was the TARDIS, Dr. Who's medium for instant travel. The stress he described wasn't just work related, either. In March 2003, he and Shaun Leane had taken an extremely depressed Isabella

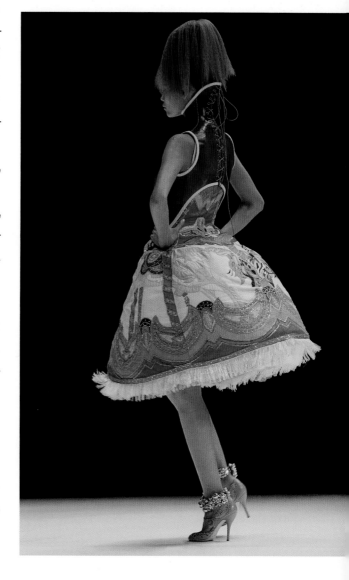

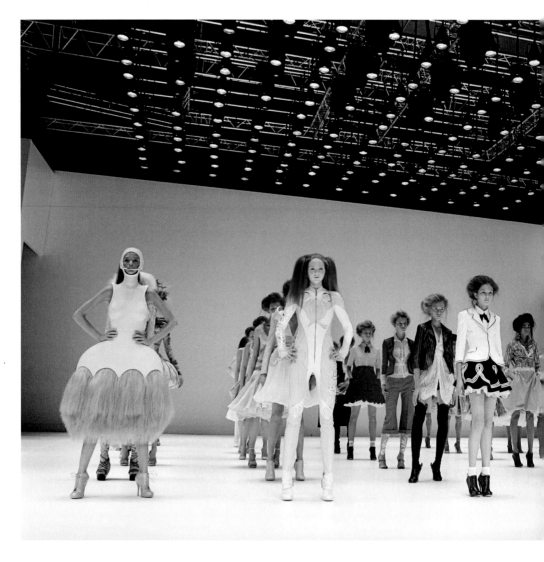

Choreographed as a living chess match by Les Child, McQueen was also inspired by the 1975 film *Picnic at Hanging Rock*, with its Edwardian charm and sinister undercurrent. The combination of ideas made for one of his most spectacular shows and beautiful collections.

Blow to the Priory Hospital in North London for treatment, paying for this on condition that she should separate from her husband for good.

As far as McQueen was concerned, Detmar Blow was the real problem, particularly as he was in favor of the electroconvulsive therapy (ECT) Issie received as treatment. In June 2004, the couple

had reconciled, but Issie's desire to kill herself had since become an obsession. By 2005, McQueen was no longer speaking to his friend because of the reconciliation, while she in turn was equally upset because he would make her wait for a McQueen outfit (he had tired of lending them to her and not having them returned). Any additional demand on him, whether emotional or work related, simply added to the pressure on him to deliver—"The more stress I have, the less productive I am," he said.

LES CHILD
DANCER AND CHOREOGRAPHER
On Collaborating with McQueen

Lee loved to play chess. So when I was approached to choreograph the show and he wanted it based on a game of chess, and I said I'd never played it, I was given a book and told to learn it.

We mapped a chessboard out on the floor of the rehearsal space—on top of a car park (parking lot) and I used chairs as the models—very difficult because we didn't have the bodies to work with, and I hadn't seen the clothes. We taped out each move onto a piece of paper, doing lovely patterns. It was very simple, just getting the models to move as if they were part of a game of chess—directing by saying, for example, "Knight moves to bishop.'" The idea was that the girls and the looks would be opposites, say a redhead opposite an Asian model, a look inspired by sportswear opposite a geisha queen. Each square was mapped out in lights, and the music was a mix of Frankie Goes to Hollywood's "Relax" and "Two Tribes."

Lee brought performance back to fashion, that energy and inspired individuality from the 1980s, comparable with Bodymap and when the models had personalities. And the influence of Leigh Bowery was very apparent. Now the models appear robotic, somnambulistic by comparison.

In a working situation, he was always present, but I miss that dynamic and creative force, the idea that someone of his greatness had called on me—he had the passion of a creative artist.

In 2001, someone at LVMH had fired a shot about McQueen's alleged drug use—"The problem with Mr. McQueen is that he is always on drugs."[25] Of course there is nothing unusual in that when it comes to the top end of the fashion industry, particularly in the diaspora at designer level. Nevertheless, he had allegedly developed a serious cocaine habit, which he never managed to successfully kick. With hindsight, perhaps LVMH would have done better to focus

on supporting John Galliano, who was fighting demons of his own. With the pressure for expansion on, for the next two seasons McQueen produced collections by the Gucci Group that were commercially driven to the detriment of his scene setting and the feats of craftsmanship now expected of him.

So, was he "the man who knew too much"? He sums it up in a statement from 2004: "Designers have to make a choice—art or money. I don't create art; I create clothes people wear." This may have been sensible, given Gucci's 51 percent stake in his business, but it ran counter to his idea of himself that went beyond being "just" a designer. "Every six months you do a show and get publicity, but it's between those six months that it deteriorates. No one in the fashion press or the buyers actually sees the trauma you go through to get things done," he added.[26]

The Man Who Knew Too Much

Autumn/Winter 2005–2006

"I want to create pieces that can be handed down, like an heirloom." —Alexander McQueen

Held at a vast school hall in Paris on March 4, 2005, "The Man Who Knew Too Much" loosely referenced Sir Alfred Hitchcock's 1956 film (a remake of his first, made in 1934.) The star was Doris Day, but she was not a "McQueen woman" any more than Audrey Hepburn had been. She was as fresh and wholesome as apple pie, whereas his

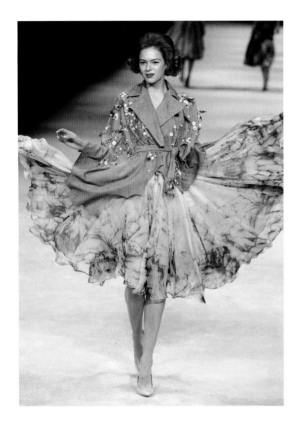

Elise Crombez, hair styled like Tippi Hedren, wears a sand-colored cape based on a trench coat, decorated with pearl buttons, feathers, sequins and beads, with multicolored silk threads, and tied at the waist, over a digitally printed floral circular skirt. The cape is a nod to the Cockney Pearly Kings and Queens tradition, adapted to the Paris runway to achieve a delicate beauty.

own palate was more attuned to the justice meted out to Michael Gambon's "thief" in Peter Greenaway's film *The Cook, the Thief, His Wife & Her Lover* (1989).

There were neat little tweed suits, trench coats, jeans cut like jodhpurs, Navaho-style wrap jackets with leather fringing and, in anticipation of his McQ diffusion line the following year, a Fair Isle cardigan-without-a-twist came down the runway. There was also a range of denim. Ball gowns based on the cold glamour of the 1950s were aimed at the red-carpet client—particularly one in scarlet, set into a swirl like a Charles James but not as good. McQueen's last was a tribute to Hollywood costume designer and couturier Jean Louis's iconic flesh-colored marquisette and crystal-encrusted gown worn by Marilyn Monroe when she sang "Happy Birthday, Mr. President" to John F. Kennedy in 1962.

This was the first collection where one could tick off references to other designers. It was also the time when McQueen didn't make his usual appearance to greet his audience at the end, which suggests he may have been even more stressed than when he would pop his head round the back after the early shows, all the while living in

terror of the DHSS. Dealing with too much money and satisfying the backers supplying it, rather than a lack of finances, was now part of the problem: the collections had to sell for his owners. And this one did. It was his biggest commercial success to date, "a parade of beautifully cut pencil skirts, coats and cocktail dresses based on Hitchcock heroines [McQueen was not a Grace Kelly man, too glacial] that had buyers and editors alike salivating, and has been one of the most influential collections of the season."

At this point, it is worth reiterating that McQueen veered between speaking his mind and toeing the party line with the press. This time he did the latter. He had been playing with the silhouette in a way that got rid of the hourglass shape. However, in an article titled "Boy Done Good," he told the *Guardian*, "I've found my customer, my silhouette, my cut. You can hide so much more behind theatrics, and I don't need to do that anymore."[27] This somewhat patronizing title does raise the question of how some simply did not trust his creative instincts, but as Sarah Mower perceptively noted for Style. com, "A cynical trotting out of an overextended theme isn't what the fashion world expects of Alexander McQueen. We know; he knows: He's bigger than that."[28]

Neptune

Spring/Summer 2006

"Women can be anything." —Alexander McQueen

McQueen's S/S 2006 show, called "Neptune," held on October 7, 2005, should have been an exuberant celebration of his role as "Poseidon" and his "mermaids"—those exotic "Dames des McQueen,"

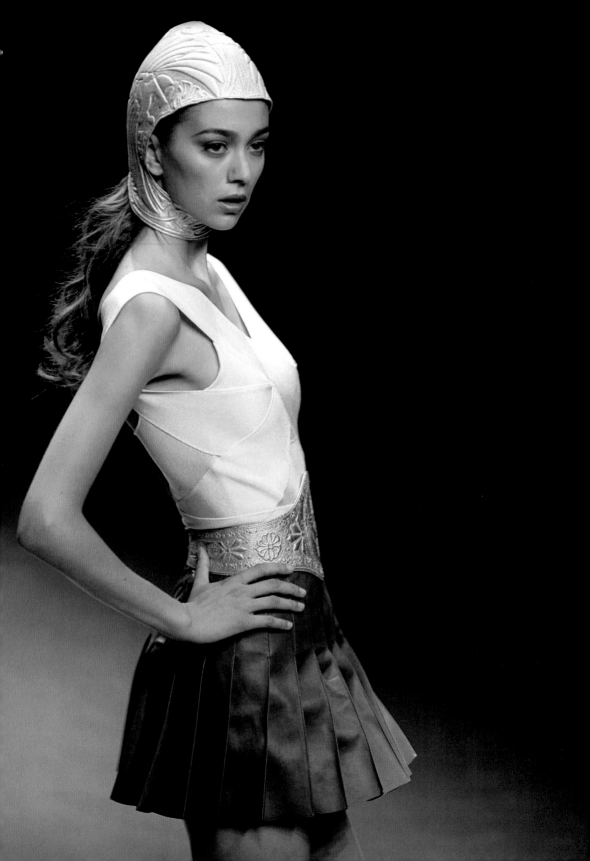

Above: Models and looks at the end of the show. **Opposite:** Ivory viscose V-neck, sleeveless bandage body, sage-green leather pleated skirt with tooled silver leather, a "boxing" belt and metallic tooled leather hood with organic patterning.

such as the febrile Issie Blow and the give-it-a-go sartorial extremist, Daphne Guinness. Instead, after no doubt highly commercial black suits and flirty dresses, those "mermaids" buying from the collection would be leggy "It" girls in overtly "sexy" short green jersey-draped tunic dresses and gold swimwear that just screamed Cinecittà kitsch. "Though some of his moves are clearly being made in an effort to sell—no criticism in itself—this show, from a designer whose capabilities have won such respect, was a letdown," wrote Sarah Mower of Style.com.[29] It simply wasn't good enough, coming from Lee McQueen.

This time he appeared wearing a T-shirt specially printed with the words **WE LOVE YOU KATE**. He was taking a stand in

support of his friend Kate Moss. The supermodel had allegedly been caught on camera snorting cocaine and was subsequently dropped by H&M from its advertising campaign and also dropped as the face of Chanel for its fragrance, Mademoiselle. At the same time, Moss was dropped but then reinstated by Burberry. The appearance was the action of a loyal friend, and in the process McQueen was telling some of the authority figures who run many of the major fashion houses with their "bottom lines," not to mention the press, exactly what he thought of them.

"She's not the first person in fashion to do cocaine, and she won't be the last. She's done more for London fashion than anyone else. Go to the newspapers and wipe their toilets. Fucking hell, you've got Colombia on your hands!" he told *Elle* magazine. It was to be his only piece of runway performance art for that season.

Widows of Culloden

Autumn/Winter 2006-2007

"I wanted to exaggerate a woman's form, almost along the lines of a classical statue." —Alexander McQueen

Kate Moss made an appearance in his next show but as an otherworldly apparition, wraithlike in a glass pyramid. She was in a film by Baillie Walsh and art directed by Lee McQueen to the haunting sound track of the movie *Schindler's List* (1993). The idea behind it was "to show that she was more ethereal, bigger than the situation she was in,"

he explained.[30] Dancing in slow motion, with semicircles of chiffon fluttering about her, Moss was the essence of the eternal female and of the "Widows of Culloden," to whom McQueen dedicated his latest collection, held on March 3, 2006.

Just as others were questioning whether McQueen had "lost it," he rallied round. He had returned to the Scottish theme and the "Highland Rape" collection of 1995 (see page 77), with which he made his name—and returned to form, too, with a collection that ignored the commercial pressure to appeal to a diverse market and talked instead about ideas and innovation. "I wanted to show a more poetic side to my work. It was all about a feeling of sadness, but in a cinematic kind of way—I find beauty in melancholy," he explained.[31] The tweedy tailoring of the grouse moors met

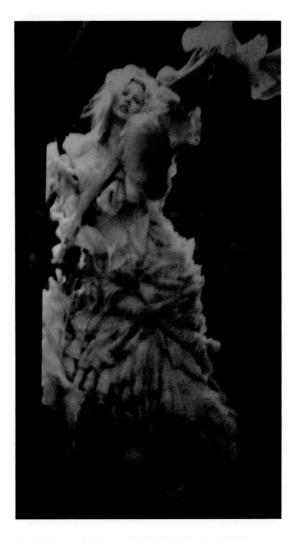

A still from a hologram of Kate Moss by Baillie Walsh, art directed by McQueen, which was the finale—and a great one: she, tousled and mysterious, fluttered in ruffles to the sound track of *Schindler's List*, composed by John Williams.

Flora MacDonald, Jacobite heroine, who famously helped Bonnie Prince Charlie (Charles Edward Stuart, the young pretender) escape from the Isle of Uist to the Isle of Skye, home of McQueen's ancestors.

The collection reflected country-house eccentricity of the day, with bird-wing hats and too-large tweeds suggestive of putting

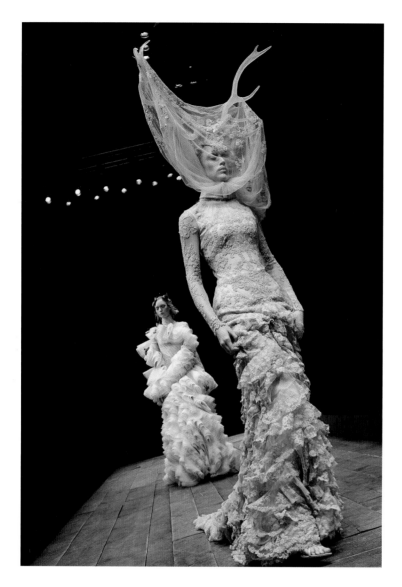

Above: Palest yellow silk with overlay of cream silk lace, fitted narrow to the hips, with cascading bias-set lace flounces, resin antlers draped with floral lace, worn by Raquel Zimmerman. Behind is Gemma Ward in a development of the "Oyster" dress, with volume-building white ruffles set in a spiral and decorated with butterflies. **Opposite:** McQueen tartan dress with bustier bodice, the plaid draped traditionally over one shoulder and then around the neck. Undergarment is a nude top with appliqué black lace and tulle underskirt. The belt buckle is tooled with a Celtic design. The model's hair is decorated with a black feather hackle plume.

on an heirloom; also intricately cut dresses and trouser suits in the McQueen tartan. There were James Tissot ruffles on a cream lace dress, topped with a headpiece of stag's antlers and a veil of embroidered lace, piercing the fabric and sticking through, creating a phantasmagorical hybrid beast-woman, wandering the highlands for eternity. The animal imagery extended to a flamenco-style dress, fitted tight to the neck and cascading in tiered ruffles, all in tiny pheasant plumage. Alternatively, there were ballooning brocade dresses with a raised, fitted bodice, or fitted black velvet gowns for the evening.

It had all the trimmings beloved of McQueen: black jet passe-menterie, feathers, embroidered tulle, brocade, asymmetry and the masculine crossover to the feminine. Cut with this were pretty Arts and Crafts–cum–Elizabethan ruffed day dresses, slouch coats and a wonderful double-breasted suit. "It was," he explained, "romantic, but melancholic and austere. It was gentle, but you could still feel the bite of the cold, the nip of the ice on the end of your nose. With bustles and nipped-in waists, I was interested in the idea that there are no constraints on the silhouette. I wanted to exaggerate a woman's form, almost along the lines of a classical statue."

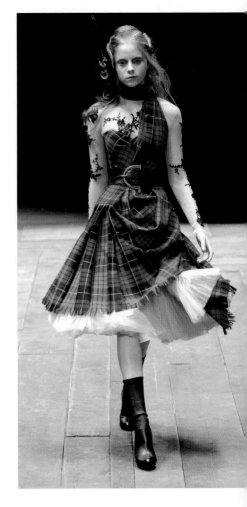

This exaggeration was to take place in the round. He designed with a side profile view in mind, as well, so what the audience saw were some of the fantastic S-bend shapes of the 1870s and 1880s, with the emphasis on the derriere—an area of erotic interest enjoying a revival at the time with Jennifer Lopez's pneumatic rump, hence the bustle.[32] When McQueen was talking about silhouettes, he meant a variety of things: distortion, displacement emphasis and a challenge to West-

ern ideas of sensuality. With its cocoon shapes and rough-edged giant ruffles, in its sculptural nature the collection is far closer to the purist cutting of Cristobal Balenciaga than to decorative whimsy. For McQueen, it represented a watershed, and from that point on, he remained as true to himself as he could be.

Sarabande

Spring/Summer 2007

"People find my things sometimes aggressive. But I don't see it as aggressive. I see it as romantic, dealing with a dark side of personality." —Alexander McQueen

Held on October 6, 2006, at the Cirque d'Hiver in Paris, according to the program notes, McQueen's "Sarabande" owed its inspiration to Stanley Kubrick's masterpiece *Barry Lyndon* (1975), to the Marchesa Luisa Casati (1881–1957) and to Goya. The title came from Handel's stately "Sarabande," used by Kubrick to add a moody baroque grandeur to his film, but there were other elements, too; the Belle Epoque glamour of Luchino Visconti's *Death in Venice* (1971), a touch of Flemish gothic, an effusion of exotic birds and the transient beauty of flowers. "My mood was darkly romantic at the time," McQueen explained. It was a near-perfect collection, most of which was part of the selling collection, including a range of whippet-slim suits and jackets with a reworking of the puffed-sleeved shoulder and certain

Daphne Guinness in lilac tulle bustled evening dress, sprinkled with Swarovski crystal, from "Sarabande." Photograph by Sølve Sundsbø. An hourglass silhouette, with hips enlarged and a circular confection of tulle spilling out at the knee and into a train, the piece has all the voluptuous glamour of Mae West gowned by Travis Banton.

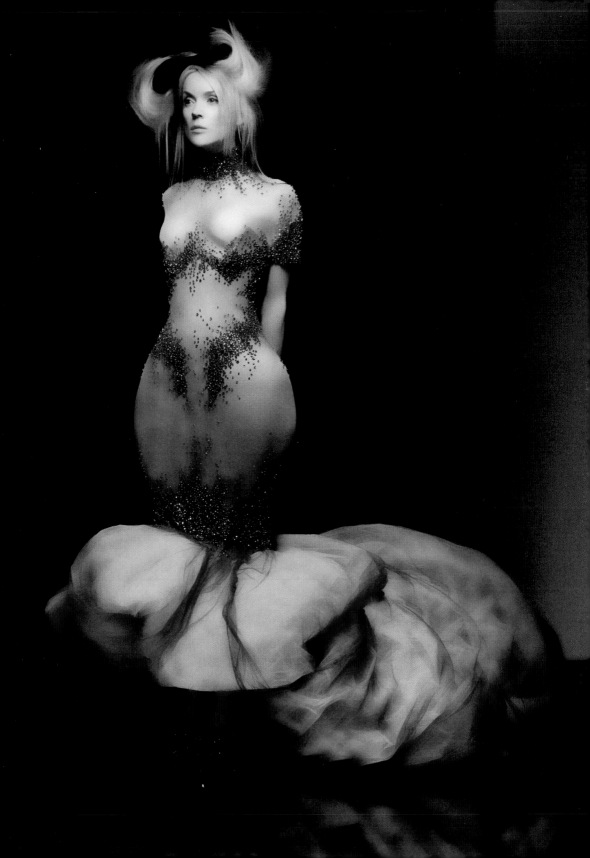

showpieces developing the contours of both hip and bottom. The aim here was sensuality, something "more womanly."

To enable the audience to see his garments "in-the-round," the stage at the Cirque d'Hiver was circular, with a massive crystal chandelier at the center. It was winched up as the show began

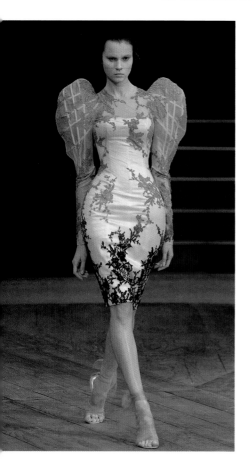

and the chamber orchestra (the women all in McQueen gray chiffon dresses) played Handel's "Sarabande"—a slow, rhythmic formal dance, setting the scene for the models. Instead of pacing with attitude, the models moved in slow formation: the first in a high-waisted black raffia redingote, ruched for shape and drape, and side-fastening, with a dramatic black silk hat twirling like a giant rose by Philip Treacy. The whole look was reminiscent of Piero Tosi's costumes for Silvana Mangano in *Death in Venice*.

Variations of sailor flap-fronted gored skirts in ivory silk and cotton with neat little-waisted puff-sleeved jackets followed, cleverly combining *garçon fatale* Tadzio's sailor's suit[33] and Mangano's black-and-white look. In the beach scene and building to black was a black skirt embroidered with crows and a bolero jacket, its sleeves just exposing the wrist; also a white bowler hat covered in black jet lace. The theme continued, with crows in embroidered Jacquard, the second black-on-a-cream, with a cutaway Poiret-like riding coat over a high-waisted, slim-fitting skirt—the black graphic of birds "circling" the skirt in a perfect realization of the elongated Directoire line. Then the silhouette moved on from sinuous to volume at the hips, bar the interruption in the story of one trouser suit in black—cropped trousers, cropped waistcoat and a jet-embroidered puff-sleeve jacket

with all the streamlined energy of the trouser suits that would define fashion at Céline in 2009. And finally, lest it should be too contemporary, Treacy's black silk hat was a re-creation of Jan van Eyck's hood, twirled into a turban in his self-portrait of 1433. A version of this had been a favorite of Issie Blow, years before.[34]

McQueen then slashed at hems, cutting away the front at knee and calf level, thrusting the bulk of fabric to the back to build up the hips with padding, creating a horizontal shoulder line. Two "Girdle dresses"—one in black, the other in cream, with 1890s gigot sleeves—were both boned at the waist, bustled and padded to emphasize hips and thighs, "to look like the statue of Diana with breasts and big hips. It's more maternal and womanly," he said.[35] It was the initial step toward his carapace line, perfected in his final collection, "Plato's Atlantis" (see also page 260).

Next came McQueen's homage to Casati, based on the portrait of the enigmatic patron and sartorial extremist by Ignacio Zuloaga (1922): draped and veiled in a floor-length gray lace mantilla, the little white dress underneath was notably unlike the spectral Casati, with its indented "strain" marks at the thighs and a padded rear. He revisited the silk petals on organza from "Nihilism" (see also page 59), adding a cascade of black ostrich feathers. Building up to the finale, the pure showpieces explored shifting contours: first, with a cream leather molded dress with nipple and muscle indentations, its raw sexuality softened by hand-painted flowers and birds reminiscent of a faded Audubon print. Then a Swarovski crystal–embroidered lilac tulle evening dress, padded hips and bustle;

The sleeves are in the 1590s "medieval" style at its most exaggerated, boned in a lattice pattern, all cut on the bias to allow for movement. The bust to lower neck is nude and embellished with cut lace. This is McQueen playing with volume and presenting a fecund rather than nubile silhouette.

a Balenciaga-style puff hem below the knee was its less voluptuous version, an overlay of lilac and purple tulle crossing at the front to create an inverted V before exploding into three tiers, resembling an

overblown exotic fungi. These muted shades reminded him of the pre-Raphaelite photographs of Julia Margaret Cameron (1815–79): sepia prints, then hand painted and dimming with age.

This sense of the temporal was expressed in his last two looks. A "funnel collared" boned bodice and boned skirt,[36] in which real and silk flowers edged both neckline and wrists, and were embedded in the skirt's tulle layers. It was one of his most exaggerated and thought-provoking pieces, a shell that altered the contours of the body while contrasting it with the softness of fading flowers.

McQueen was fascinated by the male bowerbird, which relies not on plumage to attract a mate but the ability to gather material and build a home to meet with her approval.[37] The female prefers things that are brightly colored, revealing an exotic decorative sensibility. Indeed, British broadcaster and naturalist Sir David Attenborough once presented footage of a nest surrounded by the heads of pink flowers broken off by the male and arranged for inspection. In a reflection of this, McQueen's finale dress was a confection of real peony and chrysanthemum heads sewn onto transparent silk, with pagoda shoulders and a cutaway front. It was a gorgeous manifestation of nature, but like the razor-shell dress in "Voss" (see also page 167), pieces began to fall off on the runway. Similarly to the moths in the "Voss" endpiece, this dress was also doomed. "Things rot," he later explained in an interview. "It was all about decay. I used flowers because they die."[38]

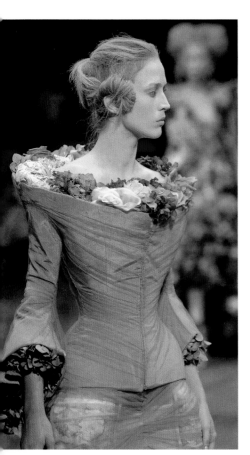

As Susannah Frankel noted in *Harper's Bazaar* magazine shortly after "Sarabande," the product was now more important than ever: McQueen needed to break even by 2007. Not

only did he have to present ideas that were commercial, but they also had to be unique, offering what was not available from anyone else. That season no other designer showed anything so historically based or so ripe with historical references. The Christian Dior ready-to-wear collection appeared to be all about sales (the press looked to Galliano's couture collections for Dior for his real ideas); Jean Paul Gaultier was now formulaic, while Balenciaga had developed McQueen's strappy, carapace look. In London, with the British Fashion Council's emphasis on "new talent," designers (with the exception of Jonathan Saunders, who was following his own instincts about print and color) simply did not match the standards of Lee McQueen. "There are only a handful of designers that influence other designers, and I have to keep one step ahead of the game. As a designer, you've

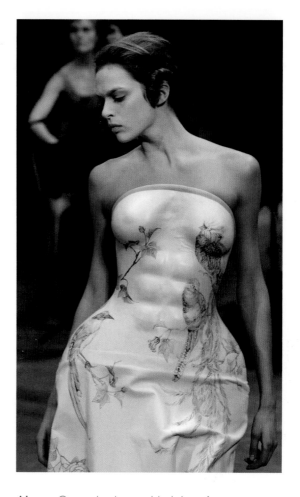

Above: Cream leather molded dress from "Sarabande," decorated with birds from early ornithological studies. **Opposite:** Scooped funnel neckline, boned bodice and 1840s "bertha" structure, with sleeves set low, the cuffs cut in a funnel shape. A soft, dusky pink is overlaid with ruched lilac tulle, as is the skirt, which has latticed boning and flowers set between silk and tulle. The notion of female fecundity is furthered by the addition of fresh and silk flowers.

always got to push yourself forward; you've always got to keep up with the trends or make your own trends. That's what I do," he declared.[39]

In Memory of Elizabeth Howe, Salem, 1692

Autumn/Winter 2007–2008

"It is important to look at death because it is a part of life. It is a sad thing, melancholic but romantic at the same time." —Alexander McQueen

It was on the suitably stormy night of March 2, 2007, that Lee McQueen presented his collection "In Memory of Elizabeth Howe, Salem, 1692." Elizabeth Howe was one of the innocent victims accused in the notorious witch trials in Salem, Massachusetts, immortalized by Arthur Miller in his play *The Crucible*. McQueen's mother, Joyce, had discovered that the family was distantly related to Howe, who was hanged on July 19, 1692, following false accusations made by young girls. For this collection, which spoke of his loathing for bigotry, McQueen visited

McQueen was greatly moved by the story of an ancestor wrongly accused of witchcraft and hanged during the Salem trials of 1692. He had also been investigating ancient Egyptian magic and religion; all came together in this collection, hence the Elizabeth-Taylor-as-Cleopatra-style makeup. Here a green, shot with gold, silk brocade coat, worked in an ancient Egyptian design, is worn over a bodysuit simulating tribal body painting, an idea that dates back to "Irere." A collar of iridescent peacock feathers edges her neck.

Salem and Howe's grave. Around the story, he wove in elements of ancient Egyptian paganism. Held in a sports stadium outside Paris, the square runway was covered in dark gravel, inlaid with a huge red crystal pentagram, above which hung a 45-foot inverted black pyramid. To add the final touch of atmosphere, a film directed by

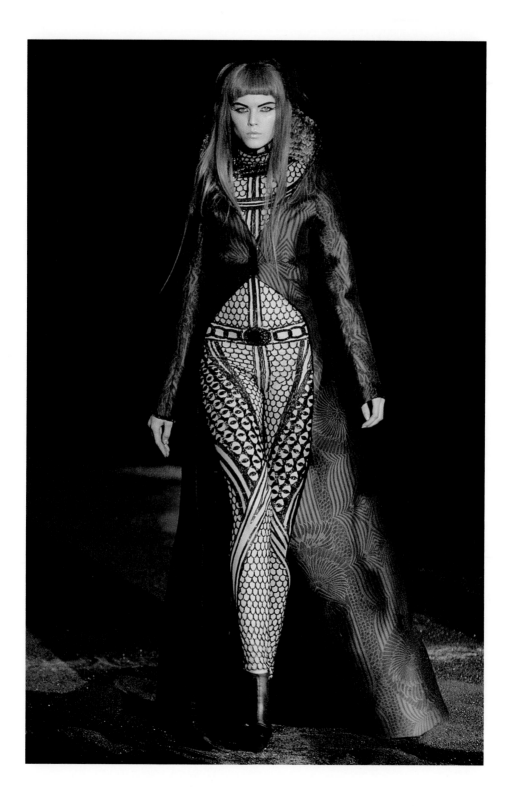

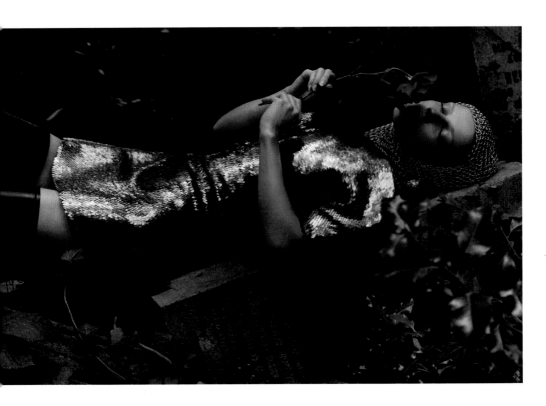

"La Pucelle," photograph by Sølve Sundsbø, January 2007, inspired by Joan of Arc, demonstrating an erotic impulse it is unlikely that The Maid, in her innocence, ever felt. Chainmail hood and gold sequin dress by McQueen.

McQueen, showing naked girls, scuttling locusts, a magnificent owl's face and skulls morphing into flames and faces was projected onto a screen. McQueen's palette was based on the iridescent green, blues and gold of a male peacock's tail feathers. The lighting was low, the models gothic and exotic, made up to resemble Elizabeth Taylor in the 1963 movie *Cleopatra*, their hair twisted into cornucopias by hair stylist Guido Palau.

It was unfortunate that some members of the press felt that the trek to the stadium in heavy traffic and pouring rain, seating placed too far from the action and lighting insufficient for scrutiny were all reasons to condemn the event, because this was a collection that

confirmed McQueen's carapace shape (which had also influenced Versace and Christopher Kane that season). It also showed a development of the cocoon line: encircling the body in fabric in a pod shape that moved from shoulders to waist, to bottom and to hips, fulfilling his desire to shift Western fashion's traditional focus away from the the waist by layering fabric onto a boned gazar underdress.[40] Cristóbal Balenciaga (who invented silk gazar) and his one-time assistant, André Courrèges, had already done so before him, but McQueen's inspiration was less purist—it was nature, specifically the spherical shape of an ovum. For this collection, his ideas were based on paganism, fertility and Hollywood's idea of ancient Egypt—a combination of glamour and the profane.

The first six looks therefore were about spheres: hips were padded and quilted in black, cream and soft greens and purple. Suits in a gold-and-blue Jacquard weave were based on the wings of the sacred ibis, dresses folded origami-style, with little winged shoulders. A gold sequinned dress patterned to create contours was matched by a gold body stocking, with gold-colored bustier with natural, slightly drooping breasts—a look beloved by McQueen since "Banshee" of 1993 (see page 69). Leather bustiers, one coming up to the chin, another with embossed fighting cocks, were intercut with more commercial looks: a shearling miniskirt; a belted cream cashmere wrap jacket; denim with fox (one in layered denim over jeans); foxes draped over the shoulders, heads intact and tails dipped in blue dye (touching on the designer's shape-shifting motif) with a leather back and strips plated like an armadillo.

The buildup to blacks began, worked as figure-hugging dresses and jackets, with a major dress: a leather empire-line piece cut asymmetrically as in ensemble "Eshu" (see page 162) over a dress, fabric twisted and tufted to look like fur. A green-and-black silk taffeta evening gown in gloomy Velázquez tones featured a bodice embroidered with a large crystal cross before the collection moved onto

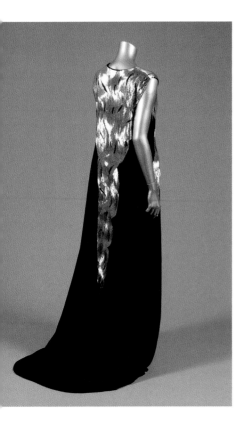 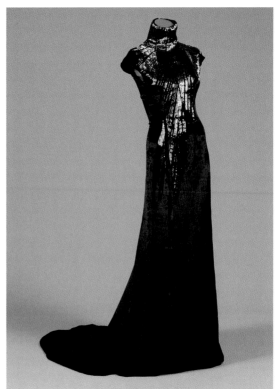

Above: Black satin and bugle-beaded evening gowns from the collection. Silver beading is applied to replicate flowing hair along the back of the silver-and-black gown, while gunmetal beading forms a starburst pattern around the high neck, shoulders and front of the black gown. **Opposite left:** In the same collection, medieval body armor and chain mail is referenced in a gold plastic bodysuit embellished with gold paillettes. **Opposite right:** Shaun Leane re-created a popular Victorian motif, the crescent moon, turning it into a Gothic masterpiece made of Swarovski moonstone, which appears to pierce the neck. Along with a star headpiece, also made by Leane for the collection, they represent pagan symbols, using colors that were captivating and powerful.

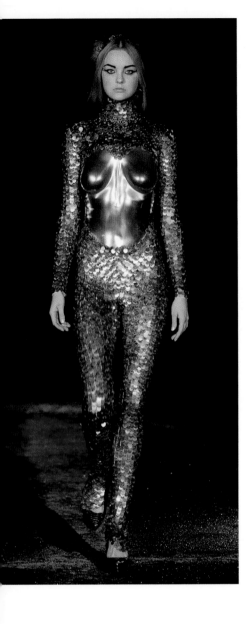
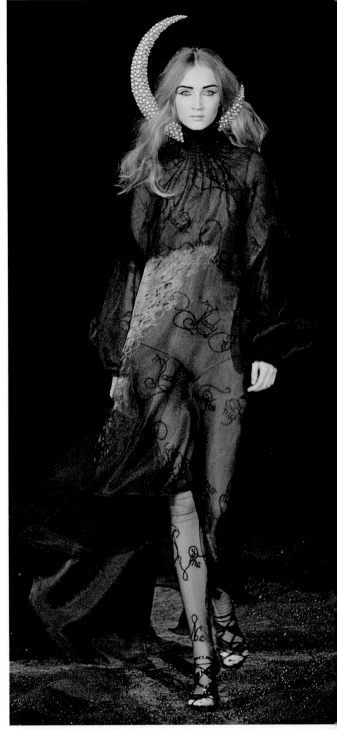

his silver and black story: a silver crescent moon Swarovski crystal headpiece and another in stars spoke of the ancient female rites of moon-goddess worship. Moving toward the finale, black evening gowns dripped like molten silver and gold with beading. Then we were back in the forests of "Irere" (see page 193), with those vampish, tattooed, painted women in beaded black body stockings—one creeping over the face, gold feathers hooding the eyes, another worn with a redingote of green, tiny peacock feathers decorating the collar.

The finale was a sheer dress—its tribal markings beaded in black, the model dusted with gold. Later the show was described as "a study in vitriol expressed via fashion."[41] But vitriol? Not so—this was a response to the outrage of what had happened to innocent women, not the corrosive vision of a poisoned mind. However, after years of accusing him of misogyny, the press expressed their outrage toward McQueen, not at the cruelty of the injustice meted out in 1692. After the collection, McQueen's creative director, Katy England, left the company, moving on to work on Kate Moss's range at Topshop.

La Dame Bleue

Spring/Summer 2008

"Beauty can come from the strangest places."
—Alexander McQueen

On May 7, 2007, Isabella Blow died at age forty-eight, after committing suicide following a number of failed attempts. Her tragic demise resulted in intense media coverage, as well as scrutiny of the fashion industry in general and of Lee McQueen in particular. Wisely,

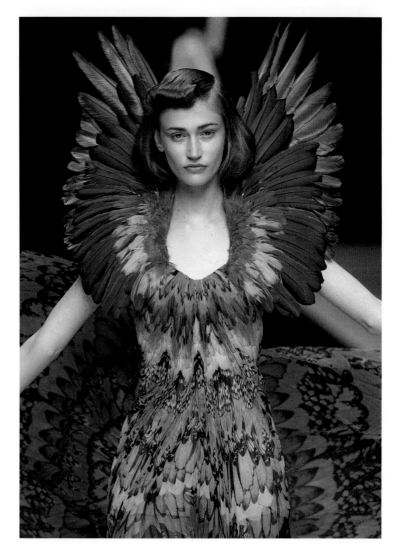

A ruff from the feathers of a blue and yellow macaw forms the collar of this plumage-inspired printed chiffon dress. The piece speaks of Isabella Blow's exuberance and love of dressing up as gloriously as possible.

he kept his own counsel until the summer of 2008, when he talked about her to two publications.[42] For McQueen, it was a terrible loss, and he chose to honor Issie in the best way he could: through his work. Whatever demons of his own he might have been fighting after her death, at the time he appeared to have put them all to one side.

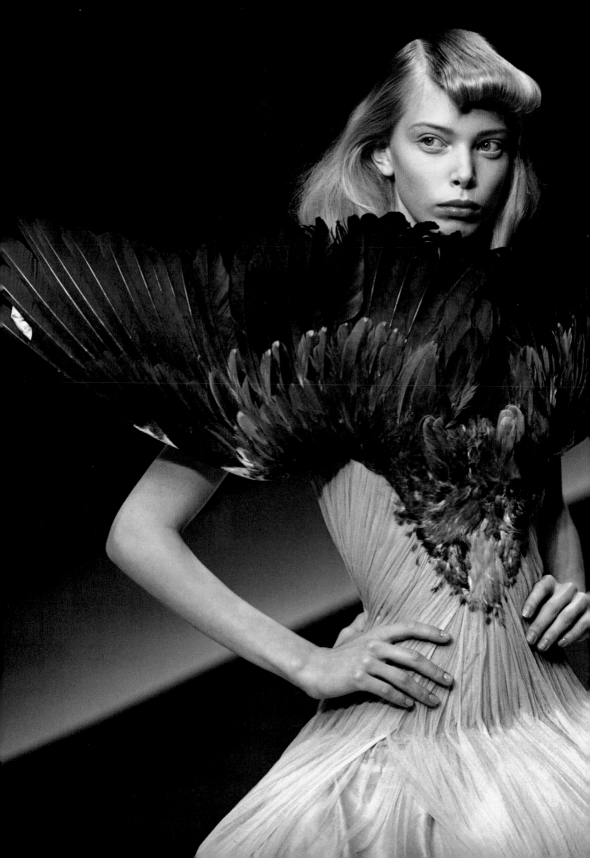

"La Dame Bleue," held five months later on October 6, 2007, at the Palais Omnisports de Paris-Bercy, was dedicated to Blow. Working with her close friend Philip Treacy, McQueen created one of his most beautiful collections. It was a fine tribute, with Blow the inspiration for the divinely eccentric tailored looks, the theatrical exuberance, styled with feathers and ingenious hats and spiced with sex. "It's about her way of thinking and that way of thinking brought light into fashion. She was a diva in what she wore," he explained.[43] Indeed, Issie Blow had correctly identified the personal element in all his work, McQueen's essential sensitivity; it was what made him unique.

Models entered the runway via a huge pair of flickering phoenixlike wings made up of lights that moved from blues and purples to whites, pinks and reds reflected on the shiny floor. The clothes were about Blow's transformation through her own garments. There were handcrafted tailored suits, coats and jackets; a jacket that morphed into shorts; and a kabuki-style pod dress with pagoda sleeves, its chiffons draped and cinched with floating strand-hems. Feathers were applied to shoulders, taxidermied wings formed a fan-shaped placket on a gray chiffon evening dress, coral-pink flamingo wings highlighted a black dress. Shoulders were sharp, some waists held in by wide belts tight as a vice. If there was an historical reference, it was in the shoulder line, wafting trousers and rolled-fringe wigs of George Cukor's *The Women* (1939), a film that might have been made for

Above: Black sequinned cocktail dress of uncompromising smartness, worn with whimsical curvilinear headpiece designed by Philip Treacy. The entrance to the runway was framed by lighting in the form of wings. **Opposite:** In his homage to Isabella Blow, who had died the previous year, McQueen updated many of his previous looks and focused heavily on birds and nature; Blow had introduced him to falconry. Pale blue chiffon puffball dress, above the knee and floating almost to the ground at the back, the neckline and upper arms are framed by the wingspan of a taxidermied bird of prey.

Pale pink python cocktail dress, based on an eighteenth-century stomacher and panniers, its modern angularity emphasized by the geometrical metal neckpiece as it hovers above her body.

Isabella Blow. Philip Treacy's hats, so much part of Blow's identity, were worn with all the insouciance of Norma Shearer or Joan Crawford, both of whom starred in the movie. Blow loved fashion and she loved it for its own sake. As the models swept down the runway, they did so with her sense of blithe aplomb.

Yet it was not brittle fashion reference; the hats by Treacy (most memorably one of feathers sculpted into butterflies and an exotic dragonfly statement-piece) grounded the collection in some of the natural world's most beautiful manifestations. McQueen matched these with butterfly and bird prints and feathers printed on chiffon dresses and blouses. Tiny dyed and hand-painted feathers in pale pink and black were applied to the face as a mask. It was a romantic Blow, daring and feminine, that he was presenting, honoring his friend with those parts of his artistry directly relating to her: Issie's love of his cutting and tailoring, the falconry and finally, his career in French couture, motivated by her refusal to see a limit in his potential. It is impossible not to regard her as a nurturing force in his career.

The Girl Who Lived in the Tree

Autumn/Winter 2008–2009

"When I design, I try to sell an image of a woman that I have in [my] mind, a concept that changes dramatically each season." —Alexander McQueen

After "La Dame Bleue," McQueen and jewelry designer Shaun Leane went on a month's holiday to India, during which Lee became a follower of Buddhism. The trip also furnished him with ideas of light, color and the influence of India, particularly in the time of the Raj, on British fashion and adornment. In this happier frame of mind, he came up with a fairy tale for his next collection. While gazing at the six-hundred-year-old elm tree in his Sussex garden, he imagined a girl who lived in it. "She was," he said, "a feral creature living in the tree. When she decided to descend to earth, she was transformed into a princess." How many men believe in fairy tales? Falling in love was what made him happiest, it seemed.[44] This innocence was directly at odds with the "Boy Done Good" persona and stemmed back to childhood days, when he drew Cinderella in a big-skirted ballgown on his bedroom wall (see page 10).

"The Girl Who Lived in the Tree" was shown on February 29, 2008, at the Palais Omnisports de Paris-Bercy. Standing at the center of the square runway was a tree, wrapped in silk tulle like a Christo installation. The narrative began with models, hair back-combed and lacquered, standing out at the sides in their black 1830s tutus like hoydenish versions of Marie Taglioni (the ballerina who first performed the forest fairy role in *La Sylphide*, 1832). These were

interspersed with black biker jackets, waistcoats and a wrap coat with white cravats at the neck. Then she met the prince, and the transformation began with a gunmetal gray taffeta Bertha-shouldered, balloon-sleeved puffball dress worn with a coral-tailed peacock headdress. A selection of bias-cut plaid and black-and-white suits, leather bike pants and frock coat struck a Regency dandy theme. Then three full-skirted black dresses, one with a tree print, another with a pair of peacocks in black lace, tails spilling out to form a delicate layer over white tulle. Instead of tottering, the models wore flat Indian shoes, stepping firmly onto the ground. The full-skirted silhouette was brought to a halt with a columnlike line, and the color began; three regimental dress coats with gold frogging in the spirit of the Duke of Wellington (a Gieves & Hawkes customer) worn with ivory silk tulle as though she had pulled on her lover's warm clothes. Suddenly, it was the young Elizabeth II in a punk-inspired ruched and draped union-flag dress. The crinoline shapes of Sir Norman Hartnell's early dresses for the Queen brought the silhouette back to hourglass, becoming increasingly sumptuous and experimental. Two dresses were layered with dyed feathers; the bodice of another (in white tulle) embroidered with red crystals, the bolero ruched to form the shape of two roses at the back.

Daphne Guinness, photograph by Michael Roberts, *Vanity Fair*, August 2008. McQueen imagined a girl, who came down from the ancient tree in his garden at Fairlight, East Sussex, was rescued by a prince and lived a life of adventure. Red silk coat, cartridge-pleated at the cuff, sculptural in form, presented with great visual drama.

McQueen should have produced empire-line dresses in white tulle at Givenchy. This was the collection that proved he could create magnificent couture at his London atelier. Perhaps unsurprisingly, on the same day he announced that, for the first time, his company had gone into profit.

Natural Dis-Inction, Un-Natural Selection

Spring/Summer 2009

"Animals … fascinate me because you can find a force, an energy, a fear that also exists in sex."

—Alexander McQueen

McQueen's motifs had been consistently to do with nature. As he progressed, it was perhaps not surprising that he was to contemplate its destruction by man, and his last three collections before his untimely death considered the environment in the face of human encroachment. His S/S 2009 collection—the invitation to which was a portrait of the designer by Gary James morphed into a skull—shown on October 3, 2008, came from thinking about Charles Darwin's *The Origin of Species* (1859) and the concept of the survival of the fittest. Darwin lived in a time when there were still places, on land and in the sea, that humans had never been. On November 26, 2008, the UK government introduced the Climate Change Act in response to the crisis over biodiversity.[45] At the same time, director James Cameron was working on his film *Avatar* (2009), which addressed man's aggressive destruction of natural habitats. McQueen explored this threat to the planet in the only way he knew: through his work. He projected a film of Earth revolving in the background and placed taxidermied animals—a tiger, a polar bear, a lion and a giraffe—at the back of the runway.

White silk dress to above the knee, transparent fabric on torso with embroidered skull in white, framed with an olive branch wreath, the leaves appliquéd and decorating the collar; a delicate appliqué bow sits below the skull.

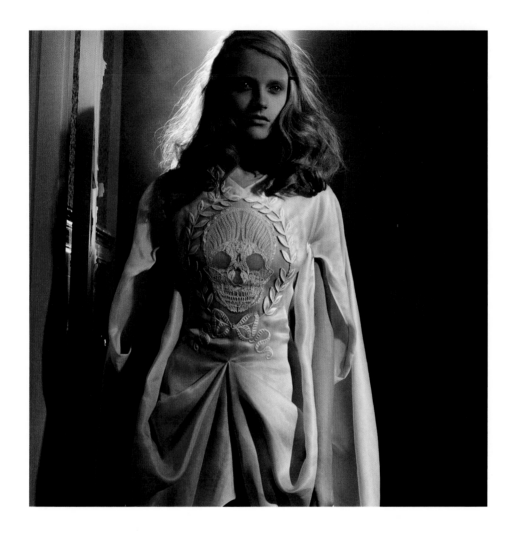

All the essential McQueen shapes were there: exaggerated hips, small waist, defined shoulders, frock coats and the cocoon silhouette. New was the extensive use of digital printing onto fabric, then cut and constructed to fit seamlessly. Perfected in "Plato's Atlantis," this was to be one of his most important influences on fashion—a decorative technique combining twenty-first-century technology with traditional technical skills. The first section concerned nature unviolated: prints of contours of wood on dresses, frock coats and trousers in a creamy, brown and café au lait palette. These were broken up by thigh-length yellow and pink dresses, cherry and apple blossom layered between

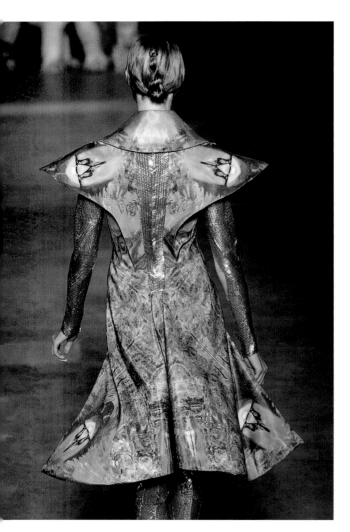
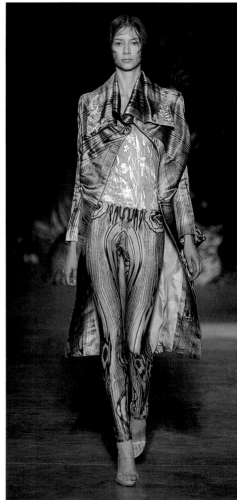

Above left: Manta ray–inspired cape, sweeping from the back, forming pagoda shoulders and deep lapels on the cutaway coat. Underneath there is a bodysuit made from fish leather; a skin decorates the center back of the garment. The natural scales are visible on this and on the sleeves. **Above right:** Frock coat and bumster trousers with a cross section of a tree print over a sheer nude top, embroidered with wildflowers and grasses in white. This section spoke of nature and unspoiled habitats. **Opposite:** Kim Noorda in a morphed sea creature, digitally printed suit with a bleached denim effect, the lapels edged with cartridge-holder, giving further three-dimensional detail.

layers of nude silk. Leather harnesses cinched the torso over flowing cream silk printed with delicate botanical details, a puffed skirt and balloon sleeve. Then came the bird reference: ingeniously draped fringing like a giant feather, cutting across the body and undulating with movement. Stunning rain forest colors in carapace shift dresses encased the body. These morphed into black and white, then black, in two fetish-style leather looks. The four finale pieces—dresses and jumpsuits delineating rigid female forms—featured thousands of Swarovski crystals as a force majeure, encasing the models in glass armor plating: the "Un-Natural Selection."

In a brilliant touch, McQueen appeared at the end dressed as a giant rabbit, like the mutant bunny in Nick Park and Steve Box's film *Wallace & Gromit: The Curse of the Were-Rabbit* (2005), a delightful tale of genetic engineering gone wrong (with Lady Campanula Totting-ton voiced by his friend Helena Bonham Carter). Suffice it to say, the view from the window of his country home invariably contained bobbing rabbits. It was where he retreated to give himself the blank canvas that he needed to think. From sylvan girl in a tree to pondering the state of the planet was not such a big leap after all.

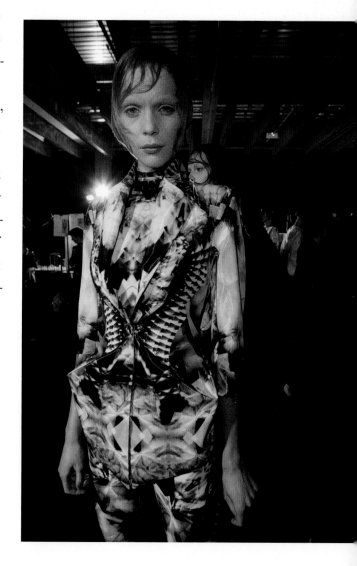

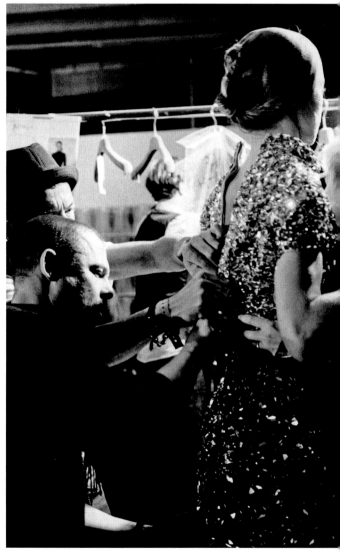

This spread: Photographs by Claire Robertson at the McQueen studio and backstage at the show, applying and fitting a crystal showpiece. The four looks using Swarovski crystal came at the end of the show—finale pieces that talked of man's dislocation with nature through the glitter and glamour of the stones; the survival of the fittest. **Opposite left:** Model Raquel Zimmermann checks her makeup before the show commences. **Opposite right:** McQueen fits the Swarovski crystal–studded minidress on model Raquel Zimmermann. **Above left:** One of McQueen's assistants in the studio is applying Swarovski crystals to the dress. **Above right:** Another assistant applies crystals to the shoes.

The Horn of Plenty

Autumn/Winter 2009–2010

"I'm not big on women looking naïve."
—Alexander McQueen

According to McQueen, "The Horn of Plenty" was a response to fashion's built-in obsolescence. He once said that he wanted his clothes to be preserved, handed down as heirlooms to the next generation, but with his accessibly priced McQ line for 250 Target stores in America's Midwest launched that month, he was aware that he himself was also part of the problem of mass-market saturation: he was, in effect, at odds with himself.[46] With more than sixty designers showing in London alone that season, and with the economic downturn following the collapse of Lehman Brothers Holdings Inc. in September 2008, he perceived a crisis—"This whole situation is such a cliché. The turnover of fashion is just so quick and so throwaway, and I think that is a big part of the problem. There is no longevity," he said.

The show was autobiographical on another level, too: "The Horn of Plenty" was the name of the pub in which Jack the Ripper's final victim, Mary Jane Kelly, was last seen before her murder. It was a metaphor for impending disaster. In order to make a statement about the excessive production of fashion, McQueen looked back to earlier collections, particularly "The Birds," in which Escher prints transformed from birds into houndstooth check. The

Opposite left: McQueen mocks the traditional French couture houses who replay the same idea over and over again with this houndstooth check, so reminiscent of Maison Dior, then he trumps it by referencing his own history–"The Birds" collection, as the houndstooth prints morphs into a new dimension. **Opposite right:** An inspired headdress by Philip Treacy in simple white cloth echoes the horned wimples of the fourteenth- and fifteenth-century Burgundian court, while a houndstooth jacket loses all design purity through an overuse of ruffles. McQueen seldom pulled his punches.

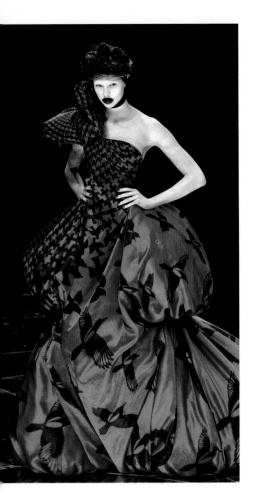

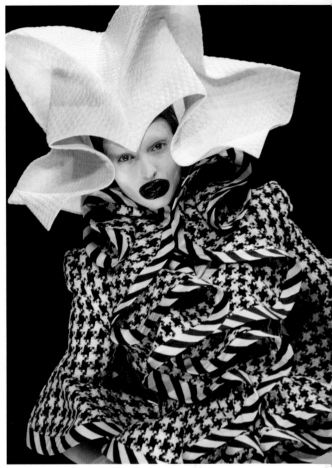

runway was scattered with broken mirrors (representing the narcissism of fashion), and in minilandfills were stacked props from his past collections. Writers saw a criticism of the luxury end of fashion now under threat, but given the subject of his previous collection—and placing "The Horn of Plenty" in the context of his next show—it was more encompassing than that. This collection, staged on March 10, 2009, addressed the subject of consumerism with a visual drama not seen since his London days. It was totally uncompromising.

He began with a pastiche of Dior's New Look and moved on to satirize the way in which fashion cannibalized itself, constantly making reference to other designers. With extraordinary (and

brilliant) headwear by Philip Treacy incorporating plastic bags, garbage-can lids, tin cans and umbrellas, he moved on to Poiret and Givenchy, as well as his own work, as stated, "The Birds," using plastic as then and to "What a Merry-Go-Round" in the harlequin prints. Each look was larger-than-life, with the caricature swagger of a drag queen—white faced, eyebrowless, square-shaped lipstick in Leigh Bowery style. What made it McQueen was the incredible control to the production: while he appeared to dismiss Dior's couture, by now reaching a Byzantine level of excess, each piece in the collection was graphic in its simplicity. "I've never been this hard since I've been in London," he told the *New York Times*. "I think it's dangerous to play it safe because you will just get lost in the midst of cashmere twinsets. People don't want to see clothes—they want to see something that fuels the imagination."[47]

Plato's Atlantis

Spring/Summer 2010

"The body parts that I focus on change depending on the inspirations and references for the collection and what silhouettes they demand." —Alexander McQueen

It was as if the shipwrecked girl had swum down into the depths of the ocean, discovered the Kingdom of Atlantis, found Namor the Sub-Mariner (Marvel comic's mutant "Homo mermanus") and married him. The technicolor fantasies of McQueen's S/S 2010 collection embraced his Piscean fantasies dating back to childhood days swimming at the local pool. As McQueen explained, the collection was set in a future world, "in which the ice cap would melt, the

waters would rise and life on Earth would have to evolve in order to live beneath the sea once more or perish. We came from water and now, with the help of stem cell technology, we must go back to survive"—in other words, Darwin's evolution in reverse. "Plato's Atlantis" was about the rebirth of man in a different element, with clothes taking inspiration from the sea and reptilian forms, all previously visited by McQueen but without being the main "story"—and without the new printing technology.

McQueen had arranged for the show, held on October 6, 2009, to be streamed live via fashion visionary Nick Knight's SHOWstudio. The runway glittered, two machines ran along it on tracks with screens showing Knight's film of Raquel Zimmermann splayed naked on sand, embracing nature to the full, with a number of writhing snakes covering her body. Nothing wrong with that, what *was* wrong was Lady Gaga, McQueen's latest acolyte, who tweeted half an hour before that

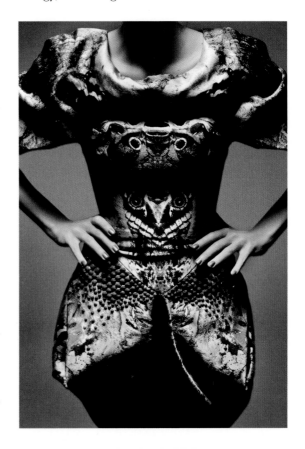

Snake print, developed from fractals from skins, on a silk print beaded dress with green enamel paillettes. "Plato's Atlantis" made women mythical hybrids in a gentler, more lustrous way than "It's a Jungle Out There"; they were no longer lethal femme fatales in an urban nightmare but gentler creatures of the deep.

her new single was to be launched at his presentation. Submerged by hundreds of thousands of "hits" from her fans, SHOWstudio. com crashed. Poignantly, what would be Lee McQueen's final show

was not streamed as a live event to what would emerge, after his death, to be a worldwide following.

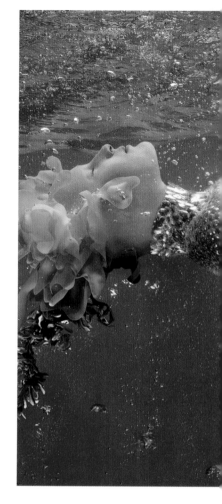

The models resembled sirens of the deep, hair piled tightly over cone structures, braided into barbaric horn shapes and cornrowed like archaic Greek goddesses. Eyebrows were invisible, eyes elongated and slitlike, with horizontal bands of eye shadow. The dresses followed his short line of S/S 2009, with the same complex construction based on combining print specific to the piece in the jigsaw making up the garment. This time there were distorted images of jellyfish, moths, fish and snakeskin. A turtle floated up the front of one dress, a primeval fish gazed out from the bodice of another. Panniered hips were emphasized with enamel paillettes like fish scales. It was a beautifully devised exercise in nature's camouflage, an organic development of the thermal imaging idea first conceived with "Voss" (see page 167). Colors moved from the golds, greens and browns of vegetation to the blues and aquas of sea-filtered light. There were bronze-green taffeta breeches and all-in-ones, and two gray wool jackets cut at the front with a fluid wavy line, worn over "jellyfish" dresses that gleamed like steel.

The shoes were another revolution: the "Armadillo," in which the foot resembles that of a ballerina *en pointe*; and his equally vertiginous "Alien" sandals, inspired by the drawings of H. R. Giger for the eponymous science-fiction movie of 1979, set in a future far less forgiv-

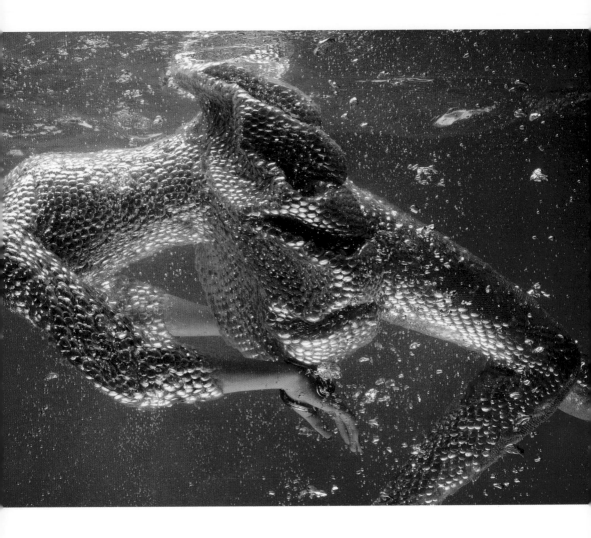

McQueen's "jellyfish" dress and trousers, covered in iridescent enamel paillettes with "worn" sections in iridescent sequins. The runway look including matching Armadillo shoes, and there are shades of the one-tailed mermaid here he drew for Carmen Artigas (see page 35). With seaweed in her hair, the enamel "scales" flashing green and blue, she is Poseidon's daughter. Photograph by Josh Olins, 2010.

ing than McQueen's vision. At the end, a "jellyfish" dress over leggings, iridescent enamel paillettes gleaming on a body that no longer looked human, clad in "armadillos." This extraordinary collection served to confirm that McQueen had achieved what he set out to do years before as a tailor's apprentice: to take fashion where it had never been before.

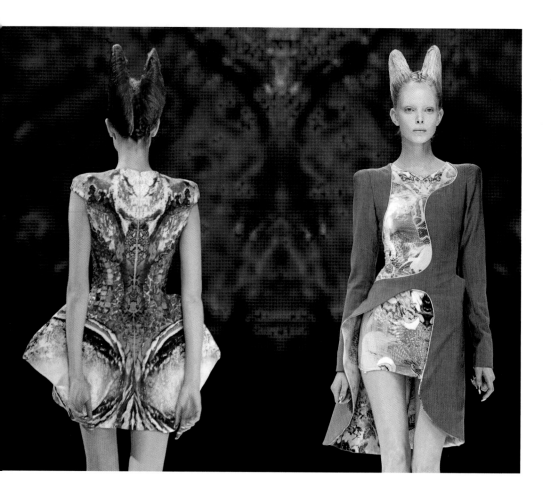

Above: McQueen's point was that, with climate change and melting polar ice caps, Homo sapiens would return to a world of water. His collection therefore recalls Atlantis, with prints celebrating aquatic forms and his women turning into coral-plated fish. Silk printed in a coral pattern with embroidered gold paillettes, left; and a gray tailored coat-dress, with undulated edge, matches the dress, right. **Opposite:** The model Shu Pei Qin, left, walks *en pointe* wearing "Armadillo" shows and silk dress printed with a moth and fish motif, overlaid bodice with laser-cut hexagons, button-stitch edging, snakeskin belt with buckles at front and rear; scrunch clutch bag. On the right, model Imogen Morris Clarke wears a dress in moth tones, the bodice in contrasting leather, the dress built up at hips and shoulders, the fabric a complex structure of fold and drape, with "Armadillo" shoes in hexagon motif.

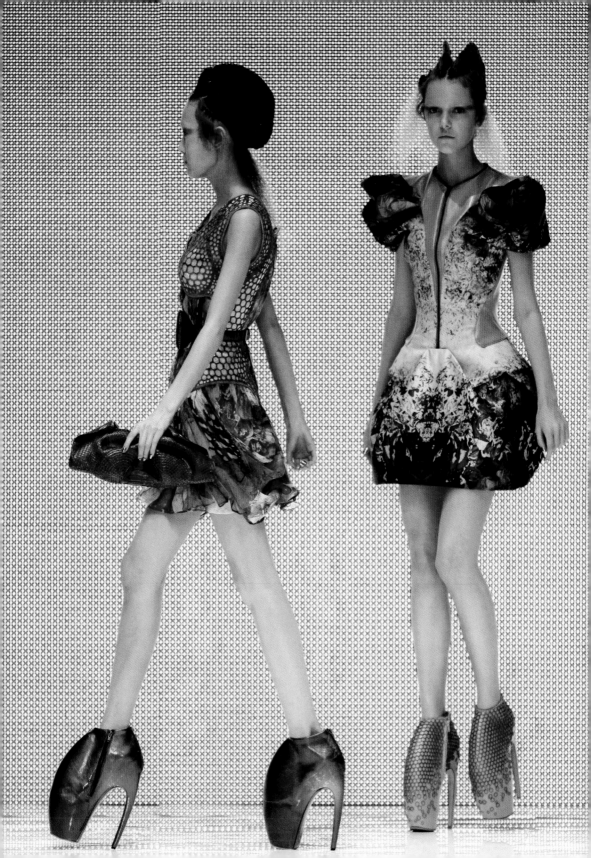

THE LAST DAYS
AND THE LEGACY

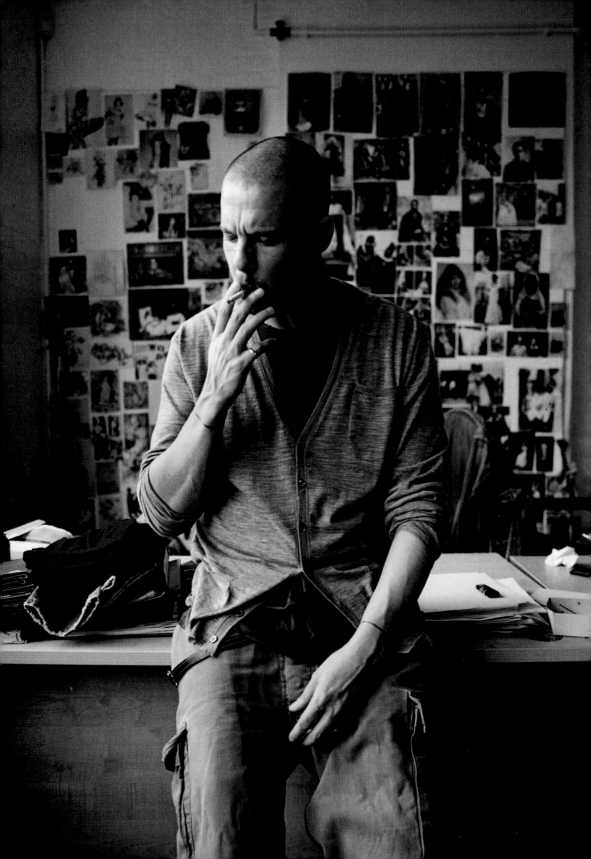

On February 11, 2010, Lee McQueen took
his own life, just nine days after his beloved mother had died. She had
been diagnosed with cancer in 2008. Joyce McQueen's role in shap-
ing her son's extraordinary talent cannot be overestimated; her love of
history and the powerful sense of identity that came from her research
into the family tree had provided him with a profound sense that any-

thing was possible. He called
her his rock; she was also his
refuge, and those swelling forms
in "Sarabande," described by
him as maternal and again ques-
tioning contemporary fashion's
concept of beauty, are a testa-

McQueen in his office, 2004, photographed by
Derrick Santini for *ES Magazine*. Note the postcards
from art galleries or museums and the photographs
on the wall behind him. His curiosity about the
new and affinity with visual art never stopped. As a
designer and person, he was always looking for new
ideas and inspiration.

ment to her. She died on February 2, 2010. His greatest fear, he told
her in the *Guardian* in 2004, was dying before her.

His mother's death proved devastating. Nine days later, the day
before Joyce's funeral, he hanged himself at his apartment in Green
Street, Mayfair. The details of his suicide note, inscribed in the cata-
log of artist Wolfe von Lenkiewicz's "The Descent of Man," remain
private, apart from the words *Please look after my dogs. Sorry, I love
you. Lee. P.S. Bury me in the church.*

A private funeral at St. Paul's Church, Knightsbridge, on Febru-
ary 25 was followed by a memorial service at St. Paul's Cathedral on

September 20, during London Fashion Week. "Is St. Paul's the place for a fashion show?" asked the *Daily Mail*.[1] Since its central aisle was once used by the fops and exquisites of Restoration London for just that purpose, the answer would have to be a resounding "yes." And how McQueen, a Londoner born and bred, would have truly appreciated being honored in the baroque splendor of Sir Christopher Wren's masterpiece, with the designer's beloved Grinling Gibbons's carved oak decorations accompanied by Björk's rendition of the somewhat mournful "Gloomy Sunday."

270

On April 28, 2010, at the inquest into his death, the Westminster Coroner Dr. Paul Knapman recorded a verdict of suicide, carried out, "while the balance of his mind was disturbed." McQueen's psychiatrist, Dr. Stephen Pereira, partly blamed his client's depression and anxiety on the demands of work: six shows a year, two for each menswear season, two for womenswear and two precollections. On top of this were the McQ ranges. The piles of detritus on the runway of "The Horn of Plenty," the escapism of "Plato's Atlantis" and McQueen's questioning of human greed in "Natural Dis-Tinction, Un-Natural Selection" are therefore partly explained by the despair he was feeling. This had, said Pereira, been going on for the past three years, and during the previous year, McQueen had made two suicide attempts.

McQueen's friend Daphne Guinness on the steps of St Paul's Cathedral at his memorial service, September 20, 2010.

"He certainly felt very pressured by his work, but it was a double-edged sword," said Pereira. "He felt it was the only area of his life where he felt he had achieved something. Usually after a show, he felt a huge comedown: he felt isolated, it gave him a huge low," Pereira explained. Perhaps these swings from creative highs to depressive lows were McQueen's own angels and demons—the title he chose for his final show—yet out of his despair came flights of beauty, images and ideas simply beyond the capability of most other designers of his generation.

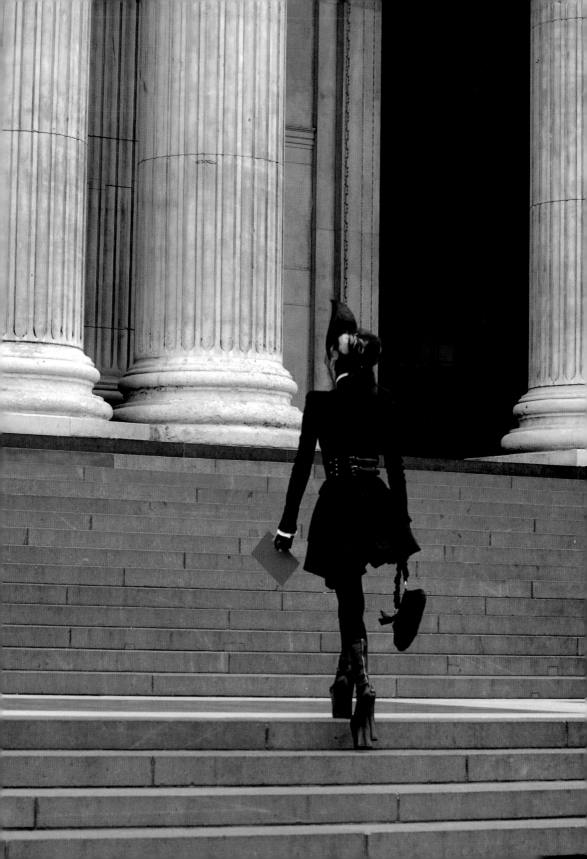

His family issued the following statement: "Lee was a public figure and a creative genius who possessed a generous, loving, caring nature. Those who were privileged to have known Lee will cherish their memories of him for all their lives. Lee was also a much-loved brother and son, and we miss him terribly. We will continue to make every effort to keep his memory alive."

Angels and Demons

Autumn/Winter 2010–2011

A week after McQueen's death, the Gucci Group announced its partnership with Alexander McQueen would continue and the A/W 2010–11 line was to be shown to a selected audience as a small-scale presentation during Paris Fashion Week. At the time of his death, there were sixteen pieces that he had cut and draped himself for the collection: these were completed by Sarah Burton, his head of womenswear design, and the team. It was decided to present them during Paris Fashion Week at the head of PPR, François Pinault's, historic townhouse. For the first time, an Alexander McQueen womenswear collection without his input on staging and context was shown. Each piece was allowed to "breathe" and to make its own statement without the energy of Lee McQueen's unique fashion theater. The effect was to make every garment appear as a precious object set against the white and gold rococo boiseries and was presented to groups no larger than ten on March 9 and 10, 2010.

In response to one journalist asking him where his ideas for "Plato's Atlantis" had originated from, McQueen had derisively snapped back, "From Wikipedia!" Following the live-streaming debacle, it's not surprising that he had decided to move away from Internet technology and to focus instead on his craftsmanship, said Burton.

Just as he had done in "It's a Jungle Out There" and "Joan," he now looked for inspiration in the paintings of the Northern and Italian Renaissance artists, particularly Hugo van der Goes, Hans Memling, Jean Fouquet and Hieronymus Bosch for print and to the image of Byzantine empress Theodora for embroidered decoration and jewelry. The collection featured a digital print of Bosch's *The Garden of Earthly Delights* on silk, over which was a gold-sequin and black-embroidered trompe l'oeil–sleeved "harness," a cartridge-pleated black silk skirt set at the hips. Another piece was a one-shoulder draped silk dress, printed with an enlarged altarpiece, its gold gothic arches forming the hem, raised at the right hip to reveal an underskirt of gold-painted duck feathers.

Two gray-and-white silk dresses were decorated with blown-up prints of grisaille angels, their wings enlarged into huge feathers. The bird/angel analogy was most apparent in his gold duck-feather coat, its collar framing the face, the coat closely encasing the body in an hourglass silhouette over a voluminous white silk tulle dress embroidered with gold, spanning out in a circle to the floor.

Gold and silver shoes, developed from "Plato's Atlantis," had heels formed of art nouveau style, angels' wings spanning out around the raised soles, gemstones and beadwork draping the ankles. The red dress from this collection particularly stands out: embroidered in gold sequins, opulent and rich in color. It connects strikingly with one red and one blue jacket in Romeo Gigli's A/W 1990 collection, which would have been in the showroom when McQueen arrived to work with the designer in 1990. Decorated with gold foliage and pineapple motifs taken from fifteenth-century Italians, the collection was "inspired by more than medievalism . . . by magic," said Romeo Gigli.[2] "Angels and Demons" was, by its very nature, an unresolved collection, but it already had that essence of what Gigli—and McQueen—recognized as magic.

McQueen could have taken "Angels and Demons" in any number of directions, but presented in that calm, intimate setting, it

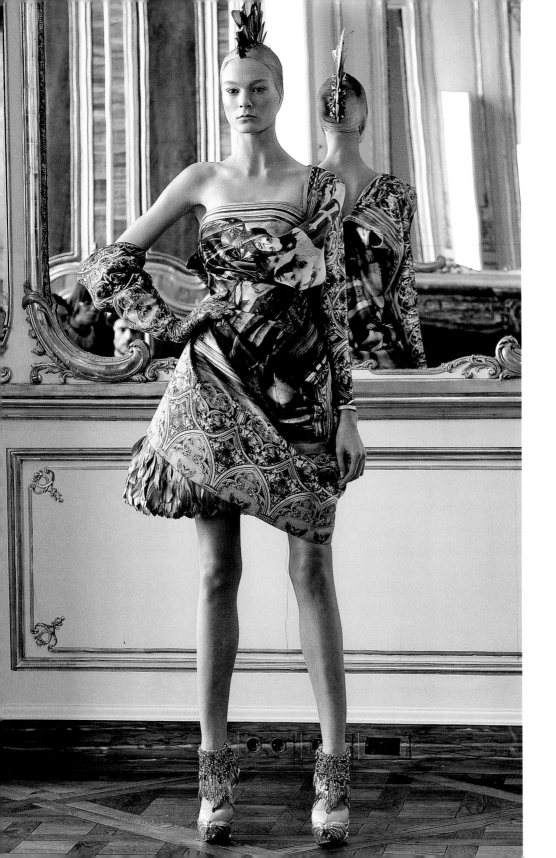

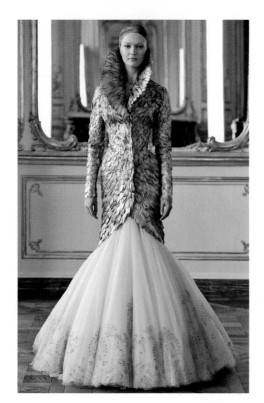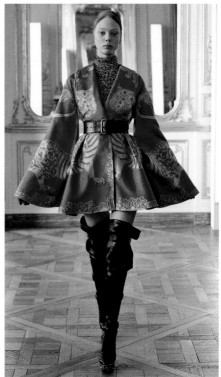

Opposite: Silk dress, one-sleeved and draped to show the print of Stephan Lochner's triptych the *Altar of the City Patrons* (circa 1442), over gray duck-feather underskirt; a feather Mohawk sprouting from a bandage coif as headpiece; and gold nylon, platform-soled, goddess heeled shoe, trimmed with beads and gemstones. **Left:** Duck feather coat, painted gold, over white silk embroidered skirt. This collection was posthumous; 80 percent had been finished at the time of his death and sixteen looks shown had been completed by Sarah Burton and the studio. **Right:** Silk brocade jacket with traditional Tibetan tiger on scarlet background, gold chain mesh undergarment, worn with thigh-high boots with gold nylon platform sole.

encapsulated the excitement of the young designer visiting art galleries in his spare time, absorbing images that fired his imagination and his spirit. That these ideas were already in place before his arrival at Central Saint Martins in 1992—and before what some perhaps condescendingly regarded as the influence of Isabella Blow—is apparent. Behind all of this was his mother's encouragement and support. Her loss must have been unbearable.

LISE STRATHDEE
FASHION DESIGNER
On Romance, Fashion, and Beauty

Out of all of us young assistants, Lee was the one who carried on and developed [in his own style] Romeo's vision of fashion. The way the garment, the female image and the catwalk show were conceived. A fashion not rooted in the street-influenced present, a woman whose beauty was not in her sex appeal or her cosmopolitan urbanity but in the fairy-tale element of fashion—speaking of other eras. Both Romeo and McQueen's women were enveloped in something other, something fantastical, the sort we might find in our dreams (and sometimes, in Lee's case, in our nightmares). A mythical creature that tapped into a female unconscious and was cleverly introduced into contemporary fashion via garments and accessories one could buy and wear. In this sense, I think Lee McQueen intuitively understood the essence of Romeo's fashion—where Romeo was coming from—more than perhaps the rest of us.

The Legacy

On May 27, 2010, Sarah Burton, McQueen's right hand for sixteen years, was named as the new creative director of Alexander McQueen. Under Burton, the Alexander McQueen brand has become gentler. Each collection is paced and considered, the shocks and jaw-dropping brilliance have dimmed. McQueen's brilliance was correctly identified by Blow as being unique because his work was autobiographical, something that cannot be duplicated. Indeed, the 661,509 people who flocked to see the "Alexander McQueen: Savage Beauty" retrospective held at the Metropolitan Museum of

Art in New York from May 4 to August 7, 2011, are testament to the designer's vision of fashion as craft, as theater and as a transformative experience.

In a speech delivered at Central Saint Martins on being awarded the CBE in 2003, McQueen paid special tribute to Bobby Hillson, whom he sometimes described as his second mother. Without her intuitive understanding of his latent talent and her decision to override the regulations and offer him a place in the MA fashion course, his blossoming would have taken longer; he might never have achieved his potential. In his will, McQueen set up a trust called "Sarabande," which will partially fund talented British students otherwise unable to pay what, for many youngsters, are prohibitively high fees. Lee McQueen wanted to see British fashion talent thrive. It is to be hoped that, along with his extant body of work, this is his legacy. In the words of his friend Simon Ungless, "Lee was a true, true friend, and he influenced the greater scheme of things."

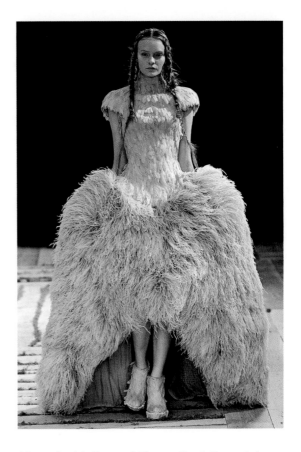

Alexander McQueen S/S 2011, Sarah Burton's first major ready-to-wear collection after succeeding McQueen as creative director. Gown of duck and ostrich feathers in gray, tinged with lilac. It was the finale piece and linked clearly with the work of the late designer in terms of materials and shape, the signature aesthetic clearly marked with this continuation of gray duck feathers used in "Angels and Demons." The dress was worn by Daphne Guinness to the Met Ball in New York City, which opened the "Alexander McQueen: Savage Beauty" exhibition on May 3, 2011.

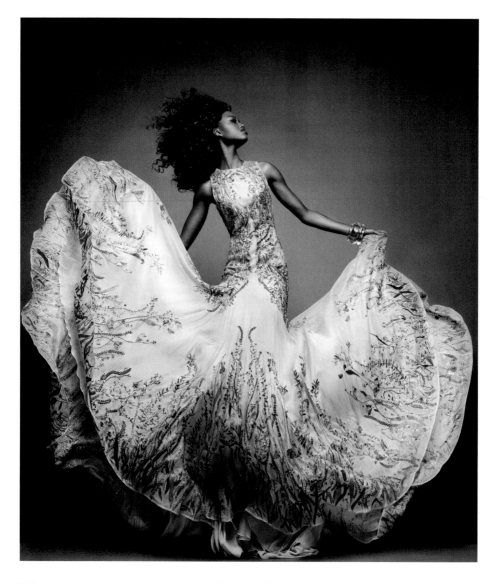

White-and-gold evening gown with gold embroidery depicting a meadow on the lower skirt, the close fit of the upper body defined by gold embroidery, by Sarah Burton for Alexander McQueen. Photograph by Sølve Sundsbø.

"There's never ever going to be anybody
like him. His was the most exciting show
to see ever, even if you weren't there.
I would hear about it on the phone and
hear Lee and hear everyone. There was
so much tension, but we had the best
laughs. He was a dear friend of mine.
I miss him terribly."

—KATE MOSS

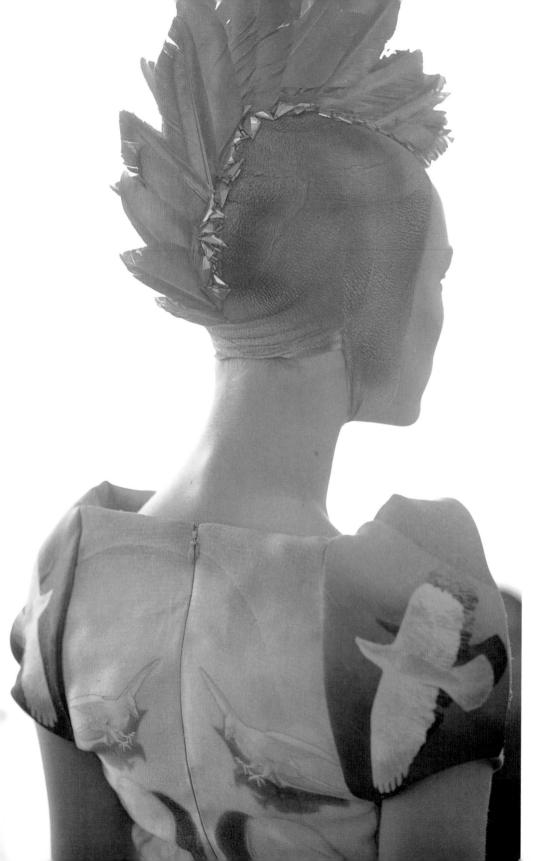

Acknowledgments

With thanks to: Neil Adams, Carmen Artigas, Virginia Bates, Kate Bernard, Lucy Birley, Dr. Stephen Brogan, Manuela Candido, Les Child, Simon Costin, Walid Al-Damirji, Fiona Dealey, Danny Gibbs, Andrew Groves, Daphne Guinness, A. M. Hanson, Bobby Hillson, David Holah, Camilla Lowther, John McKitterick, Donatella Moores, Susanne Oberbeck, Leon Powell, Antony Price, Cressida Pye, Anda Rowland, Vicki Sarge, James Sherwood, Alice Smith, Sue Stemp, Lise Strathdee, Nadja Swarovski, Derrick Tomlinson, Trixie/Nicholas Townsend, Koji Tatsuno, Simon Ungless and Katie Webb.

Thanks to my colleagues at Central Saint Martins College of Art and Design: Anna Buruma, curator, and Judy Lindsay, head of Museum and Study Collection; Hywel Davies and Alex Duncan, assistant librarians (Fashion and Textiles); and Lee Widdows for their support and help. At Kingston University Design School, the faculty of Design, Art, Design, Architecture; Professor of Design, Jane Harris; and Elinor Renfrew, Academic Director, Fashion. Special thanks for additional image research to Florence Bridge, Jack Cassidy, Chris Cowan and Phoebe Lowndes, youngsters all, who learned through the experience of researching Alexander McQueen's work just what fashion can be.

Many thanks, too, to my editor, Lisa Dyer, who made this possible, and to the team at Carlton Books.

A grisaille silk chiffon gown, dark and pale grays with black and white, the historicism of angels blown up to abstract forms by digital printing and given the McQueen touch with the addition of clearly defined pictures of birds in flight. The full skirt has several layers, the lightness of the fabric making it billow and flow with movement. Bandage coif is in dull gold set with duck feathers and gold segments.

Endnotes

Note: Introductory chapter quotes from
Alexander McQueen: Savage Beauty, 2011.

Introduction

1 Frankel, Susannah. "The Real McQueen,"
 Independent fashion supplement, September
 18, 1999.

2 Pendlebury, Richard. "The Inspiring Truth
 about the Self-Style Yob of Fashion," *Daily
 Mail*, January 30, 1997.

3 Foley, Bridget. "The Alexander Method,"
 Women's Wear Daily, August 30, 1999.

Chapter 1

1 Brampton, Sally. "London: International
 Influence," *The Fashion Year*, Zomba Books,
 1983.

2 "London Letter," *Vanity Fair*, February
 1926.

3 Alice Smith, interview with the author,
 January 20, 2012.

4 "McQueen: The Interview," *GQ Magazine*,
 May 2004.

5 Mayfair had specialized in men's fashion
 since the early seventeenth century, when
 a shop selling "piccadills" (the structure
 supporting ruffs) gave its name to Piccadilly.

6 Samuel, Kathryn. "New Kid on the Block,"
 Daily Telegraph, February 24, 1994.

7 Webb, Katie. "Alexander McQueen,"
 Sky magazine, March 1993.

8 Robert Gieve, interview with the author,
 For Him Magazine, 1988.

9 Nathan's, based in Camden Town, had cos-
 tumed Joseph L. Mankiewicz's blockbuster
 Cleopatra (1963), starring Elizabeth Taylor
 (later cited as inspiration for the makeup
 in McQueen's A/W 2007 show and Tony
 Richardson's *Tom Jones*, 1963).

10 Samuel, Kathryn. "New Kid on the Block,"
 Daily Telegraph, February 24, 1994.

11 Webb, Katie. "Alexander McQueen,"
 Sky magazine, March 1993.

12 Nieswand, Nonie. "A chrysalis of a cape, a
 fishscale skirt … the designs of Koji Tatsuno
 are True to Nature," British *Vogue*, February
 1992, p.153.

13 Tatsuno, Koji. Biography, kojitatsuno.com.

14 Hume, Marion. "McQueen's Theatre of
 Cruelty," *Independent*, October 21, 1993.

15 Frankel, Susannah. "The Real McQueen,"
 The Independent fashion supplement, A/W
 1999.

16 The building was at 107–109
 Charing Cross Road, on the edge of Soho.
 Founded in 1854, since the 1970s, the
 school produced some of the best fashion
 designers in the world, with its emphasis on
 art, creativity and individuality. Alumni not
 only included John McKitterick but also Bill
 Gibb, Bruce Oldfield, Katharine Hamnett,
 Rifat Ozbek, John Galliano and John Flett.
 Following the amalgamation of Saint Martins
 with the Central School of Art in 1991, it is
 now Central Saint Martins College of Art
 and Design, part of the University of the
 Arts London.

17 *Guardian* G2, May 30, 2003, p. 10.

18 "British Style Genius" television program,
 BBC, 2009.

19 "British Style Genius," ibid.

20 *Time Out*, September 24–October 1, 1997.

21 *Guardian* G2, May 30, 2003, p. 10.

22 Antony Price, interview with the author,
 January 2010.

23 Watson, Shane. "Mad as a Hatter," *Evening
 Standard*, July 1, 2002.

24 Sharkey, Alix. *Guardian Weekend* magazine,
 July 6, 1996.

25 MacFarquar, Larissa. "The Mad Muse of
 Waterloo," *New Yorker*, March 19, 2001.

Chapter 2

1 The Lethaby Galleries were the old Central School of Art building on Southampton Row, London WC1.

2 "Eagle Eye," *Time Out*, February 18–25, 1998.

3 Spencer, Mimi. "McQueening It," British *Vogue*, June 1994, p.125.

4 Groves, Andrew, designer and course leader for BA Fashion, Westminster University.

5 "Alexander McQueen, A True Master," *Women's Wear Daily*, February 11, 2010.

6 Webb, Katie. "Alexander McQueen," *Sky* magazine, March 1993.

7 *Daily Telegraph*, March 7, 1993. The image of a feathered leather bustier over a wool bias-cut dress was accompanied by the caption: "I believe in him," Alice Smith says, "And he needs a hand. He has no money."

8 Hume, Marion. "McQueen's Theatre of Cruelty," *Independent*, October 21, 1993.

9 Armstrong, Lisa. "New Silhouette," *Vogue*, August 1993, p.87.

10 "British Style Genius," television program, BBC, 2009.

11 Eventually, it did go on to label him as such: Mower, Sarah. "The Bill Sykes and Artful Dodger," *Independent*.

12 Hume, Marion. "McQueen's Theatre of Cruelty," *Independent*, October 21, 1993.

13 Samuels, Kathryn. "New Kid on the Block," *Daily Telegraph*, February 24, 1994.

14 Minty comprised Leigh Bowery, Richard Torry, Nicola Bateman (Bowery's wife) and Matthew Glammore. Much to Bowery's delight, the *Sun* dubbed it, "the sickest band in the world." Raw Sewage was formed of Stella Stein, Sheila Tequila and Leigh Bowery.

15 "The Costiff's inspiration for Kinky Gerlinky came from three areas. They loved attending Brazil's annual carnival and wanted to bring a taste of it to London nightlife; they went to Susanne Bartsch's Copacabana parties that were happening simultaneously in New York, which followed a similar formula to the one they chose for Kinky Gerlinky; and they had been regulars at Leigh Bowery's infamous club Taboo that had run in London from 1985 to 1986. Yet the London scene of the 1980s had been cliquey and hierarchical until house music arrived during the Summer of Love in 1988, at which point the greatly increased number of revelers and their drugs severely undermined the old order. So, the core crowd of trendies at Kinky Gerlinky was, by and large, more friendly than before. This, together with the Costiff's philosophy of fun, the good dance music and at least three hundred screaming queens of both sexes dressed up in drag, was what made Kinky Gerlinky such a riot"—Dr. Stephen Brogan, "Kinky Gerlinky," February 2012.

16 Reeve, Ed. "Alexander McQueen," *Art Review*, September 2003.

17 "Called the most expensive shoot in British *Vogue*'s history at a cost of around $125,000, this was the only time Steven Meisel shot for the British issue. It launched the career of Stella Tennant, reintroduced the idea of the aristocratic model (a familiar theme in *Vogue*'s interwar period) and gave Blow a chance to get McQueen onto its pages."— Goldstein Crowe, Lauren. *Isabella Blow: A Life in Fashion*, Thomas Dunne Books, London, 2011, p. 136.

18 Samuels, Kathryn. "New Kid on the Block," *Daily Telegraph*, February 24, 1994.

19 "Alexander McQueen: 'The latest collection has sold extraordinarily well, I've never seen so many zeros. Maybe it's because the orders are in lire.' Mint-green cotton laminated dress, $400, mules with rubber-band straps to order, from $950, at Pellicano," British *Vogue*, February 1995.

20 *Women's Wear Daily*, Monday, August 30, 1999.

21 *Evening Standard Magazine*, March 10, 1995.

22 McDowell, Colin. "Shock Treatment," *Sunday Times*, August 12, 1996.

23 Joyce McQueen would no doubt have read historian John Prebble's *Culloden*, 1962, *The Highland Clearances*, 1963, and *Glencoe: The Story of the Massacre*, 1966. "McQueen and Alexander McQueen, 'Meeting the Queen was like falling in love,'" *Guardian*, April 20, 2004.

24 Frankel, Susannah. *Alexander McQueen: Savage Beauty*, Yale University Press, 2011, p. 21.

25 Veness, Alison. "Out to Shock with a Highland Fling," *Evening Standard*, March 14, 1995.

26 *Sunday Telegraph Magazine*, September 22, 1996.

27 *Evening Standard*, March 10, 1995.

28 Sharkey, Alix. "The Real McQueen," *Guardian* Weekend, July 6, 1996.

29 McDowell, Colin. "Divided We Rule," *Sunday Times Style*, October 29, 1995.

30 Rumbold, Judy. "Alexander the Great," *Vogue Catwalk Report*, supplement in British *Vogue*, July 1996, p.27.

31 Joe Casely-Hayford to the author, January 2010.

32 "Alexander McQueen," *Sunday Times Style*, March 3, 1996.

33 Menkes, Suzy. "The Macabre and the Poetic," *International Herald Tribune*, March 5, 1996, p. 10.

34 Hoare, Sarajane. "God Save McQueen," *Harper's Bazaar*, June 1996, pp. 130 and 148.

35 McDowell, Colin. "Dress Sense," *Sunday Times Style*, July 27, 1997.

Chapter 3

1 Heller, Richard. "Fashion's Hard Case," *Forbes Global*, September 16, 2002.

2 Blanchard, Tamsin. "Fashion McQueen," *Independent*, October 14, 1996.

3 "McQueen Hasn't Decided He Wants the Givenchy Post," *WWD*, September 27, 1996, p. 2.

4 "McQueen: He'll Do It His Way," *WWD*, October 15, 1996, and "Alexandre de Paris," *W Magazine*, December 1996. McQueen was not entirely correct, however. There were other couturiers, but Lincolnshire-born Charles Frederick Worth (1826–95) was the first "dictator" of fashion, lampooned by Charles Dickens as the "Man Milliner," whose designs launched in Paris impacted the way women dressed across the globe. Worth's influence was to be felt, however, in McQueen's upcoming collections and not in the work he did for Givenchy.

5 Herbert, Susannah. "When I See Fashion Now, I Suffer," *Daily Telegraph*, January 15, 1998.

6 Rocha, Miles. "McQueen at Givenchy: Will His Reign End?" *WWD*, September 13, 2000.

7 Hume, Marion. "Working-Class Lads of Haute Couture," *Financial Times*, *Weekend*, October 19/20, 1996.

8 Frankel, Susannah. "Wings of Desire," *Guardian Weekend*, January 25, 1997.

9 Frankel, Susannah. "Bull in a China Shop," *Guardian*, October 15, 1996.

10 Hilton, Als. "Gear: Can the Young Eccentrics of the Suddenly Hip British Fashion Scene Survive Success?," *New Yorker*, March 17, 1997.

11 "I would never even think of using white and gold…" "Gear," ibid.

12 McDowell, Colin. "Dress Sense," *Sunday Times Style*, July 27, 1997.

13 Spindler, Amy. "In London Shows, Individuality Stands Out," *New York Times*, October 1, 1996.

14 Frankel, Susannah. "Wings of Desire," *Guardian, Weekend*, January 25, 1997.

15 Polan, Brenda. "Couture of a Cabbie's Son," *Daily Mail*, January 20, 1997.

16 Sykes, Plum. "Couture Kid," British *Vogue*, April 1997.

17 V., Laura, "All Hail McQueen," *Time Out*, September 24–October 1, 1997.

18 McDowell, Colin. "No Business Like Show Business," *Sunday Times Style*, March 9, 1997.

19 Quick, Harriet. "His Majesty McQueen," *Sunday Telegraph*, March 16, 1997.

20 Alexander, Hilary. "Fashion Enjoys Putting on the Brits," *Daily Telegraph*, March 13, 1997.

21 Brampton, Sally. "McQueen's Head Rules His Heart," *Guardian*, March 13, 1997.

22 Thomas, Dana. "The Eccentrics of a Couturier," *Newsweek*, February 19, 2010.

23 Simon Ungless, interview with the author, February 25, 2012.

24 Hume, Marion. "Scissorhands," *Harper's & Queen*, August 1996.

25 Spencer, Mimi. "Animal Magic," *Evening Standard*, July 8, 1997.

26 Frankel, Susannah. "Animals Wear Well in New Image of Anarchy," *Guardian*, July 8, 1997.

27 Menkes, Suzy. "McQueen's Dance of the Macabre," *International Herald Tribune*, July 8, 1997.

28 Sykes, Plum. "Couture Kid," British *Vogue*, April 1997.

29 Betts, Katherine. "McCabre McQueen," American *Vogue*, October 1997.

30 *The Face*, November 1996.

31 Ballard, Bettina. *In My Fashion*, David Mckay, New York, 1960, p.259.

32 Herbert, Susannah. "When I See Fashion Now, I Suffer," *Daily Telegraph*, January 15, 1998.

33 Rocha, Miles. "McQueen at Givenchy: Will His Reign End?" *WWD*, September 13, 2000.

34 Simon Ungless, interview with the author, February 25, 2012.

Chapter 4

1 John McKitterick, interview with the author, January 2012.

2 A.M. Hanson, interview with the author, February 2012.

3 Simon Ungless, interview with the author, February 25, 2012.

4 McDowell, Colin. "Alexander McQueen," *Sunday Times Style*, March 3, 1996.

5 Menkes, Suzy. "The Macabre and the Poetic," *International Herald Tribune*, March 5, 1996, p.10.

6 Total cost of show was estimated at over $100,000 to stage with additional help from ICI and the rest made up by McQueen. Spencer, Mimi. "McQueen Rains as the King," *Evening Standard*, September 29, 1997.

7 "McQueen Rains as the King," ibid.

8 Fallon, James. "McQueen: He'll Do It His Way," *WWD*, October 15, 1996.

9 Rickey, Melanie. "McQueen Takes London By Storm," *Independent*, September 29, 1997.

10 V., Laura. "All Hail McQueen," *Time Out*, September 24–October 1, 1997.

11 A.M. Hanson, interview with the author, February 2010.

12 Inscription from McQueen on the Central Saint Martins's edition of *The Face*, April 1998.

13 "London: Pip Pip Hooray," *WWD*, February 27, 1998.

14 "Speaking English," *WWD*, September 29, 1998.

15 *i-D*, January/February, 1999.

16 Durst, Andre. Schiaparelli AW 1936–1937, "Rope hurtling out of oblivion, surrealist-fashion, spring coiling over a purple satin dress," *Vogue*, February 5, 1936, p. 53.

17 Mower, Sarah. Style.com.

18 Dunn, Joseph. "Role Model," *Sunday Times Style*, October 14, 1998.

19 Quinn, Sue. "Disabled Aimee Takes Centre Stage," *Guardian*, September 28, 1998.

20 Mills, Simon. "Backstage with the McQueen of New York," *Evening Standard*, September 20, 1999.

21 Foley, Bridget. "The Alexander Method," *WWD*, August 30, 1999.

22 "McQueen Madness," *WWD*, September 21, 1999.

23 Mills, Simon. "Backstage with the McQueen of New York," *Evening Standard*, September 20, 1999.

24 "Purple," *Alexander McQueen: Savage Beauty*, Yale University Press, 2011, p. 150.

25 Mower, Sarah. Style.com.

26 Frankel, Susannah. *Independent*, September 28, 2000.

27 McDowell, Colin; Woods, Richard; Gage, Simon. "Boy Done Good," *Sunday Times*, December 10, 2000.

28 Fallon, James. "The McQueen Chronicles," *WWD*, September 28, 2000.

29 "The McQueen Chronicles," ibid.

30 Fallon, James. "McQueen's New Deal," *WWD*, February 23, 2001.

31 "McQueen's New Deal," ibid.

Chapter 5

1 Fallon, James. "Meet Alexander the Shop-keeper," *WWD*, November 23, 1999.

2 Croft, Claudia. "McQueen Goes Shopping," *Evening Standard*, November 1, 1999.

3 Isabella Blow was always adamant that she had performed the introduction to the Gucci Group, from conversation with author 2003.

4 Heller, Richard. "Fashion's Hard Case," *Forbes Global*, September 16, 2002.

5 Fallon, James. "McQueen's New Deal," *WWD*, February 23, 2001.

6 "McQueen's New Deal," ibid.

7 "McQueen's New Deal," ibid.

8 Menkes, Suzy. "Mr. Letterhead: McQueen Shows a Corporate Side," *International Herald Tribune*, September 18, 2001.

9 Davis, Maggie. "The Boy Is Back in Town," *ES Magazine*, January 4, 2002.

10 D'Souza, Christa. "McQueen and Country," *Observer*, March 4, 2001.

11 Blanchard, Tamsin. "Blow By Blow," *Observer*, June 23, 2002.

12 Fallon, James. "McQueen's New Deal," *WWD*, February 23, 2001.

13 Wilson, Anamaria. "An Encounter with McQueen," *WWD*, August 1, 2002.

14 Quick, Harriet. "Killer Queen," British *Vogue*, October 2002.

15 "Killer Queen," ibid.

16 Armstrong, Lisa. "Go to Gucci ... I'd Rather Die," *Times*, March 3, 2003.

17 At the Jean Paul Gaultier A/W 2003–04 show, security guards had bundled protesters off the runway in fur wraps, a misguided action that was met with disapproval in the press.

18 Porter, Charlie. "On Target: British Designers Prove a Hit in Paris," *Guardian*, March 10, 2003.

19 Chamberlain, Vassi. "Lean, Mean McQueen," *Tatler*, February 2004.

20 Frankel, Susanna. "McQueen Is Gifted Enough to Persuade Women to Take Risks," *Independent*, June 12, 2003.

21 Chamberlain, Vassi. "Lean, Mean McQueen," *Tatler*, February 2004.

22 "Lean, Mean McQueen," ibid.

23 "McQueen Said to Turn Down YSL Post," *WWD/GLOBAL*, February 2004.

24 Bilmes, Alex. "McQueen: The Interview," *GQ*, May 2004.

25 Goldstein Crowe, Lauren. *Isabella Blow: A Life in Fashion*, Quartet Books, 2011, p. 178. Also: Goldstein, Lauren. "The Guys From Gucci," *Time*, April 9, 2001.

26 *Isabella Blow: A Life in Fashion*, ibid.

27 Cartner-Morley, Jess. "Boy Done Good," *Guardian*, September 19, 2005.

28 Mower, Sarah. Style.com, review, Alexander McQueen, A/W, 2005–06.

29 Style.com, ibid.

30 Lowthorpe, Rebecca. "The Boy Is Back in Town," *Elle*, September 2006.

31 Frankel, Susannah. *Alexander McQueen: Savage Beauty*, Yale University Press, 2011, p. 111.

32 This became a house signature, masterfully executed by Sarah Burton for Alexander McQueen in the case of Pippa Middleton's bridesmaid's dress for the wedding of the Duke and Duchess of Cambridge in 2011.

33 Played by Björn Andrésen.

34 An earlier version by Philip Treacy in the muddy red of the original was worn by Isabella Blow in the early 1990s.

35 Multibreasted sculpture of Artemis at Ephesus. Purple Fashion, 2007.

36 Inspired in part by the collars of the over-gowns of the mid-fifteenth century, pulled back and out from the body by the cut and weight of fabric.

37 The bowerbird is native to parts of Australia and Papua New Guinea.

38 Frankel, Susannah. "The Real McQueen," *Harper's Bazaar*, April 2007.

39 "The Real McQueen," ibid.

40 Frankel, Susannah. "Oh Cleopatra! McQueen's Luxe Partywear for a Pagan Princess," *Independent*, March 3, 2007.

41 Foley, Bridget. "The Real McQueen," *W*, June 2008.

42 Frankel, Susannah. "Collections Report," *AnOther Magazine*, S/S 2008, p. 222

43 Frankel, Susannah. *Alexander McQueen: Savage Beauty*, Yale University Press, 2011, p. 26.

44 "Collections Report," ibid.

45 Aimed at reducing greenhouse gases by 80 percent by 2050 in line with the Kyoto Protocol.

46 McQueen's deal with Target was to produce a line of inexpensive clothes and accessories for one season, with the top price of $129.99, launching its "Designer Collaborations" range.

47 Wilson, Eric. "McQueen Leaves Fashion in Ruins," *New York Times*, March 11, 2009.

Chapter 6

1 Hitchens, Peter. "Is St. Paul's the Place for a Fashion Show?" *Daily Mail*, September 27, 2010.

2 Watson, Linda. "Courtly Gestures," British *Vogue*, December 1990.

Image Credits